70
1999

I0045495

CLEMENT

THE UNIVERSITY
OF WISCONSIN
PRESS

Clement Greenberg
ART CRITIC

GREENBERG

A R T C R I T I C

Donald B. Kuspit

Published 1979

The University of Wisconsin Press
114 North Murray Street
Madison, Wisconsin 53715

The University of Wisconsin Press, Ltd.
1 Gower Street
London WC1E 6HA, England

First printing

Printed in the United States of America

For LC CIP information see the colophon

ISBN 0-299-07900-7

For J. C.

Contents

Preface

I have tried to avoid all clichés and to unframe Greenberg—to
remove him from the context in which he has been "framed."
At the same time, while ending this stereotype, I have tried to
show the underlying consistency of his thought, making its
cornerstones and pathways explicit. I conceive of this work as
a kind of archaeological reconstruction: digging through the
layers of thought in his various articles, taking words and
phrases as clues to concepts, structuring them until they make
coherent sense, and finally exhibiting them, not simply as
finished museum pieces, but as clues to a classic outlook, of
which Greenberg is the latest heir and reviser. At the same
time, I have valued the results in terms of the total range of
conceptual and practical possibilities that make up what we
would like to mean when we speak of criticism.

D.B.K.

November 1978

ACKNOWLEDGMENT

I am grateful to the National Endowment for the Humanities for the Younger Humanist Fellowship which supported this and other studies in contemporary American art criticism.

Clement Greenberg
ART CRITIC

Issues and Attitudes

The significance of Clement Greenberg cannot be overestimated. He is the designer and subtle manipulator of modernism, which is the single most important and influential theory of modern art. A summary and codification of that art's purist thrust, modernism is the backbone of Greenberg's practice of art criticism. Reviewing the essays in Greenberg's *Art and Culture*,[1] the fruits of this practice, Hilton Kramer writes:

> there can be no doubt that *Art and Culture* is art criticism
> of a very high order—the highest, I should say, in our
> time. It is the only book in its field that could be seriously
> compared to the celebrated works of literary criticism

produced in this country in the thirties and forties. *Art and Culture* is, moreover, the most important book of its kind since the death of Roger Fry . . . Like Fry's work, it represents a period—in this case, the twenty years following the start of the Second World War—and its publication may very well mark the end of that period. To understand *Art and Culture* is to understand a great deal about the artistic values that came out of the war and the Cold War years.[2]

"It was Greenberg alone," as Barbara Reise says, "whose journalism championed Pollock, Gorky, De Kooning, Smith, and Robert Motherwell to the public at large in the 1940s," championed them "against the dominance of the 'School of Paris.' " It followed that

When the work of the artists known as the "first generation" Abstract Expressionists began to receive international acclaim in the 1950s, the quality and courage of Greenberg's insight was recognized as well. He was asked to organize or write prefaces to exhibitions of the artists' work for academic and commercial galleries, both in America and abroad. He organized major exhibitions of painting by Pollock, Gottlieb, and Newman; he contributed introductory essays to the Hans Hofmann exhibition at the Kootz Gallery in 1958, and to Betty Parsons' 1955–56 group show of "Ten Years" work by the Abstract Expressionists associated with her gallery. His role easily shifted from the alienated critic writing art columns for intellectual magazines to an Impresario in the New York art-world judged by his commitment to a specific type of art and respected for its ultimate (commercial and influential) success. As such he took on the character of a Prophet in the New York art-world. Artists like Anthony Caro, Morris Louis, and Kenneth Noland sought his criticism and advice, and gallery directors sought his predictions; when Greenberg selected the "Emerging Talent" exhibition at the Samuel Kootz Gallery in 1954, Louis and Noland were included.[3]

Greenberg's fame rests on his discovery, advocacy, and encouragement of unknown artists, who later achieved na-

tional and finally international recognition. His fame also rests on the theory by which he justified his taste and specified their significance. The importance of the artists Greenberg singled out for attention is no longer in question. But the principles of his art criticism, first presented informally in the pages of *The Nation* and subsequently in didactic form in *Partisan Review* and elsewhere, remain controversial. They are questioned as much for their manner of presentation as for their viability.

In fact, it is impossible to lay out Greenberg's way of thinking about art in general and modern art in particular without becoming caught in a crossfire. He may be, in the words of Edward Lucie-Smith, "one of our most eminent critics," in fact the critic "whom most of us think the most influential critic of modern art now [1968] writing."[4] But he is also, in Max Kozloff's opinion in perhaps the most extensive attack on Greenberg, the critic with the greatest "hardness of line," an authoritarian way of establishing his views by "decree," and, as a correlative, a "quasi-religious tone" to his "aesthetic."[5] In other words, he is tyrannical and dogmatic, giving his "personal intuitions" an aura of absoluteness which turns them into gospel truth. Kozloff's view of Greenberg as a kind of oracle of modern art, speaking ex cathedra as though he were a Pope and infallible, goes hand in hand with Patrick Heron's belief that Greenberg "degrades criticism to the status of fashion-picking."[6] Perhaps the most cynical of all the skeptical views of Greenberg's criticism, this belief has been consistently stressed from the start of Greenberg's career. It first appeared in a letter by Fairfield Porter in 1941.[7] (Porter's kind of realism had much to lose from Greenberg's advocacy of abstraction.) In general, Heron thinks that Greenberg's criticism is simply an "academic" ideology justifying "sectarian" taste: the criticism functions as an imprimatur on a temporary fashion in art.

This kind of attack means to debunk Greenberg's method as well as its conclusions. It assumes that Greenberg means to reconcile fashion and history by regarding aesthetic

evaluation of fashionable new art as valid when it is made from historical perspective. But Greenberg assumes there is only one correct historical perspective, so that the proposed *rapprochement* falls flat. From this point of view, Greenberg is, wittingly or unwittingly, a historical determinist, trusting in the inevitability of a certain dominant pattern in history. This untested, and perhaps untestable, presupposition of implicit determinism is the springboard for his version of what is mainstream in the history of modern art. In this argument, however, no mainstream can be decisively established. There are too many different kinds of art, that satisfy many different kinds of interest, to determine which is normative.

In response, one must note that what might be called Greenberg's credo of the normative exists not only to give determinate shape to the mass of raw facts which from a naïve point of view constitutes history, but to permit the critic to transcend the conditions of the moment which inevitably seem to converge on any event and obscure its significance. Greenberg's determinism and sense of the normative are two aspects of the same attempt to make the personal judgment of the moment, which the critic seems bound to, as good as the judgment of history. By combining the short and long views of art—intuitive response and the reflective understanding afforded by historical perspective—Greenberg means to give his criticism sublime credibility. Nonetheless, from Heron's point of view the certainty of judgment Greenberg achieves by this combination falsifies the value of much art, either sweeping it aside or working hard against it. Greenberg is understood to be all too ready to rank works of art in the name of a limited vision of artistic values, which gets its critical cutting edge from a limited sense of art's substance. Most damning, his vision, whatever its predictive sweep, is said to mystify understanding of individual works of art. As Kozloff says, "the only real identity a critic can gain . . . is in doing his best to explain that of the work of art," a task vitiated in Greenberg's case by the fact "that the

critic leaps ahead of the work of art, prophesying rather than following its objectives."

There are many more attacks, perhaps the most subtle of which is Lawrence Alloway's classification of Greenberg as almost unqualifiedly "aestheticist," as though he had nothing to say about the relation of art to life and culture.[8] All clearly acknowledge the importance of Greenberg's criticism, if only by the intensity of their response to it. But none quite spells out its terms and methods in significant detail. Instead, as noted, Greenberg's critics generally attend to what seems to be the most invidious consequence of his position evident without fully articulating it, viz., the raising of certain kinds of art and artists—a limited ideal of art—at the expense of others. The rationale for this endorsement—and reading Greenberg one realizes that it is not made unequivocally—is never treated with precision. One wonders how well his position is known, and whether its full complexity is realized. In general, discussion of Greenberg's "values" is usually tainted with such prejudice against them as to distort his outlook almost beyond recognition.

One reason for this may be that any attempt to take seriously Greenberg's intellectual rationalization of his aesthetic judgments is handicapped from the start by a general and fundamental objection against such rationalization in criticism. Greenberg's antagonists implicitly assume that his intellectual justification of the choices of his sensibility is a stopgap measure, rather than what he claims such justification to be, a demonstration of the objective grounds of taste.[9] For his critics suppose that all such choices are irrational, and that it is naïve presumption, sign of a desperate desire for authority, to assume objective grounds for taste. To pretend such grounds exist falsifies the activity of criticism, which is an expression of the "genius" of sensibility. Any attempt to rationalize sensibility's workings and discriminations undermines them by inhibiting them. The common view is, as Kozloff puts it, that criticism begins with "visceral reactions," which are personal and intuitive,

and ends with their elaboration. To pretend that criticism does anything else is to make it ring hollow with foolish, indeterminate speculation. In this view, criticism involves groping through one's experience of—arousal by—the work of art to the work of art itself, in a kind of trial-and-error if not exactly hit-or-miss way. Presumably, one can determine the identity of the work of art simply by introspectively examining one's vital response to it. One arrives at a "sense" of the work of art and its implications—perhaps a consensus of one's individual reactions to it—which makes no claim to be objective, or is only incidentally so. Taste at best "highlights" the particularity of a work of art rather than reaches any general conclusions about it. Thus, since it is assumed that taste cannot objectify art, Greenberg's attempt to force taste to do so by grounding it on general ideas is said to misrepresent it. The problem with Greenberg, then, is that he tries to justify his personal experience of art with general considerations about its nature and history. It is this which leads him to regard his understanding as ultimate and his judgment as infallible. As Kozloff remarks, "for all hopes to the contrary, it may never be possible adequately to link aesthetic intuitions and general ideas." As he recognizes, this is exactly what Greenberg tries to do and, according to Kozloff, fails to do, because it is impossible to do.

And yet Kozloff cannot help but pay attention to Greenberg's "general ideas," however much he gives them short shrift. Clearly, he feels free to do so because to him the very notion of successfully joining them to "aesthetic intuitions" is preposterous. Like many other critics of "our most eminent critic," Kozloff embeds his analysis of Greenberg's ideas in a polemic which assumes that they fall short of their stated goal and so need not be considered seriously. Such polemical discourse is not designed to understand the ideas it attacks but to ridicule the very possibility of presenting them. Kozloff reduces Greenberg's ideas of "dialectics" and a "cyclical view of art history" to empty rhetoric. He then sympathizes with Greenberg for the "fact" that such

ideas, which have been falsified by radical oversimplification, cannot do justice to intuitions, and remarks on the "feeling of inadequacy" signaled by being forced back on ideas in criticism. This puts Greenberg exactly where polemical strategy demands that he be: unable, like all the other humble critics, to rely on anything but his sensibility. In other words, he is shown to be subject to the same inescapable limitations as all art critics, and thus his claims to being a thinker are reduced to rubble. Worse yet, the notion that he has a definite point of view from which to make critical judgments is reduced to absurdity. For on Kozloff's terms, the critic's point of view changes with that of the work of art he is reacting to. No stable point of view is possible, because of the variety of art. The critic must be a chameleon, spontaneously responsive to a changing environment of art.

Greenberg's attempt to lift himself above the mire of blind intuition and create a criticism based on reasonable concepts is disallowed by his detractors, because for them, flying as it does in the face of the facts of art and the nature of taste, it is not a realistic possibility. But Greenberg's conception of criticism takes its methodological fundament from Kant's assertion, in the *Critique of Pure Reason,* that "thoughts without content are empty, intuitions without concepts are blind." Criticism is the effort to reconcile general thoughts about art with particular intuitions of works of art to achieve a depth experience of a certain kind of art (in Greenberg's case, modern abstract art). Kant, for whom criticism meant the reconciliation of sense and reason in the understanding of experience, supplies the operational principle of Greenberg's criticism. His adversaries mock this conception because it is absurd to them, in their tendentious reliance on sense. But from Greenberg's Kantian point of view, they make only half the effort of criticism, because they fail to see its whole point.

These adversaries, then, while dismissing Greenberg's theoretical ambitions, are quick to praise his intuitive practice. They claim him as one of themselves, another conventional critic

relying on sensibility, but stubbornly refusing to take the articulation of its intuitions as the be-all and end-all of art criticism. For them, he is mistaken in not thinking they can stand on their own, and his speculative buttressing of them will topple of its own weight, or collapse at the slightest touch. Kozloff, who manhandles Greenberg's thought, writes that "one scratches his dialectics only to find underneath an aesthetic sensibility too frequent to be accidental," which is why Greenberg "will not fall down," however much his thought might be pushed down. Kozloff is all too ready to respect Greenberg for "the conviction of his eye," as if to apologize for the fact that in the same breath Greenberg's "need to stamp a particular order on post-war American painting" is ridiculed. That is, Kozloff acclaims Greenberg's sensibility but denies his sense of the logic of certain events in art history. And indeed no one can be deprived of their sensations, however much their logic can be disputed and removed as unrelated to their sensations. Greenberg is entitled to his sensations, which are acute and "fascinating," but not to his interpretation of them.

The problem, once again, is that in rationalizing his personal taste he turns all kinds of important artists "out of court." As Heron writes, "Why does a critic have to harm his case by denying the existence of everything outside his personal range?" Greenberg, of course, does no such thing. By making, however, sharp distinctions about the way different kinds of art work, he seems to be imposing values. That is, he seems to be using his personal discriminations as a standard rather than simply stating them. In general, Greenberg's opponents implicitly believe and have no wish to tamper with the wisdom embodied in the proverb *chacun à son gout*. One must simply lay out one's taste and not impugn anyone else's, and the best critic is the one who can lay out his taste forcefully—viscerally—and make a case for the propriety of his sensations. Good critical behavior expects one taste to be tolerant of another, for all are, at best, opinions, not true and careful knowledge. However much Kozloff, in his critique of Greenberg, signs off with a plea for criticism as the pursuit of truth about works of art, he

has a sense of the futility of such an enterprise when it does not recognize the very narrow grounds on which it can claim to be truthful. These grounds are next to impossible to stand on, so that the truth that art criticism has to offer seems embarrassingly awkward. Such "truth" can only be a personal report of sensation, which seems trivial next to the art.

Greenberg's attempt to make taste objective would eliminate the infinite regression of sensation that reliance on pure sensibility causes—i.e., the dwindling away of one sensation to a "deeper" one, to "prove" the point of the first "shallow" one. His attempt at objectivity is the only alternative to a criticism based on sensibility. For it is such art criticism, rather than Greenberg's, that reduces to absurdity. Sensibility is not pure to begin with, and if it was it would be inarticulate, and criticism would be caught, as in fact it is for many, in a round of ineffables, which however poetic are mute. In a sense, such intuitive criticism is far easier to pursue than a criticism using ideas, which makes great demands in erudition as well as logical acumen. As it is, every critic in practice needs ideas to articulate his sensibility, and even to lead it on to new experience. Ideas lure sensibility beyond itself, suggest to it sensations it may never have expected. Sensibility is not completely dependent upon the art it blindly burrows into for its content. Such immersion in the work of art may be a necessary first step of taste, but it does not exhaust its experiential possibilities. Ideas must finally be used to penetrate the work of art so that it loses all opacity and becomes transparent, and as such completely possessed. Without ideas to clarify art, taste becomes static and nugatory, and even self-defeating, for it begins to miss the nuances of perception on which it traditionally prides itself. Not grounded on concepts, perception becomes whimsical or leaden, in either case forfeiting or distorting its possibilities.

Kozloff doubts that Greenberg "would care to acknowledge" the "conflict" at the root of his criticism. But he openly admits the conflict of intuition and idea, sensibility

and logic, the personal and the objective. He does not, however, view it as a permanent dilemma, an unsolvable and so inherently absurd double bind it is best to abandon, or else a Gordian knot to be cut with a single stroke of "visceral reaction." Greenberg accepts the complication offered him by the conflict, and sees it as something art criticism can clarify only by turning to the philosophy of art. If it does not do so, it will never become fully responsible for itself. Its methods will remain undependable and its purpose obscure. In fusing criticism with philosophy, as in his attempt to demonstrate the objectivity of taste, Greenberg is not willfully cultivating paradox. He is not establishing himself as the priest of a perverse dialectic, and interpreting its mysteries to the profane layman. Instead, he is openly acknowledging a perpetual problem of responsible criticism—viz., the extent to which it is willing to subject itself to tests of validity. He is even asking whether it is possible to do so—i.e., whether such tests can be found.

Greenberg is acutely aware of the working critic's need for theoretical justification if he is to avoid the pitfalls of description and partisanship. Art criticism can avoid degenerating into a mere accumulation of details (which seem to void each other) or into favoritism only by becoming seriously theoretical. Greenberg argues this directly in a 1955 review of two books by Bernard Berenson, *Piero della Francesca; or, The Ineloquent in Art* and *The Arch of Constantine; or, The Decline of Form.*[10] In this review he observes "how much the working critic he [Berenson] remains amid his efforts to formulate theory, and how often the latter serves him merely as an *ad hoc* means of praising specific works of art." Greenberg is desperate to avoid the trap of ad hoc argument, which is what naïve taste, which cannot justify itself adequately, degenerates to, and what criticism relying solely on sensibility unwittingly encourages. He does not want to falsify theory into a case of special pleading. To avoid doing so, he argues that one must "take the trouble to render . . . generalization viable beyond [one's] own empirical practice as a critic." Berenson, because he does not

seriously attempt to move beyond his personal empiricism, yet makes generalizations in order to make himself clear and objective, creates confusion. Criticism can become truly clear and objective only when it uses the generalizations which arise in the course of aesthetic experience seriously —i.e., self-consciously and logically—and as part of a comprehensive philosophy of art. The generalizations which theory attempts to make viable and use to validate taste arise from the extended exercise of taste itself; they are not arbitrarily imposed as universal instruments of analysis. Nonetheless, it is clear, from Greenberg's argument, that their generality is confirmed only by a universal approach to art.

For Greenberg, Berenson "invites one to take issue with him by the very ingenuousness with which he reveals the operation of his taste. This is the trait of the great critic, and Mr. Berenson is one of the greatest of them all. But he is a working critic, not a philosopher of art." Greenberg would like to be both; let it never be said that he is ingenuous. Or at least he would like to use a philosophy of art—a set of justified and logically related generalizations regularly arising in the course of aesthetic experience—to clarify and objectify his empirical judgments as a working critic. Thus, when his taste invites one to take issue with him, he would not be reduced simply to underlining his sensations—i.e., turning them into poetry by tautologously emphasizing them. In other words, he would not regard his taste simply as a strong bias, and justify it in terms of the power with which it takes possession of an art. Rather, he would defend his perceptions with a series of conceptual arguments which would reveal their cogency. He would take the mystery out of taste or, what is the same thing, he would take the subjectivity out of aesthetic judgments by showing the impurity of sensibility—i.e., by showing the way it could not even begin to function without making certain conceptual assumptions. Greenberg does not mean to dismiss intuition, or even to subordinate it to logic, or to subsume it in logic, but rather to show how intuition and logic operate to-

gether, the latter clarifying and validating what the former discloses and "proposes." Logic takes intuition beyond immediacy of experience and shows its conceptual obligations, as it were. This perhaps reduces its intensity, but reveals its significance.

Greenberg admits the limitations and difficulties of this process of intellectual clarification. He is also aware of the uncertainty or hesitancy it causes in the working critic. It is difficult always to be theoretically backtracking, for it interferes with the spontaneous exercise of judgment. But, as noted, the assumption that only spontaneous response or "visceral reaction" is involved in art criticism is part of what might be called the myth of the purity of sensibility. And also as noted, the uncertainty caused by the critic's need to justify his sensations, or to articulate their conceptual component, can sharpen sensibility rather than inhibit it. By not letting it jump to conclusions on the basis of its immediate experience it can be made more "telling." Nonetheless, the working critic finds it difficult to use general ideas in his on-the-spot situation. When one faces the art, abstractions about it seem to remove one from active experience of it, destroying its charge. At the same time, it can be argued that obsession with the particular sensation of the work at hand also removes one from the work, for it makes it hard to get any general perspective on the art. Greenberg is acutely aware of the problems of reconciling the conventional working critic's pursuit of the work's particular sensation or flavor with the conventional philosopher of art's pursuit of general ideas about art. Because he is aware of those problems, and because he wants to use both gambits to get close to the art, he is also aware of the difficulty of determining the significance of present art and of predicting future art. He thus denies what he has been consistently accused of. "Whatever we conclude about the greatness of art in the past, we shall not be able to lay down limiting or enabling rules for the achievement of greatness in the present or future until aesthetics has become as exactly scientific as physics."

Greenberg does not claim to offer a despotic determination of present and future art. He is willing, however, to generalize from his experience for the sake of a more accurate rendering and reading of it. When he generalizes he seems to become dogmatic, for he comes to accept certain ideas about art as more fundamental and important than others, which it is impossible to do on an entirely intuitive basis. Moreover, since, as noted, he attempts to give comprehensive, logical form to his generalizations, he seems to become altogether abstract or philosophical, i.e., he seems to work on a level of generalization that has no relation to intuitive experience. In other words, in attempting to make his generalizations viable, he develops them in and for themselves as well as to validate his taste.

It is when he does so that his commitment to Kant comes to the fore. On the basis of that commitment he makes perhaps his most startling methodological move, at least from the point of view of a criticism that attempts to rely totally on sensibility. He generalizes aesthetic distinctions so that they can be used as categories of understanding of art per se. Greenberg does not use a piecemeal method of generalization, extending a distinction as the working critic's situation warrants it—i.e., to help him with some particular art. Rather, Greenberg takes distinctions intuited in the course of aesthetic experience as signs of a general consciousness of art, and thus is free to return them to experience as indications of what is typically at stake in the functioning of any given art. Instead of, as he thinks Berenson does, letting these distinctions appear and disappear in the course of the experience of a particular art, he develops them systematically and uses them to analyze all art. He does not wait on the art, expecting it to reveal itself through the distinctions that might arise in sensibility, but he catalyzes sensibility by bringing the distinctions to bear on the art. He tries to avoid what he thinks happened to Berenson when he began to theorize about his experience of art—viz., he found his general ideas to have an adventitious, even arbitrary relationship to his experience, so that

they justified nothing in it. Because Berenson was unable to articulate adequately the premises of his own sensibility, he was unable to enrich its experience. It remained bogged down in distinctions which occurred to Berenson in the course of his aesthetic experience, but which, because he took them for granted, in a simple-minded, even naïve, way, became fruitless, and ultimately seemed extraneous and imported. He could not see the necessity of these distinctions; he could only experience them. This necessity is revealed when they are generalized. And only by being generalized, and tested universally, can they prove their value. Only by being taken absolutely, as the constants of a consciousness of art, can such generalizations show their power to illuminate art.

> To approach art philosophically means ... to abstract from one's experience of it. Kant had bad taste and relatively meager experience of art, yet his capacity for abstraction enabled him, despite many *gaffes*, to establish in his *Critique of Aesthetic Judgment* what is the most satisfactory basis for aesthetics we yet have. Kant asked how art in general worked. Mr. Berenson asks, more specifically, how the visual arts work and what makes the difference between good and bad in them; but the answers require almost as much abstraction. *His* answers, however, diminish rather than abstract from his experience, and his experience again and again escapes from his theories.

Greenberg does not want his experience to escape from his theories, or his theories to diminish his experience. In Berenson's case this happens because he does not realize the "knotty questions" behind such felt distinctions as that "between the illustrative and the 'decorative' or non-illustrative." He takes it as a qualification of his personal experience rather than as a generalization that might inspire the understanding of any work of art. Above all, from Greenberg's point of view, Berenson sees simply two kinds of art, not a dialectic inherent to and determining the possibilities of every art. By understanding Berenson's distinction dialectically Greenberg treats it as more than something that

might casually arise in the course of the experience of a particular art. The tension between the illustrative and the decorative is understood as immanent in every art, giving the critic a sure way of understanding the complexities of artistic appearance. The critic is no longer intuitively abandoned or trapped in a visceral reaction to them. The art's appearance can be clarified through the dialectically understood distinction. The art is thereby more knowingly, and so more fully, enjoyed. Through a dialectical understanding of the art one can even "ride" its tensions, rather than be submerged by them. Simply by understanding its complexities as tensions one is already in "control" of them.

Berenson, whose criticism is based on sensibility, is content to intuit the distinction, and assumes that aesthetic experience will supply an infinity of such distinctions, each nuancing the art. But Greenberg, the philosophical and dialectical critic, knows that experience is finite, and tries to determine the significance of the few distinctions it offers, and to understand any given art as substantially as possible in their terms. These distinctions are at once the limitations of the experience and the art. Moreover, the philosophical critic can never take sensiblity naïvely; he knows that it is generalized to its roots. Its intuitions are abstractions whose logic needs to be made explicit. Aesthetic intuitions are not sensuous delights, viscerally available for the asking, but spontaneous insights requiring conceptual articulation. To use an analogy, aesthetic experience is like a dream in which intuitions are the manifest content and ideas the latent content. The immediacy of the dream image gives way to its meaning as its workings are understood. While Greenberg idolizes Berenson as a model working critic, he thinks a new model of criticism is necessary, one which is deliberately philosophical. The new philosophical critic avoids the subjective pitfalls and objective contradictions of the old critic who relied exclusively on his taste. The new critic is also a connoisseur, but above all he must be able to justify his judgments and distinctions coherently—i.e., show the coherence of his point of view.

It is Greenberg's general conception of the "self-critical tendency" in modern art, involving "the use of the characteristic methods of a discipline to criticize the discipline itself," that generates the greatest animosity to him.[11] That is, of all his ideas his concept of modernism has most brought down on him the charge of dogmatic narrowness. It has led him to conceive of criticism as the evaluation of every art in the light of its treatment of its medium, understood not only as fundamental to the art but as the source of all its consequence. Nicolas Calas has noted, with some truth, that Greenberg's concept of modernism is Hegelian rather than, as Greenberg claims, Kantian in origin.[12] Self-critical means dialectically self-conscious. Calas also points out that modernism is absurd as a general logic of art, since it misses so many of its meanings. But Calas misses Greenberg's main point. The theory of modernism is not meant to rationalize the development of modern art nor to exhaust all its possibilities of meaning. It is rather concerned to make us conscious of the way a significant work of art actually works. That is, Greenberg does not claim that all art is necessarily "philosophical," or entirely self-referential, but that what is significant to the art as art, and what we experience in it when we experience it as art, depends upon the logic of its treatment of its medium.

The dogmatism in this is Greenberg's insistence on the logical priority of the medium to what it conveys, and on the fact that when we are experiencing the art as art we are experiencing this logical priority. That this is a "fact" is of course open to question, particularly by those who understand the medium as just that, a medium of meaning, and who locate the "art" in the meaning mediated. But for Greenberg the medium is the primordial fact of art insofar as it gives us aesthetic experience. The meanings it mediates have to do with cultural rather than aesthetic experience. The big question here, of course, is whether it is possible to have aesthetic experience that is not culturally conditioned. We will see that Greenberg himself does not think so, although cultural experience is so transformed

and generalized in aesthetic experience as to be hardly rec-
ognized, at least directly or without interpretation. In any
case, for Greenberg the handling of the medium that is
general to any art determines its quality as art. Only that
art which does not take its medium for granted, but brings
it into question as it were, can truly have quality and be
significant as art. Greenberg may think like this because of
an implicit belief in the medium as, in Hegel's phrase, the
"concrete universal" of art, reconciling its particular with its
general nature. Thus, the "message" of any given art can
never be thought of as independent from its "formal facts,"
as Greenberg calls them. The message is always in dialecti-
cal relationship with the medium. Modernism is Green-
berg's demonstration "that the prime fact about a work of
art is not what it *means*, but what it *does*—how it works, how
successfully it works, as art."[13] There are actually no priori-
ties here; for Greenberg, a work means through what it
does. In aesthetic experience what a work means is simul-
taneous with what a work does.

One can say of Greenberg what he said of Roger Fry:
"Even at his most dogmatic Fry usually has hold of the
truth somewhere, and here he has hold of a good piece of
it."[14] Such defensive exaggeration seems necessary to bal-
ance the prejudiced polemics and seemingly deliberate mis-
understandings of Greenberg's detractors. They hardly give
credence to his judgments, let alone believe in his concep-
tion of criticism. Why should they, since they are engaged
in what the psychoanalysts call the killing of the father—the
father of modern American art criticism. For they are all,
in the last analysis, his sons.

Dialectical Conversion

In a masterly article on "The Role of Nature in Modern Painting" (1949)[1] there is a footnote (rare in Greenberg) which is an important clue to Greenberg's way of thinking about art. The footnote introduces the idea of dialectical conversion. The idea seems remote, because of its abstract character and generalizing sweep, from ordinary aesthetic experience, with its emphasis on the concreteness of the work of art. This is perhaps why Greenberg repressed the footnote in his revision of the article for his book *Art and Culture* (1961). He may have thought it led the ordinary art reader speculatively far afield. He also may have been repressing his own early Marxist commitment. As Hilton Kramer notes, Greenberg began his career as

a Marxist of the Trotskyite persuasion. In the early for-
ties he was for a time an editor of *Partisan Review* when
that journal still inclined to a Trotskyite position in politi-
cal matters along with its liberal interest in modern art
and literature. In the late forties and fifties he was an
editor of *Commentary*, a journal that wielded considerable
influence in dispelling Marxist illusions about Russia's
role in the Cold War and in revising the aims of Ameri-
can liberalism. During the forties the bulk of Mr. Green-
berg's criticism appeared in *The Nation*, a magazine he
served as a regular art critic and with which he broke,
eventually, for political reasons.[2]

Greenberg himself has written that "some day it will have to
be told how 'anti-Stalinism,' which started out more or less
as 'Trotskyism,' turned into art for art's sake, and thereby
cleared the way, heroically, for what was to come."[3] It may
be that Greenberg's repression of the footnote on dialectical
conversion is part of his turn from a kind of Marxism to art
for art's sake, and in fact signifies the completeness of the
conversion. Indeed, as Kramer says, "*Art and Culture* is cer-
tainly one of the principal documents of this transition
from purist ideology in politics to pure aestheticism in art."[4]
In the aftermath of this transition the concept of dialectical
conversion may have seemed to Greenberg a rhetorical
abstraction or empty intellectual flourish. *Art and Culture*,
which removes such flourishes, comes down decisively on
the side of aestheticism, although as we will see it is not so
pure as Kramer thinks. Part of its impurity is that it is fully
comprehensible only through such general ideas as dialecti-
cal conversion.

Art and Culture, incidentally, devitalizes originally fervent
materials, as though the book format requires some special
dignity, which must quiet the air of controversy and daring
in the originally lively articles. The book revises irritable,
strongly felt articles, written in outspoken, sharp response
to particular events, with the signs of the sorting out of is-
sues still visible, into finished polished essays, each of them
oracular in tone, as on a grand occasion. As Barbara Reise
says, Greenberg's writing "in the 'forties, and to a lesser de-

gree in the 'fifties . . . had been obviously passionate, avow-
edly personal, conveying a real impression of direct con-
frontation with his artistic enthusiasms."[5] At the time of the
publication of *Art and Culture*, she notes, his writing had not
only become "more didactic" and "concerned with philoso-
phy and history" (it had always been concerned with them),
but seemingly "removed from concrete aesthetic encoun-
ters." What is above all sad about the conversion of per-
sonal article into impersonal essay is the closing and pre-
sumed settling of issues under open discussion. In the
essays there is no sign of the inner debate that made the
articles exciting and vital. Also, the strong feeling in the
articles becomes a firm stand in the essays, which give the
sense of a ritual chanting of known truth. What was origi-
nally an idea in formation—i.e., an empirical insight in the
process of being generalized—has become an eternal truth.
It can thus be preached, i.e., laid down as law. Where the
article shows an idea being explored as it is being used, the
essay indoctrinates in sound thinking.

The footnote:

> The process by which Cubism, in pushing naturalism to its
> ultimate limits and over-emphasizing modeling—which is
> perhaps the most important means of naturalism in paint-
> ing—arrived at the antithesis of naturalism, flat abstract art,
> might be considered a case of "dialectical conversion."

The concept of dialectical conversion also occurs, unnamed
but in clearer form, in another article written in 1949. In a
discussion of Courbet, Greenberg remarks: "We see once
again that by driving a tendency to its farthest extreme—in
this case the illusion of the third dimension—one finds one-
self abruptly going in the opposite direction."[6] In 1962 the
concept is still a part of Greenberg's thought. He writes of
the "dialectic" by which Abstract Expressionism arrives at
"homeless representation" as one in which the "ineluctably
flat," pushed to the extreme, becomes unexpectedly rep-
resentational, as in Jasper Johns's flag paintings.[7] For

Greenberg, the whole history of art is a matter of dialectical fluctuation between abstraction and representation, a case of the ironical conversion of opposites. An art which does not initiate such a conversion or carry it further—i.e., show it in process—is insignificant for Greenberg. Thus, because of its universality for Greenberg, we should not be surprised to find him looking for dialectic far afield from the art he customarily deals with, and even using it to understand art culturally as well as aesthetically. By 1972 we find the idea of dialectic almost overgeneralized; it is no longer specific to the tension between abstraction and representation. "It could be said even that the Indian "will to art" is actually a very masculine one, and that it drives towards the feminine precisely because it is so masculine. (Just as it is my paradoxical impression that the Indians could so abundantly depict or describe sexual activity because sex was not really that much on their *minds*, in their *heads*.)"[8] Greenberg usually abbreviates the paradox of dialectical conversion, for him the source of art's "freshness" and "surprise," into the union of opposites: "opposites have a way of meeting."[9] He believes that art in general works dialectically: "It is one of the functions of art to keep contradictions in suspension, unresolved."[10] This entitles the artist to "inconsistency." *In nuce*: "Contradictory impulses are at work, and the triumph of art lies—as always—in their reconciliation."[11]

What is dialectical conversion? To regard it as the way a "thesis" or possibility of art negates itself to become its opposite or "antithesis"—an unexpected actuality—in the course of realizing itself, is to miss the struggle and unpredictability of the process. Greenberg is not unaware of the ironies of self-negation in the realization of art. For example, he notes that, in Milton Avery's painting, decoration is as it were compelled "to overcome and transcend itself by its own means."[12] He is more aware, however, of dialectical conversion as a kind of "wrench," in part the sign of "*retroactive* power," "by which a long and rich tradition" still asserts itself.[13] It reverses direction to reexplore its pos-

sibilities, reviving lost, overlooked, or still latent yet realizable possibilities. Dialectical conversion is an indication of the enduring viability of what seemed a finished art, and of its new possibilities in aesthetic experience. This leads to a reexperiencing of it, as in Greenberg's treatment of the later Monet, who is freshly perceived as an abstract painter rather than traditionally as an impressionist.[14] The transcendence of opposites is a sign of the unforeseeable release of an art's energy in the process of working it out to its "logical" conclusion. In the twentieth century, perhaps Greenberg's main example of such transcendence is Matisse, whose art makes a number of opposites, such as "coldness versus warmth" and "spontaneity versus reflection, beside the point."[15] In a sense, dialectical conversion demonstrates the urge to unity within a situation of dichotomies (such as those Wölfflin posits), but with a sense that the unity revives the vitality of the terms of the contradiction, which seemed set in their ways. That is, conversion shows the continued viability of the terms of the dialectic, but now by reason of their connection or harmony rather than disjunction or opposition. The opposition of the terms is not allowed to harden, but made the potential for a harmony. Greenberg's insistence, however, on the struggle that attends the dialectic's operation, and hinders any neat working out of its nuances, precludes the possibility of regarding it as inevitable. He does not assume that just because there is a dialectic it will be automatically set in motion. What made the later Monet relevant to the art of the 1960s for Greenberg was the struggle of some artists to achieve a new kind of pictorial unity, not the necessity of this unity coming into being on the basis of Monet's late work. The idea of dialectical conversion reminds us only that nothing is necessarily lost or closed in art, and also that it will not necessarily be found or opened again. What becomes surprisingly viable and fresh again and so can be re-viewed depends upon present creativity, with all the difficulties of its own experience.

Dialectical conversion involves, then, a rich sense of the

possibilities of art history, but no sense that they are acti-
vated by an autonomous logic. Rather, they are recognized
and set in motion by an individual artist, i.e., by his per-
sonal history, his personal experience of the history of art,
and his personal perspective on his world. At the same
time, Greenberg has a strong sense of the difficulty of
overcoming objective history, cultural as well as artistic.
Again, this does not mean that he regards it as predeter-
mined, but rather as a reality which makes itself felt in im-
mediate and personal experience, whether or not we are
conscious of its effect. For Greenberg, we had best be, if we
are to get the best out of its influence. That is, Greenberg is
aware that art is never created *in vacuo* but is always be-
holden to a past. How that past manifests itself in present
art—what power the past is allowed to have—depends upon
the consciousness and self-consciousness of the working art-
ist. This sounds simple enough, yet as noted in the first
chapter Greenberg has repeatedly had to repudiate the
charge that he believes in historical necessity. In fact, he
openly attacks the idea. Instead of "consulting" "a priori
dogmas about the historically necessary" to understand art,
one must grasp it through "the pleasure and exaltation to
be experienced" from it.[16] "Historical necessity does oper-
ate," writes Greenberg, "but not with the consistency . . .
expected of it." This is because historical necessity is sub-
sumed by dialectical conversion, which involves the working
through of the historically given in experience. Recognition
of historical necessity is an acknowledgment of what is
given in experience, but not a guarantee of how it will be
worked with in individual experience. Put another way,
necessity is submerged in the conversions of experience,
conditioning its dialectic but not foreordaining its history.

Thus, by historical necessity Greenberg means the weight
of the past, not certainty of the future, nor determination
of the present. Greenberg takes great pains to deny that
because painting "has freed itself from the necessity of rep-
resentation" it is "at liberty to reject all but the most recent
past."[17] He does not believe "that it has made a new start

and created a new instrument for itself." Rather, "the advanced painter cannot withdraw his attention from the past with impunity." "Cézanne to the contrary notwithstanding, the moderns are not the primitives of a new tradition, but the liquidators of an old one. Abstract art is still western European art." Greenberg does not want modern artists to become "provincial toward the past art of our civilization," for it would lead to a "failure of self-criticism." The "inverted historical provincialism of the 'modern'" threatens the future of his art by limiting its resources. What seems at times an emphasis on historical necessity, in the form of a demonstration of continuity with the past, is Greenberg's way of reminding the modern that his art is not self-created and utterly original or unique but historically conditioned, more profoundly than he knows or cares to admit. The sooner the working artist recognizes this the more he can understand himself, and the more he can understand himself the more he can sound his own depths, discover his own possibilities.

Greenberg, then, does not know where history is going, but he knows that where it goes will be determined in part by a dialectical response to given art. This response will convert the past into what seems irreconcilable with it, and as such is a point of departure for new work. But it is an illusion, as Greenberg emphasizes, to think that this dialectical point of departure spontaneously generates. Moreover, the critic has to examine the new work that results through the dialectical response that generated it, rather than take it as a historically unique phenomenon. Belief in the absolute uniqueness of new art obscures or falsifies the process through which it is created. Analysis of art must concentrate on the difficulties of this dialectical process—on its false leads as well as best results—rather than on the obvious differences, generally in look, of its results from those of the past. The look is superficial, the process is essential, and from the viewpoint of the process not only is there more continuity between past and present art than might be supposed, but the consequence of the differences be-

tween them can be determined fairly directly. The illusion
of historical necessity arises as the result of a retrospective
glance at the products of the process, which convey a sense
of it as over and done with. What is needed is an empathe-
tic yet critical evaluation of the process itself. Recognition of
historical necessity can depress and inhibit the working art-
ist. He had best look to the past in the light of his present
experience of art. He is then more likely to convert it
dialectically. That is, he can come to recognize that the
problems that seemed solved in the past are still open is-
sues, not so much awaiting new solutions as to be recon-
ceived in the light of new experience.

But even this idea of the creative transmutation of old
problems does not fully clarify what dialectical conversion
means for Greenberg. Dialectical conversion implies that
the old problems, without having been solved, are replaced
by new ones. A new direction is discovered, as it were. The
old problems lose their import without having been "truly"
solved, and new ones loom up without any expectation that
they will be finally solved. The importance of a problem is
that it defines the conditions for artistic activity and aesthe-
tic experience. New problems define new conditions, and
dialectical conversion is a sign that they have arrived. For
Greenberg, recognition of the full importance of dialectical
conversion means awareness of its power to destroy old
premises of operation, in art formulated as problems.
Dialectical conversion means changing the terms of the
problem, not solving the problem in its original terms. As
Greenberg says, "the only answer" to persistent problems
"is one that, as Marx says of historical 'answers' in general,
destroys the question or problem itself"[18]—in other words,
gives an answer that invalidates the old question as mean-
ingless or insignificant. Greenberg makes this point specific
to art: "The Cubists inherited the problem, and solved it,
but—as Marx would say—only by destroying it: willingly or
unwillingly, they sacrificed the integrity of the object almost
entirely to that of the surface."[19]

The shift from representation to abstraction does not

solve the problem of representation but destroys it and creates the problem of abstraction. Abstraction does not simply dismiss representation as irrelevant or insignificant, but abolishes it, without worrying about whether or not it can be solved, or ever was. In fact, there is no decisive or final answer as to how best to represent the integrity of the object in art. Nonetheless, in the course of probing the problem, trying various solutions, the surfaces of the object are invariably attended to. The "facets" of the object must be related to the pictorial surface. And it is discovered, in the very attempt to relate the facets to the surface and to one another "naturally," that they can be related "unnaturally." They, as well as the pictorial surface, are thus brought to consciousness as phenomena in themselves. The artist becomes aware of the "independence" of both kinds of surface from nature, and from the task of representing its objects. A new problem of art replaces the old one while being continuous with or generated from it. Surfaces, of various kinds, become the "object" of the painting, its subject matter. Again, there is no ideal way of handling these almost purely pictorial surfaces. There is no route decorative abstraction must necessarily travel. Whatever route it takes, however, will be determined in part by the dialectical conversion of known routes, a conversion which begins with a seeming detour: the re-viewing of past representational art in abstract terms.

Greenberg's reference to Marx should not be overemphasized. It is well known that his concept of dialectic is Marxist in origin. What is less well understood is that his use of it is neither Marxian nor Hegelian but loosely Deweyan. Greenberg has neither the Hegelian nor Marxian concept of rigorous determinism, but rather Dewey's emphasis on organic parity between subject and object. Where Marxian dialectical materialism gives the object dominance over the subject in historical development, and Hegelian dialectical idealism gives the subject dominance over the object in spiritual development, Greenberg's dialectical empiricism, as it can be called, gives them equal weight in

aesthetic experience. For Greenberg, dialectic works by reason neither of objective historical necessity nor subjective spiritual necessity, but by individual experiential necessity, what might be called the individual's "will to experience." The point is that dialectical process is located in and constitutive of what is in effect the creativity of individual experience, rather than in any kind of universal necessity. For Greenberg, such creativity is particularly evident in modernist art, with its self-critical mode, and in art criticism, with its attempt to reconcile sense experience and general ideas. Individual, not general, will matters for Greenberg in art, although the general defines the limitations of the individual. That is, once the dialectical process is underway various kinds of necessity operate to exert pressure on it, to make themselves felt. It is the inevitable pressure of limitations, the pressure to define the terms of the process, which are never arbitrary. Greenberg's crucial point is to shift emphasis from the product of dialectic—a product which now seems subjectively charged, now objectively determined, and of course is both—to the work of dialectic. For him, works of art if more than tentative are still far from ultimate. Like rocks with cracks they show the tensions of the work that brought them into being. They reflect the pressures of the dialectical struggle of experience that converted them from molten matter to subjective symbols.

CHAPTER 3

Unity

Dialectical conversion works itself out in terms of "the unity and completeness of single works" of art for Greenberg.[1] Unity is "the first requirement" of a work of art and, as he says, quoting Max J. Friedländer, the "sure sign of originality."[2] Greenberg speaks of "reassuring unity . . . that final exhilaration which is the most precious thing in art's gift."[3] For Greenberg, we "feel and judge" the work of art "in terms of its over-all unity"; its "quality" is a function of its existence "as a whole."[4] As he said in an interview, what he looks for in any kind of work is "that instantaneous unity."[5]

Greenberg acknowledges many "principles of unity" in the history of art, but he singles out Cubism as "that purest

and most unified of all art styles since Tiepolo and Wat-
teau."[6] In a sense, Greenberg's career is an attempt to jus-
tify the preeminence of Cubism as *the* modern style with
which an artist must "make a real contact." Thus, the fail-
ure of Kandinsky "to grasp the pictorial logic that guided
the Cubist-Cézannian analysis of appearances" means that
his art can never stand up to that of "Picasso, Braque, Gris,
and Léger in their prime."[7] Jacques Lipchitz, when he ac-
cepted Cubism's "principle of inner consistency," was able
to produce sculptures which "seldom fall short of a satisfy-
ing unity."[8] But after 1925, "since detaching himself from
Cubism," Lipchitz's "unsureness of purpose . . . manifested
itself in a confusion of intentions within a single work," so
that his art lost all "sense of direction." Cubism is the
touchstone of modern art for Greenberg, the point of de-
parture for all late development of any quality, and the
measure of greatness in modern art's handling of both
form and feeling. Thus, Paul Klee is important as the artist
who most influentially spread the Cubist gospel beyond
France,[9] Mondrian because he "was the only artist to carry to
their ultimate and inevitable conclusions those basic tendencies
. . . which cubism defined and isolated,"[10] and Clyfford Still
because "his paintings were the first *serious* abstract pictures . . .
that were almost altogether devoid of decipherable references
to Cubism."[11] Cubist unity teaches the artist to "work at style in
order to *achieve* content" and feeling.[12] Otherwise, as in
Rouault, "who favors a certain kind of content mainly for the
sake of style," unity will be forced. Or, as in Soutine, "the
violence of the will to direct emotion" creates "distortions . . .
too exclusively and too immediately dictated by feeling and, in
evading plastic controls, destroys unity."[13] The same is true of
Van Gogh, whose art, by reason of its nervous directness and
violent originality, "lost in strength and unity; it became more
striking and strident, but also more monotonous in its stri-
dency. The pure flow and its sure, subtle coordination fail. He
had become too sick to control and modulate the expression of
his feeling, to the directness of which he now sacrificed almost
everything else."[14]

Unity is, then, the be-all and end-all of art for Green-
berg. I want to reduce his conception of unity to its fun-
damental parts, and show how these operate together and
apart. The achievement of unity requires sacrifice, which
separates great from lesser artists, as when Henry Maurer
never realized what "Picasso and Braque knew from the
first"—namely, that "modulated natural local tones" can-
not be combined "with an analytical investigation of the
planes composing space."[15] To do so creates an "exces-
sively complicated" design which destroys pictorial unity.
The artist who refuses to sacrifice natural feeling and
natural content (the latter is usually a vehicle for the
former) is generally expressionist, often arty, and some-
times has an "ill-digested" sense of what art is about, viz.,
unity. But it must be emphasized that for Greenberg the
necessity of unity, while precluding directness of expres-
sion, i.e., "natural communication," with its obvious emo-
tional overtones and human use, does not mean the ab-
sence of "inner, emotional, dramatic form." In fact, art
sacrifices natural outer expression for abstract inner ex-
pression; art's unity is thus of necessity dramatic or dialec-
tical. Where in nature we find disparity obvious and unity
hidden, in art we find unity obvious and disparity subtle.
In art all discrepancies are dialectically or dramatically re-
lated, whereas in nature they tend to tear asunder. The
key to unity in art is the tension within it, and the impor-
tance of modern art is that its unity is based on a new kind
of tension. "As in the case with almost all post-cubist paint-
ing of any real originality, it is the tension inherent in the
constructed, re-created flatness of the surface that pro-
duces the strength of . . . art."[16] Although speaking of
Jackson Pollock, Greenberg means this tension within flat-
ness, or the integration of "the plane surface with astound-
ing force," to be the measure of modern unity in general.
This forceful integration of flatness is the source of mod-
ern art's "more reverberating meaning" than was achieved
by methods of unity in previous art.

General Need for Unity

But the need for artistic unity is deep and general for Greenberg. The achievement of artistic unity is essential, beyond the requirements of any medium, for dealing with the reality of life and the world. Such achievement is a general means of bringing order to disorder, or rather creating islands of order—as Greenberg calls Mondrian's paintings—within a general disorder. To unify artistically overcomes and brings under control, if only in consciousness, resistant reality, whether the inner reality of emotion or the conditions of outer reality. At times Greenberg suggests that artistic unity is the only guarantee of survival within the general madness, the only way of coming to terms with both its excesses and limitations. "Mondrian's . . . pictures, with their white grounds, straight black lines, and opposed rectangles of pure color, are no longer windows in the wall but islands radiating clarity, harmony, and grandeur— passion mastered and cooled, a difficult struggle resolved, unity imposed on diversity."[17]

The arts create fictions which transcend—i.e., seem to overcome and control—time and space, which are the conditions of the givenness of reality, or the limitations of being which it seems beside the point to resist. Yet we experience such limiting conditions as active constraints, or perhaps as passively resistant to ourselves, and so we think and feel they can be overcome, or at least feel the necessity of bringing them under control. In art, through identification with its unity, or through aesthetic experience of it, we think and feel we have succeeded. We believe, in what Kant called a transcendental or dialectical illusion, that we are beyond time and space. In the aesthetic experience it does not matter whether this belief is true or false, only that we be thoroughly saturated, religiously intoxicated with it. Still speaking of Mondrian, Greenberg writes: "In other words, the vision of space granted by plastic art is a refuge from the tragic vicissitudes of time. Abstract painting and

sculpture are set over against music, the abstract art of time in which we take refuge from the resistance of space." Greenberg neither affirms nor denies Mondrian's "metaphysics," as he calls it, although he is quite capable of regarding such theories as "spiritual pretension." Instead, he concentrates on Mondrian's artistic achievement, on how his paintings work. Interestingly enough, in his description of how a typical Mondrian painting functions Greenberg cannot avoid using some of Mondrian's spiritual language. He thereby gives credence to the general idea that art has an important spiritual function, which can be known through aesthetic experience. This function is part of, as Greenberg puts it, art's "exaltation."

Succinctly put, art always involves, for Greenberg, "the triumph of intention over resistant matter."[18] As such, art is a general goal of human activity. "The task of art is to impose the greatest possible organic unity upon the greatest diversity. The gauge of achievement is not only the degree of unity or perfection of form—any piece of kitsch has that—but also the resistance of the material unified. How far does the artist strain towards completeness before applying the controls of his art"?[19] For Greenberg, "an integral factor in the exaltation to be derived from art" is the "extension of the possibilities of the medium (and of the tradition)" to "what seemed ... too intractable, too raw and accidental, to be brought within the scope of aesthetic purpose."[20] Not to integrate the matter, of whatever kind, that resists intention—or, what is the same thing, not to give it form or assimilate it by giving it style—is to allow it to run rampant. Indeed, Greenberg's greatest strictures are against what he calls "surplus of realism," or the "recital of events" (or emotions) which are experienced to be "more interesting in themselves and their texture than in their resolution," i.e., in the artistic unity which reconceives or freshly envisions them.[21] Without the drive to unity, the "realism" that stands between a working artist and his achievement of "style" cannot be overcome, and there can be no experience of the exaltation or abstract power of transcendence of

art.[22] Instead of unity, there is arbitrary intensity. Instead of style, there is disruptive content, often very personal, as in Soutine and Van Gogh. Art, for Greenberg, is the struggle between abstract style and real content (natural objects and natural emotions), a content that seems to resist consciousness when it is suffered without style. For Greenberg, the lesson of the expressionists is that even personal emotion is intractable—i.e., resistant to control—for the person who experiences it. Style is necessary to survive one's own emotions, if for nothing else. For the expressionist type of artist this is no doubt a personal style, but still a structure that permits him to give form to his existence, and bring out its originality in a pointed manner. Soutine's "effort to force a very personal content upon a conventional, therefore impersonal, scaffolding had produced startling works, but had not significantly transformed the scaffolding itself, only wrenched and shaken it. Now the scaffolding was given more of its due, and whatever loss was suffered in intensity was compensated for by a gain in unity."[23]

Only the photographer can afford to be realistic—"literary"—and ignore "decorative unity."[24] For such unity is hard to come by in photography without falsifying the medium. "We forgive the modern painter" for concentrating "his interest on his medium . . . because he puts the feeling he withholds from the object into his *treatment* of it." But "we are reluctant to forgive the photographer, because his medium is so much less immediately receptive to his feeling and as yet so much less an automatic category of art experience." Thus, the photographer ought to put his feeling into the object—i.e., into reality. For if he puts it into his medium he is likely to become arty rather than artistic. That is, when the photographer deals self-critically with his medium he will produce a pseudo, artificial style, one unable to sustain significant unity. For Greenberg, naturally expressive subject matter is almost all for photography. But to attend to such subject matter is not to create art, since the resistance of the subject matter has neither been recognized nor overcome.

Simultaneous Unity and Diversity

Greenberg's call for "perfection of form," then, does not mean emptying it of content. The "strength" of perfected form comes from the resistance of content to transformation. The greater the resistance, the more "difficult" the unity, and the more demanding and steep the perfection. For Greenberg, the refusal to recognize that "a great work of art is . . . a thing possessing simultaneously the maximum of diversity and the maximum of unity [perfection of form] possible to that diversity"[25] leads to Roger Fry's and Clive Bell's notion of "significant form," an "excessive simplification" arising from an "attempt to isolate the essential factor in the experience of visual art."[26] Also essential is resistant diversity. While "final perfection" involves "the inextricability of part from part of realized whole," final perfection is not per se of the essence of art, "simultaneous unity and diversity" is.[27] The problem of art in general—a problem for which there are numerous possible solutions, none of them absolutely binding or convincing—became explicit for and "obsessed" Picasso anew after Cubism, when he determined "to compress the infinity or variety of visual detail offered by any given segment of nature in a set of linear abbreviations that, under the pressure of the unity and economy dictated by the plane surface, would constitute a memorandum to the imagination."[28]

Art compresses into unity what naturally resists such economy. It concentrates and generalizes through the medium, giving a "hint of the quality of *all* emotion," arousing a "reaction" that cannot be "defined or limited by its cause on the canvas."[29] "The generalizing function belongs chiefly to the medium," says Greenberg, and what it generalizes is emotion. By making the medium the object of his diversity of emotion the artist generates a singular emotivity, which reverberates through the unity of the medium. To the extent that he controls the medium he seems to control his emotion, distilling its essence from its diversity. It is this distillation that is received by the anten-

nae of the critic in aesthetic experience. It is the exalted emotion that Greenberg regards as characteristic of art.

But Greenberg never forgets that such exaltation has its source in natural temperament, and without the resistances of temperament significant emotion is not aroused. Art, encountering no emotional resistance in its attempt at concentration, becomes flaccid, or else flies apart. "Perhaps he [Hans Hofmann] insists too little on the resistances of his own temperament—in every artist there must be something that fights against being set down in art and yet whose setting-down constitutes part of the triumph of art."[30] Temperament is another kind of resistant matter that art must respect but overcome; it ignores such matter at its peril. Hofmann, because he does not dramatize his temperament or, what is the same thing, establish himself in dialectical relationship with it, "surrenders himself too unreservedly to the medium—that is, to spontaneity." This observation acquires greater importance when we view it in the light of Greenberg's modernism, which we now see does not mean that the medium alone is of importance in art. It is what is done to the medium that matters, what it is made to reverberate with—what kind and quality of resistant matter, personal and worldly, that is brought to bear on it, and what kind and quality of spontaneity or intention it brings to bear on matter. The medium is the matter of art which is in dialectical tension with the matter of the life-world, and it is in the artist's handling of the medium that we see his intention toward the life-world, and his ability to triumph over it.

In general, Greenberg thinks that art is "the only field of meaningful achievement left"[31] because it is the only field which makes a determined effort to triumph over the resistant matter of life—things and feelings—by unifying them stylistically. It is the only field in which a fictive or imaginative unity is achieved in fact—visual fact—as well as in principle. Artistic unity is not simply an end in itself; it serves human life by affording a ready opportunity, in contrast to the opportunities nature and life afford, for aesthetic experience, which serves life by relieving it of the pres-

sures on it. Art represents the triumph of unity over arbitrary intensity, fiction over diverse reality, and the limits of art are only those of its own intention toward everything that resists it. For Greenberg, the conflict at the core of Kafka's art symbolizes the conflict at the heart of art per se:

> Explicit, conscious poetry was on the way, as Kafka might have seen it, to a falsification of reality—and not only of Jewish reality. But might not all art, "prosaic" as well as "poetic," begin to appear falsifying to the Jew who looked closely enough? And when did a Jew ever come to terms with art without falsifying himself somehow? Does not art always make one forget what is literally happening to oneself as a certain person in a certain world? And might not the investigation of what is literally happening to oneself remain the most human, therefore, the most serious and the most amusing, of all possible activities? Kafka's Jewish self asks this question, and in asking it, tests the limits of art.[32]

The poetic unity of art, because it is a respite from what is literally happening to oneself, in all its tedious yet overwhelming immediacy and with all its nuances of personal and public meaning, seems to play life false. But Greenberg answers Kafka with Mondrian, and argues that art serves life's deepest aspirations, subtly satisfying humanity. "The clarification of equilibrium through plastic art is of great importance for humanity. It reveals that although human life in time is doomed to disequilibrium, notwithstanding that, it is based on equilibrium. . . . If we cannot free ourselves, we can free our *vision*."[33]

Artistic Unity in Modern Life

The art-life connection is, his critics to the contrary, at the core of Greenberg's thinking about art. But it is life distilled by art, life indirectly rather than directly present. It is object and emotion existing by analogy in an autonomous art event rather than in an event in nature or life. The work of art is an analogue for a life event, which like every

analogue abstracts from and concentrates its source, shadowing and refining its substance. For Greenberg, the work of art exists with particular poignancy in the modern world, for while the unity of being that art actualizes is life's own implicit ideal, it seems impossibly remote in modern life. In general, art articulates this ideal, at times tautly realizing it, thereby showing unity to be a viable value, if not showing, and offering few clues to, how this desirable value can be realized in life. In modern life disunity and diversity seem more widespread and acceptable than ever, suggesting that unity is difficult to achieve in modern art (because there is more resistance to it) and very dramatic when it is achieved. Traditional kinds of artistic unity seem facile because they are not equal to the strenuous demands of modern artistic unity, and many kinds of modern unity quickly become traditional. (Greenberg abides by Cubism because its unity is not easy, and so not readily appropriated. It must be constantly worked at in aesthetic experience, thereby keeping that kind of experience fresh and intense.) In general, the task of art—to propose unity—in a world in which no center authoritatively holds things together becomes at once more difficult and more important. As unity becomes harder to realize in practice, it becomes more crucial to comprehend and imagine in theory, for it remains essential to life. Despite increasing acceptance of diversity, even divergence, as the way of life, unity is still a necessary imaginative "memorandum," reminding life what it finally needs for its own survival.

"Completeness," the upshot of "concern with unity and order," "can only be attained by an infinity of reverberations" within the "narrowness" of means the medium epitomizes.[34] That is, the reduction of life to a particular medium is already a step toward unity, for it imposes limitations on expression and isolates one of life's material conditions from the others. But the habitual discord of modern life raises the "reverberations" to fever pitch. The effort to make the medium express more of life and feeling than it is capable of doing threatens to tear the medium apart. In

Greenberg's words, the effort to give the medium a "maximum of expressiveness" leads the artist to "rape" or "overpower" it, as Rouault and Soutine tried to do.[35] The medium is made expressive contrary to its best usage, distorting its possibilities. The expressionist experiences the medium as too limiting and particular to express the abundant feelings of life clamoring for expression. The medium rather than life is experienced as intractable or unyielding: the medium rather than life is experienced as resistant, for it makes demands unnecessary for the expression of life. It is once again Soutine who epitomizes for Greenberg the contemporary expressionistic tendency to transcend the medium, or else manipulate it beyond its resources, in a desperate desire to force art to encompass the life that is more comprehensive than it. "What he wanted of the art of painting seems to have belonged for a long while to something more like life itself than like visual art."[36] And to be "more like life" in the modern world means ultimately to be indifferent, not simply antithetical, to art, for the unity that art proposes is not only increasingly difficult in modern life, but is regarded as insignificant and irrelevant to it.

If it must have art, the modern world makes it suicidal. In response to the modern world, art is tempted to forego aesthetic—unifying—purpose for increasingly intense and direct expression of life. Some art comes to seem little more than an instrument for registering life's impact, a seismograph registering its emotional quakes. It is in response to this extravagant expressionistic tendency to exploit the medium beyond its resources and to bankrupt it, making it act exclusively in the name of the logic of life rather than in the name of its own subtle logic, that Greenberg insists on the integrity of the medium. For it is only through the medium that artistic unity becomes possible in modern art. It is as if, in insisting on a critical response to the medium in art, Greenberg was balancing the claims of art against those of life. The possible purity of the medium stands against the actual impurity of life, and art can reject life's diversity as much as life can reject art's unity. At the same

time, we must remember that for Greenberg artistic unity is not an end in itself but a way of making explicit the need for unity implicit in life. While this need may never be satisfied in life, it can be satisfied by art. Whether in life or art, however, unity can never be mechanically determined or forced, but evolves organically or dialectically. The "priority" Greenberg gives the medium is in part meant to counteract not only the priority given life by expressionist art, but also that art's sense of the relentless, overdetermined way life is given, which denies life any "higher" purpose, i.e., a possible unity.

While Greenberg is prepared to acknowledge that in the modern situation of extreme diversity the medium will be treated in an extreme way, almost as an end in itself, he is not prepared to acknowledge that art can forfeit the high goal of unity and remain art. And while the only way of maintaining the ideal of unity is to assert the medium as a possible end in itself, this does not mean that such an assertion has nothing to say about life's diversity. On the contrary, the extreme character of the demand for purity, which seems to do violence to art as a mediation of life, is a response to the extreme diversity of modern life which seems to do violence to, in fact altogether undermine, the ideal of unity. Greenberg seems to suggest that an art which purifies its medium serves modern life's unacknowledged need for unity as nothing else in modern life can.

> The gradual transitions from value to value which were axiomatic for the old masters and expressed their sense of the unity of life are replaced by abrupt contrasts and broader and flatter definitions of value—which give the modern sense of the disunity of life and the superior unity of art. For modern art is able, apparently, to reconcile the most violent contrasts, something that politics, philosophy, and religion have been incapable of doing lately.[37]

That is, in the very act of giving the modern sense of the disunity of life, attention is called to the medium, purifying it—calling attention to the value of its unity.

For Greenberg, it is because art alone works by analogy that it brings balance. Thus, "Mondrian's pictures attempt to balance unequal forces: for example, one area, smaller than another, is made equivalent by shape and spatial relations."[38] Neither politics, philosophy, nor religion is able to displace the problem of the reconciliation of opposites from the realm of life to that of the medium. They are forced to deal with the problem directly, and so they find it unresolvable. But art, because it knows that it is unrealistic to expect the reconciliation of opposites in life, and yet necessary for the survival of life to insist on that reconciliation, "envisions" it abstractly. Simply because art sublimates the tension between opposites by treating them through the medium, it is able to imagine, and concretize in a work, their unity. The transfer from life to the medium closes an open conflict, bringing its terms under control. That is, the transfer abstracts the terms of the conflict, muting its significance for life. In a sense, the transfer drains the life out of the conflict, and suggests that the opposites are not absolute in life. Put in a new situation, they can be treated abstractly, and the violence of their relationship becomes less irremediable. Their reconciliation can then be "worked out" under the "ideal" conditions of the medium. In actual life their "diversity" could never be conceived as having a dialectical logic to it. It is not inevitable, however, that the "work" of art reconciles the opposites. It may fail, and in its frustration at not finding a way out of their tension, the work of art may become expressionistic, i.e., exploit the tension.

Traditional and Modern Unity

Unity is the traditional goal of Western art, and its achievement or lack of achievement is the basis of Greenberg's criticism of that tradition. Greenberg seems to think that the unity of Western art once reflected unity in Western life, which no longer exists. It is perhaps this difference

that more than anything else differentiates traditional old master from modern art, and "necessitated" the change from representational to abstract art. Unlike traditional art, modern art no longer takes unity for granted. Instead, modern art must make unity explicit or literal, thereby rescuing it from the oblivion modern life threatens it with, and showing it to be an enduring, viable ideal. For Greenberg, the change to abstraction does not eliminate art's relation to nature, but alters it: "Nature no longer offered appearances to imitate, but principles to parallel." While modern society may not offer a viable ideal of unity of life, eternal nature continues to offer a general ideal of unity. Like nature, abstract art, through its emphasis on the medium, displays a subtle yet powerful unity. The hidden connection between abstract art and nature circumvents the disunity in modern society.

For Greenberg, "too much of fifteenth-century Flemish painting lacks that instantaneous, compact and monumental unity which the contemporaneous painting of Italy developed and to which Western pictorial taste has oriented itself ever since."[39] Greenberg criticizes Fry for "identifying this kind of unity so exclusively with the articulation of volumes in 'credible' space; after all, abstract art, with its shallow or non-existent depth, has shown itself capable of achieving it." It is the continuity of taste for unity that matters for Greenberg, not the absolutization of one means of achieving it. Italian Renaissance painting and American abstract painting, the one implicitly and the other explicitly abstract, are the same in principle—in the pursuit of unity—but are different in method. Unity in Renaissance painting was achieved by the construction of a credible space, through the abstract means of mathematical perspective; and by the articulation, in this credible space, of credible volumes, by means of an abstract sense of the proportion relating their parts as well as by means of perspective. Renaissance unity was achieved, ideally, by means of systematic, rational measure. Space and volume were to submit

to its a priori logic and to be experienced through that logic. For Greenberg, modern unity is achieved, ideally, by means of the medium, which can be attended to either unsystematically and irrationally, as in the analytic Cubism of Picasso and Braque, or systematically and rationally, as in Mondrian. Greenberg assumes that the medium also, like measure, has its a priori logic. From this fundamental continuity between traditional and modern Western art, other continuities inevitably follow. Thus, space is still of the essence of abstract art, as in the field painting of Still, Newman, and Rothko, although it is no longer a credible space, and what volumes it contains are only suggested, and have more to do with the texture of the medium than with the effort to articulate a credible object. What is particularly striking about the continuity between Renaissance and modern painting is that both assume that exclusive commitment to verisimilitude is *the* obstacle to pictorial unity. "Where painters are as fully committed to verisimilitude as the Flemings were, incoherences in the illusion will almost always be reflected in the surface pattern. Unity as such is an uncertain thing in even the best of early Flemish painting."

For Greenberg there are, however, subtle differences between the way traditional and modern art mediate unity, differences which are not entirely dependent on the differences between the representational and abstract methods of attaining unity. In modern abstract art there is less attention to unity per se than to the dramatic or dialectical tension out of which it arises and through which it is grasped. Thus, however much it is realized, pictorial unity seems evasive in modern painting. But pictorial tension is always explicit. For Greenberg, unity is a kind of implicit substratum in traditional painting, and once revealed seems free of tension. The faults of tension that seem to exist in the crystalline completeness of a Renaissance painting result not from the resistance of an unresolved reality, but from the artist's lack of skill in realizing the foreknown rationality of unity. In a Kantian term already noted, unity exists in modern art as a "dialectical illusion," i.e., a compulsion to

wholeness which conceives of it but cannot experience it. Tension, however, is phenomenally experienced, and the source of whatever "practical" wholeness the modern work of abstract art has. For Greenberg, the major tension in modern art is the "heightened tension between the illusion and the independent abstractness of the formal facts."[40] This dialectical tension, not its mechanical resolution, is "the emblem both of an originality and a mastery," and constitutes the unity of the modern work of art.

Purity

It is a gross misconception to think, as Leo Steinberg does, that Greenberg "wants all Old Master and Modernist painters to reduce their differences to a single criterion, and that criterion as mechanistic as possible—either illusionistic or flat."[41] Greenberg proposes no such dogmatic either/or. He neither praises nor raises one at the other's expense, but rather shows their dialectical interplay. Admittedly, he advocates purity, but as a historical tendency rather than as an absolute. "The tendency toward 'purity' or absolute abstractness exists only as a tendency, an aim, not as a realization."[42] While Greenberg's commitment to "purity . . . an art that makes demands only on the optical imagination"[43] becomes more complete as the conditions for its realization become more obvious, he never fails to conceive of purity dramatically. This is true even when purity in practice comes to mean the equivalence of pictorial factors in polyphonic unity, for that equivalence is always realized by dialectical means. In general, for Greenberg purity is the unrealized ideal of modern artistic aspiration. It haunts abstraction with the possibility of complete control of the medium, and with that control the possibility of completeness of the individual work of art.

> It follows that a modernist work of art must try, in principle, to avoid communication with any order of experience not inherent in the most literally and essentially construed nature of its medium. Among other things,

> this means renouncing illusion and explicit subject matter. The arts are to achieve concreteness, "purity," by dealing solely with their respective selves—that is, by becoming "abstract" or nonfigurative. Of course, "purity" is an unattainable ideal. Outside music, no attempt at a "pure" work of art has ever succeeded in being more than an approximation and a compromise (least of all in literature). But this does not diminish the crucial importance of "purity" or concrete "abstractness" as an orientation and aim.[44]

There is anxiety behind the imperative of purity, the anxiety aroused by the foreknown defeat of the ideal. Its failure in practice is the result of the implicit subject matter in abstraction, the disguised illusion generated by it—i.e., the presence of the illusion which is allusion. Objects come and go in experience, but the emotions they generate remain, and remind us, if not of the objects, then of their effect on us. In a sense, abstract art deals with this emotional residue of experience. Pure art begins, as Greenberg insists, not only with the medium, but with this emotional residue. Pure art is about the literalness of both, or the way both can be made concrete, or, more exactly, the way their reciprocity makes each explicit. To accuse Greenberg of mechanistic reduction to purity as Steinberg does is to ignore his sense of its emotional roots. Purity is an effort to make explicit implicit emotion without creating a literary illusion about it. And it is also the effort to make explicit the implicit medium of an art by charging it with emotion. In the process, both medium and emotion are generalized and clarified. Both are reduced to their fundamentals, i.e., made increasingly frank or self-evident.

To sum up this line of thought, for Greenberg the affirmation of the medium is inseparable from the affirmation of emotion, but it is emotion abstracted from life and distilled into a kind of perfume, which is exactly what Kandinsky meant when he spoke of the perfume of abstract forms. When art depicted objects, emotion generated by the artist's response to them clung to the objects, charging them

with a power beyond themselves. Similarly, the abstract forms which are the substance of modern art are also charged with emotion, also exist temperamentally. In a sense, the presentation of abstract forms goes deeper into life than the depiction of natural objects in natural space. For abstract forms lead away from obvious appearances to emotional reality, and thus can mediate the subjective sense of objectivity more directly than illusionistic depiction. The frankness with which abstract art declares its medium helps it mediate emotional meaning, for such frankness implies a general assertion of the implicit. Much as emotion is, in a sense, the ground of life, so the medium is the ground of art. When art meant illusionistic depiction, both emotion and its medium were taken for granted, and so seemed of secondary importance to the illusion itself. With abstract art the primary importance of the medium and emotion are realized. Both are freshly and simultaneously affirmed, the freshness enhanced by the simultaneity. The reciprocity of medium and emotion, the primordial manner in which both are given in abstract art, generates a new freshness in inner experience. One might even say that for Greenberg abstraction exists to revitalize experience by affirming its inwardness with new resourcefulness. Abstraction comes to seem stale, and the literal assertion of the medium comes to seem tautologously empty—a dull object lesson about an elementary fact of art—only when one forgets that abstraction means to make implicit emotion explicit. Nicolas Calas understands abstraction mechanically because he forgets or does not want to accept its emotional or personal component: "Why does the technique of purification of painting or sculpture have to possess a self any more than does the technique of purification of metals or liquids?" [45]

Purification is not a technique but a process, and the tension innate to it is symbolic of the emotional tension innate to life, which is why the tension of the process rather than its resolution becomes explicit. In the purification of metals or liquids it is the end product that matters, whereas in the purification of painting or sculpture it is the sense of self

generated by the irreducible tension of the process that matters.

> The Old Masters always took into account the tension be-
> tween surface and illusion, between the physical facts of
> the medium and its figurative content—but in their need
> to conceal art with art, the last thing they had wanted was
> to make an explicit point of this tension. Cézanne, in spite
> of himself, had been forced to make the tension explicit
> in his desire to rescue tradition from—and at the same
> time with—Impressionist means.[46]

Greenberg makes the same point more fully and gives it a broader historical context.

> Recording with a separate dab of paint almost every percep-
> tible—or inferred—shift of direction by which the pre-
> sented surface of an object defines the shape of the volume
> it enclosed, he began in his late thirties to cover his canvases
> with a mosaic of brush-strokes whose net effect was to call
> attention to the physical picture plane just as much as the
> tighter-woven touches of the orthodox Impressionists did.
> The distortions of Cézanne, provoked by the extremely lit-
> eral exactness of his vision as well as by a growing compul-
> sion, more or less unconscious, to adjust the representation
> in depth to the two-dimensional surface pattern, contrib-
> uted further to his inadvertent emphasis on the flat plane.
> Whether he wanted it or not—and one can't be sure he
> did—the resulting ambiguity was a triumph of art, if not of
> naturalism. A new and powerful kind of pictorial tension
> was set up such as had not been seen in the West since the
> mosaic murals of fourth and fifth century Rome. The little
> overlapping rectangles of paint, laid on with no attempt to
> fuse their dividing edges, drew the depicted forms toward
> the surface while, at the same time, the modeling and con-
> touring of these forms, as achieved by the paint dabs, pulled
> them back again into illusionistic depth. The result was a
> never-ending vibration from front to back and back to
> front.[47]

Such a change is not an arbitrary development in the his-
tory of art, or the result of the mechanical operation of

dialectical conversion, but is necessitated by emotion and by a general turn inward. Recognition of the tension of inner experience is reflected in the new pictorial tension. Thus, as Greenberg says, Cézanne's "registration of what he saw was too dense, not in detail but in feeling; his pictures were too compact and the individual picture too even in its compactness, since every sensation produced by the motif was equally important once its 'human interest' was excluded." But the "human interest" that aroused the dense feeling was not excluded but dialectially converted into the "inspired, felt relations" on which "the quality of art depends . . . as on nothing else."[48] Moreover, for Greenberg dense feeling is important not only for the "variety of affect" without which " 'big' art" is impossible, but for the frankness or literalness to which it leads.[49]

In other words, the tendency to purity is the result of the pressure of dense feeling, which needs to affirm itself independently of its sources. Its intensity carries it beyond its objective cause, much as a unified work of art arouses, as Greenberg notes, a "reaction" which cannot be "defined or limited by its cause on the canvas." The emotion becomes abstract and seeks abstract embodiment, which the medium gives it, thereby becoming expressively charged. Literalized by the medium as it were, dense feeling is no longer an adjective to the noun of the object but substantive in itself. In abstraction, emotion is no longer the halo around objective reality but a free power—its relations, and so obligations to objective reality, suspended. Abstractly existing in and through the abstract medium, dense feeling generates a tension which seems to have its own intention. Thus, while the ultimate achievement of abstract art is to make "rightness of form" as frank or factual as possible, Greenberg believes this is inseparable from doing the same for emotion. In fact, our sense of the rightness of form has a good deal to do with our sense of its expressive power. In a sense, abstract art refines "the physical facts of the medium and its figurative content" until they interpenetrate in the "never-ending vibration" of an emotional rhythm. It is the energy of this rhythm that animates aesthetic experience.

Pictorial Space

While unity is "conclusive," its dialectical tension gives it "crispness."[50] This offsets unity's "monumentality," which "has little to do with size" but with the tightness of the coherence created by dialectical tension.[51] For Greenberg, the monumentality of unity has nothing to do with "the logic of appearances" but with "the logic of somatic structures."[52] Unified form is a somatic structure for Greenberg, and he is acutely conscious of the tension which creates and sustains the structure, tightening it into coherence. He is particularly conscious of the effect the picture's edges have on its formal unity. "One can already notice in Manet how much more crowded the picture begins to be toward its edges. Think, by contrast, of the immense space in which Rembrandt's figures swim." Moving from Manet to Cubism, i.e., to an increasingly cramped picture, Greenberg writes: "Pictorial space became more cohesive and cramped (in Cubism), not only in depth, but also in relation to the edges of the canvas." For Greenberg this cramping is resolved— the surface is smoothed out into decorative unity—in the post-Cubist "symphonic" field picture, whose elements are treated as equivalent. Such treatment prevents cramping, for the pictorial elements can interlock more directly than when they are arranged according to a system of priorities.

Cramping, in effect the result of coming up against the limits of the medium and respecting them, plays an important role in the transition to the new ideal of pictorial coherence as decorative unity of surface. Cramping is a way of working all vestiges of verisimilitude out of the picture. It forces the illusion of depth essential to verisimilitude onto the literal surface, thus making the surface dense and tense. Put another way, the cramping registers the conflict of the surface, freshly literal yet full of decaying illusion. In a sense, the edges pull illusionistic depth to the literal surface, in the process destroying the credibility of space without clearly creating that of the medium. Also, the process flattens, distorts, and ultimately eliminates credible content, refining it into an emotional vibration, an allusion com-

municated through the vibrancy of the cohesive surface.

Cramping is a step on the way to this surface vibrancy, which is finally achieved when pictorial space is sufficiently unified to "erase the old distinction between object-in-front-of-background and background-behind-and-around-object, erase it at least as something felt rather than merely read."[53] Cubism first accomplished this: "All space became one, neither 'positive' nor 'negative,' insofar as occupied space was no longer clearly differentiated from unoccupied. And the object was not so much *formed*, as exhibited by precipitation in groups or clusters of facet planes out of an indeterminate background of similar planes, which latter could also be seen as vibrating echoes of the object." For Greenberg, the drama of interlocking positive and negative space, the determinate and indeterminate, into a tight yet still tense unity, repeatedly plays itself out in abstract art. For example, we continue to find it in Anthony Caro's sculpture. "That the ground plan will at times echo as well as interlock with the superstructure or elevation . . . only renders the unity of the piece that much harder to grasp at first. Yet just those factors that make for confusion at first make for most unity in the end."[54] Interlocking into unity is crucial even for realistic art. Thus, Milton Avery's landscape painting depicts "things that had grown into the places they occupied and which interlocked of their own accord into both foreground and backdrop."[55] Again, "it is the unity of the picture that constitutes its virtuality as a successful work of art, not the juiciness of the brushstrokes, nor the amount of paint quality per square inch."[56] In neither realistic nor abstract art does the literal rendering of nature matter, but rather the rendering of unity, which always assumes attention to the medium.

Positivism

Greenberg's modernistic insistence on literalness (in painting giving "the picture plane its due as a physical entity"[57]) in all aspects of the work of art (emotion, medium,

space, unity) is part of his assertion of the radical positivism and materialism of modern life. The inescapable positivism and materialism of modern life make themselves felt in the inevitable literalness of modern art, whose abstractness articulates that literalness. Positivism insists on the frank assertion of material facts. In a sense, modern abstract art simply asserts frankly the material facts of art. Ultimately, Greenberg argues that such quintessential positivism leads to existential pessimism,[58] for it is an expression of alienation,[59] the characteristic modern emotion. He will argue that abstract art cannot be cheerful, although it developed "on the crest of a mood of 'materialistic' optimism."[60] The mood has become one of materialistic pessimism. Whatever the mood, the key point for Greenberg is the consistent materialism of modern life, its tireless attention to facts. Accepting this materialism, Greenberg attends to art "in which facts are transfigured without being violated."[61] In nineteenth-century America this kind of art was most successfully realized by Winslow Homer, whose love of "the abstract fact"* epitomizes modern materialism in general.[62]

Although optimism reigned in Paris in 1912 and pessimism reigned in New York in the 1950s, what is important about positivism is that it asserts the "relevance to human feeing" of the "rawness of matter," i.e., abstract fact. Modern art's attempt to create a "tight picture-object" whose "parts would be fitted together more tightly, interlocked like those of a watch's mechanism"[63] was one aspect of the modern attempt to triumph over matter, while acknowledging its omnipotence in principle. Art triumphs

*In *Art and Culture*, p. 188, Greenberg simplifies this, superficially for the sake of clarity, to the assertion that Homer "loved *facts* above all other things." This is another example of the way the change from article to essay leads to a loss of complexity, subtlety, and intellectual liveliness. By his simplification Greenberg also buries the important idea of dialectical conversion, much as, in reprinting "The Role of Nature in Modern Painting" (*Partisan Review* 16 [Jan. 1949]: 78–81) in *Art and Culture* (pp. 171–74) he dropped the footnote which first presented the idea. Greenberg's attempt to cover his Hegelian tracks with American pragmatism—the conflict between dialectic and empiricism in his thought—is the unresolved core of his critical position. Because he never works out the logic of their relationship, he increasingly tends to reduce both to glib generalizations.

over abstract fact by giving it "aesthetic pertinence," i.e., by purifying it until its materiality, and the human feeling invested in it, are unmistakable.

In Cubism positivism was given aesthetic pertinence by breaking material objects "into more or less interchangeable units" ("facet planes") until the objects "are no longer necessary as entities." They exist only as general facts, or in abstract facticity. Cubism depicts facet planes, not material objects, and the "decisive effect" which the planes give is a function of the somatic structure into which they are tightened and thus made aesthetically pertinent, and the frankness with which they are materially rendered without thereby losing their abstractness. For Greenberg, of course, the somatic structure cannot be achieved without the frankness—no tightening without literalness, and vice versa. Greenberg's awareness that "the superior largeness" of the best modern art originates in respect for "matter, material, sensation, the all too empirical and immediate world—and the refusal to be taken in by anything coming from outside it,"[64] is echoed in his emphasis on such factors as "frank color" as important elements in modern art.[65] In general, he acknowledges the "profound matter-of-factness"—the profound frankness—of modern art, already operational in Impressionism and Cézanne.[66]

Directness, frankness, literalness, matter-of-factness, and also primitiveness, form a constellation of synonymous positivistic elements which represent for Greenberg "the ultimate truth of life as it is lived at present."[67] It took "mental cases," he says, to recognize this truth and bring it into the open—eccentrics like Cézanne, madmen like Van Gogh, "balmy" types like Henri Rousseau. But once articulated, modern life's concern to "reduce" everything "to solely empirical considerations ... without the deception (but also protection) of faith in anything" becomes *the* concern of modern art and the mode of modern aesthetic experience.

That which modern art asserts in principle—the superiority of the medium over whatever it figures: thus the inviolable flatness of the picture plane; the ineluctable shapedness of the canvas, panel, or paper; the palpability

of oil pigment, the fluidity of water and ink— this expresses our society's growing impotence to organize experience in any other terms than those of the concrete sensation, immediate return, tangible datum.

Positivism is an emotional attitude toward experience as well as a means of organizing it, and an emotional attitude toward the work of art as well as a means of tightening it into unity. The work of art "realizes" the attitude. As Greenberg says, "style" becomes "the emotion itself,"[68] and feeling—transposed and generalized rather than immediate and particular—becomes "intrinsic" to form.[69] Thus, if we accept Cézanne's assertion "that painting involved crude, crass materials,"[70] that "one has to be a painter through the very qualities of painting,"[71] we have to accept his tense, dense feeling. As Greenberg says, "great art" is impossible without "truth of feeling."[72] The crude, crass materials of painting exist to "conquer new experience," not as ends in themselves.[73]

Mastery of Emotion

Greenberg is aware of how difficult it is for artists to use their materials to express a new intention, more precisely, to create a primary new attitude that can conquer experience. He thinks that "very few know, feel, or suspect what makes painting great anywhere and at any time—that it is necessary to register what the artist makes of himself and his experience in the world, not merely to record his intentions, foibles, and predilections."[74] "To register what the artist makes of himself and his experience in the world" is a difficult matter of "transposition of the aesthetic to and from the rest of experience," which means taking leave of "immediate emotion and familiar forms." (Immediacy and familiarity correlate.) It means giving up any preconceived notion of selfhood and experience, or forcing such a notion on one's art. Aesthetic transposition involves trancendence of familiar and immediate forms of selfhood, experience, and art—anything that might preinterpret their process.

For Greenberg, many artists do not have the "ambition" to forego the familiar and immediate, to attempt to experience anew and create new forms to register that experience. They have only the "pretension" of having done so. When strong temperament and intense emotion have to be mastered—in effect renounced, and reconceived anew through new art—the artist experiences even greater difficulty, and greater temptation to pretension. But when the aesthetic transposition of such temperament and emotion succeeds, the result is great art.

For Greenberg, David Smith is the major example of such success. In a sense, Smith is the answer to Soutine. Smith had similar emotional excesses, but he finally brought them under control, after much struggle.

> Smith is one of those artists who can afford mistakes and even need them, just as artists need and can afford bad taste and incapacity for self-criticism. It is most often by way of errors, false starts, overrun objectives, and much groping and fumbling in general that great and original art arrives. The inability or unwillingness to criticize himself may permit Smith to lapse into illustrative cuteness or decorative whimsicality, or to descend suddenly to a petty effect, but it also enables him to accept the surprises of his own personality, wherein lies his originality. Which is to say that he has been triumphantly loyal to his own temperament and his own experience in defiance of whatever precedents or rules of taste might have stood in the way
>
> The very copiousness of his gift, the scale and generosity of his powers of conception and execution, are what more than anything else impel him to overwork a piece of sculpture, to act unconsiderably on every impulse, and explore every idea to its limits. Yet when the piece is brought off, its triumph is enhanced by the sense we get of a checked flow whose further, unactualized abundance and power reverberate through that which is actualized. And we would not get this sense were Smith not a headlong, reckless artist ready to chance anything he felt out of confidence in his ability to redeem in another piece whatever went wrong in the given one.[75]

In the last analysis the difficulty described results from the artist's attempt to reconcile seemingly irreconcilable opposites, and so his loss of control of the drama of their relationship. Indeed, for Greenberg, Smith's art finally succeeds because of its "varied fusion of felicity and ruggedness . . . complex simplicity . . . economic abundance, starkness made delicate, and physical fragility that supports the attributes of monumentality." Once again success comes from accepting the limitations of the medium. Thus, Van Gogh and Cézanne were impassioned, temperamental personalities, but "it was Van Gogh's misfortune and distinction that, unlike Cézanne, he could not rejoice in the limitations of his medium."[76] Greenberg goes so far as to say that Cézanne became at times "so absorbed . . . in the means that he would . . . often lose sight of the end, his own emotion."[77] Thus "even the best of Cézanne's art seems unconsummated. Pictures filled with superb passages such as would by themselves earn any painter a great reputation fail somehow to coagulate, and remain instances of great painting rather than great paintings. Lacking the simultaneous unity and diversity and the inextricability of part from part of realized wholes, they miss the final perfection." Thus, even an artist "with the real emotion and the true sense of our time" can fail. In our own day, Baziotes is an example of such an artist. Many of his works "were marred by his anxiety to resolve them; the necessity of clinching a picture dramatically, also the sheer love of elaboration, led him to force his invention and inject too many new and uncoordinated elements."[78] Again, in the end, Greenberg returns to the touchstone of unity, the ability to balance through tension, to reconcile the emotion of abstract fact and the abstract fact of emotion. As always, what matters for Greenberg are "works that were flawless in their unity and abundant in their matter, works in which there was a fusion of power and elegance that abated neither."[79]

CHAPTER 4

The Decorative

For Greenberg, the most complete modern painting, with the most abstract unity and the frankest recognition of the medium, is "the 'decentralized,' 'polyphonic,' all-over picture which, with a surface knit together of a multiplicity of identical or similar elements, repeats itself without strong variation from one end of the canvas to the other and dispenses, apparently, with beginning, middle, and ending."[1] The all-over picture arrives at comprehensive unity by means of the principle of equivalence.

> Mondrian's term, "equivalent," is important Just as Schönberg makes every element, every voice and note in the composition of equal importance—different but

equivalent—so these painters render every element, every
part of the canvas equivalent; and they likewise weave the
work of art into a tight mesh whose principle of formal
unity is contained and recapitulated in each thread, so
that we find the essence of the whole work in every one
of its parts. (See *Finnegans Wake* and Gertrude Stein for
the parallel to this in literature.)*

Equivalence is *the* principle of modern "high art."† It gen-
erates "hallucinated uniformity," which "monotonously" re-
verberates. This monotone makes the unity of the work
self-evident and, simultaneously, makes the work suffi-
ciently dense to evoke significant feeling. Moreover, the
"accumulation of similar units of sensation" makes the work
decorative. In fact, when Greenberg wants to convey fully
the quality of abstraction in the all-over picture he speaks
of its decorative unity. Incidentally, Greenberg regarded
Arnold Friedman's "atmospheric" landscape paintings as
important early examples of the American all-over picture,[2]
and Kandinsky as a major example of the failure to paint
polyphonically.[3]

*In the *Art and Culture* version (pp. 156–57), Greenberg italicizes
"importance" and "equivalence," as if to hector us into awareness of his
key concepts. The sudden emphasis, while not entirely dogmatic in flavor,
gives the whole paragraph a pedantic cast. It is as if we were being taught
an old but important lesson, and as if the concept of all-over painting was
self-evident.

†Greenberg is preoccupied with the distinction between high and low art
or, as he puts it in "Avant-garde and Kitsch" (*Art and Culture,* pp. 3–21),
superior and mass culture. In "The Plight of Culture" (*Art and Culture,* pp.
22–33), this becomes a struggle between "high civilization" and the forces
that threaten "cultural decline." Greenberg sees himself carrying the
banner for high art and civilization, and sees the critic as sustaining the
distinction between good and bad art—keeping it as clear as possible. Good
art creates a "higher, recovered unity" ("The Later Monet," *Art and
Culture,* p. 43), in which discordant elements are made visually equivalent.
Put another way, in a high civilization incommensurate elements are made
stylistically commensurate, while in a low civilization they are taken
matter-of-factly—inartistically, vulgarly—and not reconciled. Taste alone
can "recover" unity from disunity, or perceive the "higher" unity high
civilization conceives.

For Greenberg the all-over picture undermines "traditional Western easel painting," which "subordinates decorative to dramatic effect." This is the historical importance of the all-over picture: it reverses the usual priorities of painting. Where dramatic depth once mattered, undramatic surface now matters. Or rather, surface which is implicitly dramatic, if still without hidden depth. Where the traditional easel picture "cut the illusion of a boxlike cavity into the wall behind it," the all-over picture responds to the wall itself, and dramatizes the wall, as it were. This ultimately undermines the goal of verisimilitude, for if a picture is no longer to cut a fictional window in the wall, there will no longer be any view of the real world beyond it. Above all, there will no longer be any dramatic plunge through the wall, in expectation of a world. With this loss, a whole logic of expectation collapses: the dialectical conversion of nature into art disappears, and with it the sense of discrepancy between nature and the illusion of nature. That is, the drama of the conceived and perceived relationship between nature and art is no longer an aesthetic issue. While the decorative effect is not the result of the collapse of such dramas, the relaxing of the tension between the illusory and literal in the all-over picture helps nullify the distinction between the "depth" and "surface" of the work. Surface seems all. In a sense, this is what it means for a work to be decorative: it is free of any re-presentational purpose, and is strictly presentational. This means that it exists in the terms of its own making, rather than in terms of the world it makes. Fully decorative, the picture can never even hint at an illusionistic purpose, for it seems too obviously what it is in itself, too obviously one with the conditions of its own creation. And these are all conditioned by its medium; the need to be true to the medium comes to replace the need to be true to nature. In the decorative picture, painting per se and the pictorial are inseparable. For Greenberg, the most autonomous, abstract, and modernist picture is the decorative picture.

Greenberg recognizes that the modern decorative picture came into existence slowly, almost accidentally, with no

great clarity about its principle of creation. The principle of equivalence that brings "decorative structure" into existence emerged dialectically yet fitfully. Decorative structure was fully realized only in Abstract Expressionism, which understood that when "every area" of a picture became "equivalent in accent and emphasis," the picture no longer had nor needed a center. It became, in an expression Ezra Pound used to describe James Joyce's *Finnegans Wake*, entirely a matter of "circumambient peripherization," or, in the dialectical language of Nicholas of Cusa, a realm in which circumference and center could not be differentiated. It was loss of the center that finalized uniform reverberation and "realization" of the surface. Traditional easel painting could never give up that center, however evasive the image of nature became. It was only when it was realized that the loss of nature did not mean the loss of artistic possibilities—on the contrary, expanded them—that the means of organizing the picture suggested by nature could be dropped. With nature no longer the artistic model, there was no longer any need not only for distinctions of depth but for any "central" coordinating factor.

The decorative picture, then, is pure surface, and whatever sensation of depth it suggests is the result of the differentiation of that surface. The quality of such differentiation is crucial for Greenberg. On it depends whether or not the surface *"breathes,"* and thus whether or not the picture is perceived as a decorative structure or a mechanical design: that is, as either a vital or fatal form. For Greenberg, the all-over picture is vitally decorative because its surface is "fresher, opener, more immediate" than that of the traditional easel picture.

> There is no insulating finish, nor is pictorial space created "pictorially," by deep, veiled color, but rather by blunt corporeal contrasts and less specifiable optical illusion. Nor is the picture "packaged," wrapped up to seal it in as an easel painting. The canvas is treated less as a given receptacle than as an open field whose unity must be permitted to emerge without being forced or imposed in prescribed terms.[4]

Like "every fresh and productive impulse in painting since Manet," the all-over picture "has repudiated received notions of finish and unity," and extended "the possibilities of the medium." It thereby "compromises" easel painting "in its very nature," for the all-over picture, organized "in terms of flatness and frontality," seems to demand a highly differentiated surface to muster its full effect—to breathe. For flatness and frontality to appear fresh, open, and immediate, they must optically convey the illusion of infinite nuance. Without this illusion, which precludes an easy grasp of pictorial space, decorative structure is not viable. It comes to seem preconceived, if not predetermined. It becomes an emblem of the medium's limitations, rather than an expression of its organic possibilities.

In general, the traditional easel picture cannot offer to decorative structure the open field it needs to make it forcefully and expansively reverberate. Instead, traditional easel painting predicates the closed depth, next to which all differentiated surface loses significance. Worse yet, it uses parts in a way almost deliberately antithetical to the principle of equivalence. Their diversity is emphasized rather than underplayed, to aid dramatic effect. Thus, every aspect of traditional easel painting defeats the purpose of decorative structure, viz., to make the surface breathe with a life of its own.

But "standard taste" prefers traditional easel painting, and finds the all-over picture, with its purely musical surface, offensive. "Standard taste is offended by what looks like an undue looseness and, as usual, mistakes a new spontaneity and directness for disorder or, at best, solipsistic decoration." Standard taste mistakes spontaneity for solipsism, and regards directness as an apology for the absence of binding order. This conception of the decorative as a superficial veil of surface on a work lacking any inherent logic can in fact readily arise from perception of the all-over picture. The erroneous perception reveals a true problem, the problem of any painting completely surface-oriented. "Although it [the all-over picture] still remains

easel painting somehow, at least when successful, and will still hang dramatically on a wall, this sort of painting comes closest of all to decoration—to wallpaper patterns capable of being extended indefinitely—and in so far as it still remains easel painting it infects the whole notion of this form with ambiguity."[5]

It is significant that Greenberg calls the ambiguity "fatal" in his revision of "The Crisis of the Easel Picture" (1948) for *Art and Culture*. This suggests not only that the easel picture that becomes decorative is self-destructive, but that decorative painting that does not have the drama usually thought of as belonging to easel painting is trivial. The point is that "the new 'polyphonic' painting, with its lack of explicit oppositions"—the source of drama—can ring hollow just because of this lack. The decorative and the dramatic are irreconcilable, but without any dramatic quality the decorative seems devitalized, and even absurd. Its music seems spiritless.* Greenberg makes this point when he remarks that decorative uniformity seems "antiaesthetic." On the one hand, the decorative expresses "the [modern] feeling that all hierarchical distinctions have been exhausted, that no area or order of experience is either intrinsically or relatively superior to any other." This articulates the collapse of the dramatic, which depends upon hierarchical distinctions. On the other hand, it seems impossible to function, or experience a picture's functioning, without making such distinctions, if only nominally. Without them, and the tension they generate, experience goes slack. Aesthetic experience presupposes perception of contrast, the most elementary differentiation, and contrast is cognized by hierarchically analyzing it. Without such analysis, unity seems to

*For Greenberg the all-over picture, with its decorative surface, most successfully achieves the condition of music, the ideal of modern painting. This ideal replaces the traditional one of the picture as an imitation of poetry. For Greenberg, Paul Klee is the major example of an artist in transition from poetic to musical painting. See "On Paul Klee," *Partisan Review* 8 (May-June 1941): 225.

lose viability; it comes to be experienced as trivial. In other words, without implicit drama, decorative structure loses impact and becomes, truly, mere "effect." The decorative picture comes to seem the sum of its techniques rather than an evocative whole.

Now for Greenberg the way out of this impasse—the way to reconcile the decorative and dramatic, or more precisely, to create a decorative picture charged with implicit oppositions—is paradoxical: the decorative must be transcended by means of the decorative itself. As he says: "Decoration is the spectre that haunts modernist painting, and part of the latter's formal mission is to find ways of using the decorative against itself."[6] It is only by being turned against itself that decorative structure becomes somatic structure, i.e., a vital unity.

Matisse was a leader in this dialectical conversion of the decorative. In fact, it is thanks to him that "the word 'decorative' is no longer used as freely as it once was in finding fault with works of pictorial art," for "too much of the best art of our time was criticized, when first seen, for being too 'decorative.' "[7] Matisse turned the decorative against itself by "flattening and generalizing his motifs for the sake of a more abstract, 'purer,' and supposedly more soothing effect."[8] Greenberg finds him "feeble" and naïvely decorative only when he does not push toward purity, as in "his paper cutouts, his ventures into applied art . . . tapestry designs, book decorations, and even murals." But Matisse had "unprecedented success" in "his efforts to assimilate decoration to the purposes of the easel picture without at the same time weakening [its] integrity" when he "increased the tension between decorative means and nondecorative ends." Like the later Monet, Matisse accomplished this by "establishing scale as an absolute esthetic factor," i.e., "by dint of the monumental."

For Greenberg, scale stretches the decorative to its limits, tensing it so that it seems to transcend itself. Monumental scale stretches a finite surface over a seemingly infinite field, putting it in opposition to itself. For Greenberg, scale

is the answer to the "new will to expressiveness" that Picasso's art ultimately succumbed to.[9] By establishing scale as an absolute aesthetic factor Matisse extended the possiblilities of the medium, articulating its abstractness freshly and frankly asserting its dominance. Scale became a new, if conspicuous, way of showing that dominance—of making the medium powerfully immediate while showing its "openness." In contrast, Picasso's attempt to make his abstractions freshly expressive resulted in the naïvely decorative. He unwittingly reduced his forms to redundant, if variegated, wallpaper, until they became formulas. In fact, his post-Cubist development can be viewed as a demonstration of the conception of Expressionism as decorative realism. Thus Picasso, whose Cubism, like Matisse's Fauvism, "deprived of its traditional force . . . the distinction between the decorative and the pictorial," began "in the thirties to inhibit the abstract or decorative fulfillment of his painting" in the name of a new expressivity. While making "it almost a matter of doctrine to shun a 'purely' decorative unity," he nonetheless loaded his pictures "with decorative space-fillers." That is, "Picasso, in trying to turn decoration against itself, in the end succumbs to it," because he could not, as Matisse did, conceive a new aesthetic goal, but only an old experiential one. Picasso's new will to expressiveness had no new experience to express, and relied on old aesthetic means. Used repetitiously, these became decorative patterns. Worst of all, Picasso gave up, as Matisse never did for Greenberg, the attempt to rediscover his medium and find fresh aesthetic purpose in it. Picasso's will to expressiveness—his new will to master old experience—masks his lack of fresh mastery of his medium, the absence of any intention toward it. When an art loses the tension aroused by the attempt to articulate new aesthetic problems it becomes exclusively and obviously "decorative." It begins to belabor the old problems, and especially their solutions. Because both are foreknown, the result is an overstated work. The art becomes simply a new manipulation of an old dialectic.

Milton Avery suggests to Greenberg another way, correlative with Matisse's, of overcoming the decorative by means of the decorative. Truth to feeling makes the decorative reverberate somatically. Pressured by feeling, its forms become crisply rather than limply abstract. The force of Avery's feeling for nature makes his use of the decorative dramatic. Empty forms are played against one another, "opposed," until they seem full. Where Matisse sets the old decorative facts of flatness and frontality in the new aesthetic context of scale, Avery, generally indifferent to scale, charges the familiar formal facts with new meaning and force by making them embody—by means of introducing new contrasts in them—an intense feeling for nature. Truth to his feeling for nature, rather than nature itself—rather than the ideal of verisimilitude—matters for Avery, and that truth is communicated, as it always is for Greenberg, by the creation of a subtle yet striking dialectic within the very texture of the abstract fact of the medium. The decorative comes to mean more than the repetition of old forms by becoming a means for the reconstitution of the medium.

> The younger, abstract painters who admire Avery and have learned from him do not share his naturalism, but they see in his paintings how intensity and truth to feeling, no matter what its source, can serve to galvanize what seem the most inertly decorative elements—tenuous flatness; pure, value-less contrasts of hue; large, "empty" tracts of uniform color; rudimentary simplicity of design; absence of accents—sheer, raw, visual substance—into tight, dramatic, almost anecdotal unities with the traditional beginnings, middles and endings of easel paintings. His example shows them how relatively indifferent the artist's concrete means become once his formal training is finished, and how omnipotent is the force of feeling, which can body nature forth with the abstractest elements, and compel decoration to overcome and transcend itself by its own means.[10]

Matisse and Avery are rare artists. For Greenberg most artists find it hard to sustain transcendent decorative pro-

duction. They succumb to expressivity, momentary passion. They are unable to continue to produce "satisfactory creations ... which ... remain ineloquent, mute, with no urgent communication to make, and no thought of rousing us with look and gesture," creations which are, if they are at all expressive, evocative of "character, essence, rather than momentary feeling or purpose."[11] "It is enough that they exist in themselves," but when such works become flamboyant and fail, they seem arty and dumbly—we might say empirically—decorative. They seem naïve to have tried to rely entirely on the decorative in the first place. There is no failure like that of decorative art; its self-transcendence unsuccessful, it collapses into utter banality, and seems stultifying.

Greenberg's protestations to the contrary, it is failed decorative unity, weak somatic structure, that he is most responsive to—quick to spot. This seems inevitable, given Greenberg's assumption of the difficulty of creating successful decorative art. Moreover, there is not only more failure than success in art—a general poverty of high art—but poor art is all too often mistaken for good art. Thus, Greenberg has more cause to use "decorative" in the pejorative than eulogistic sense, although it is for him an inherently ambiguous epithet. (The ambiguity derives from the tension between traditional easel painting and modern all-over painting, although it is a tension exacerbated by the difficulties of decorative transcendence.) The decorative becomes a way not only of making qualitative distinctions between artists, but a reminder of what in fact for Greenberg is the constant threat to advanced painting. The decorative represents all that does not breathe, that is inert in advanced painting, as well as the dialectical self-transcendence of art.

> Mondrian has shown that it is still possible to paint authentic easel pictures while conforming to this strict—and more than strict—notion of painting. Nonetheless one begins to see a danger in it for the art of painting as we have known it. Pictorial art of this sort comes very close to decoration. Mondrian's greatness may be said to consist in good measure in having so successfully incorporated

the virtues of decoration in easel painting, but this is small guarantee for the future. Painting of a kind that identifies itself exclusively with its surface cannot help developing toward decoration and suffering a certain narrowing of its range of expression. It may compensate for this by a greater intensity and concreteness— contemporary art has done so with signal success—but a loss is still felt in so far as the unity and dynamics of the easel picture are weakened, as they must be by any absolutely flat painting. The fact is, I fear, that easel painting in the literally two-dimensional mode that our age, with its positiveness, forces upon it may soon be unable to say enough about what we feel to satisfy us quite, and that we shall no longer be able to rely upon painting as largely as we need to for a visual ordering of our experience.[12]

The "plane surface" is no longer experienced as "resistant," so that absolutely flat painting loses the tension that lets its surface breathe, the differentiation that evokes feeling. With this loss of tension or immanent dialectic, flatness loses its reason for being and becomes simply a wall for decorative design. Unless flatness can be experienced as resistant, and therefore tension arousing, it can never become decoratively dramatic. Flat painting then literally falls flat. It is stillborn, or insipid, and at best "arty," which for Greenberg is "the symptom of a fear for the identity of . . . art."[13] In other words, when pejoratively understood, the decorative is a sign of the loss of artistic identity. In contrast, the attempt to be decoratively dramatic is an attempt to create a highly visible artistic identity. Greenberg seems to suggest that artistic identity can be more easily lost in flat painting than in traditional illusionistic painting. It is presumably easier to fall flat than to fail at an illusion; some vestige of nature always exists in it. There is no compelling reason, however, why this should be so. An ambiguous unity can appear in illusionistic art, as Greenberg himself recognized was the case in the work of the Flemish primitives. It may be that since flatness is a fact of the medium of painting the failure to articulate it dialectically leaves one with less of anything that could be called art. Failure to

create a convincing illusion may still leave one with a sense of nature, so that the convention that regards art as an imitation of nature is respected if not satisfied.

Greenberg is particularly sensitive to attempts to force the dramatic. Apart from the expressionistic way of doing this, it can also be done by stylizing a style, or reducing it to a cliché. The complex interplay of the formal facts of the style, and the facts themselves, are simplified, and as such predictable. The tense dialectic of unity, resolved finally by the viewer, becomes a manipulation or juxtaposition of standardized formal facts, which the viewer merely acknowledges. Neither artist nor viewer does much work to make this art. Greenberg thinks such stylization is commonplace, even among masters thought of as great. True greatness exists in the struggle to create original style, not in the stylization which makes it unoriginal and easily accessible, and thus corrupts or falsifies it. The artist who can establish a new tension is great, not the artist who makes it a convention. The artist who makes art is great, not the artist who makes art arty. Greenberg notes "the archaic artiness of Moore, Marini and Giacometti, the cubist artiness of the younger British sculptors, or the expressionist-*cum*-surrealist artiness of the Americans."

The mechanical conversion of art into artiness, style into stylization, is the source of the decorative, negatively understood. Such conversion is achieved by "staging" an art or a style, as if to say that its unity was still in question, and needed "prompting." The unity is theatrically put through new trials, which attempt to reconstitute it but instead only dismember it, polish its parts until they glisten with slick transparency, and reassemble them into the mold of the old unity, where they loosely fit. The old tight coherence is lost; a generalized look replaces a particular tension. A mechanical tension replaces a dialectical one. The art acquires a Platonic intelligibility; its unity is no longer lived, but has become the dead letter of an idea of unity. The art becomes pretentious rather than achieved. With the decorative use of a style the concrete conditions of its achievement

are discarded. What it had to resist to come into being is regarded as irrelevant to its being, so that the art itself no longer seems to resist us. As such, it becomes meaningless as art, i.e., as a dialectical transformation of a resistant life content. Stylized, artificially dramatic, the art loses its import; it no longer seems to focus emotion. It seems to have more flair than force. It becomes an ornamental excrescence rather than an articulate tension. Become decorative, living style is exploited for its look rather than reexperienced in its tension. It loses its character, and becomes a "personality." It gets by on charm rather than strength. It has become decadent.

For Greenberg the descent to the decorative occurs in three stages, each signifying an increasing degeneration of style: (1) repetition; (2) felicity, which either masks fear for the loss of artistic identity or the absence of an independent artistic identity; and (3) fashion, which makes the art acceptable to standard taste, i.e., makes the art entirely a matter of good taste. Already in the first stage the art begins to cater to those who want easy unity, self-identity with no tension. The complexity in this conception of the decadence of a style is Greenberg's belief that it is caused by the attempt to make the art expressively "apply" to life. That is, the mechanical conversion of a dialectical style into a decorative convention results from the attempt to make the style arouse feelings that it had nothing to do with in its origin. It is assumed that once achieved, by whatever specific means in response to whatever resistant reality, the style is generally useful for life or feeling. It becomes therapy, or else entertaining, and finally even the object of veneration. Like a religious relic, it is expected to have all kinds of magical powers, and one is expected to commune with it rather than to analyze it. Its presence is regarded as lucky, and so finally it is spread through life as a luck charm. In decorative form everybody can have a piece of style. The irony of the decorative is that it attests simultaneously to the sacred power of the original style and the vulgar demand for that power, which makes it profane and

popular, and thereby no longer powerful. Arty styles are the attempt to transmit the power of original style as painlessly as possible to as large a public as possible while maintaining the aura of the original style. And, for those who do not know any better—for that large public—they succeed.

Decoration is magically applied style. It is style applied to life in the name of an affective ideal—i.e., a utopian sense of life's emotional possibilities. For Greenberg, it comes down to an attempt to be cheerful, to create universal cheer, as though that could alleviate alienation. In other words, the decorative is not only a form of false consciousness of art—i.e., an attempt to deny the tensions in it—or to diminish their intensity by regularizing them or making them predictable. The decorative is also an attempt to generate false consciousness of life. Art is used, by being made decorative and spread through life, to convey the sense that life is a realm of reconciliation rather than conflict. When the walls of one's world are decoratively arty it seems the best of all possible worlds, simply because it is "aesthetically" attractive. Of course, the decorative also gives a false meaning to the aesthetic. Under its auspices, aesthetic experience becomes a realm of benign, easy unity rather than one of difficult, tense dialectic, in which unity is more achieved than received. The decorative as it were hands one unity on an artistic platter, a unity one can then wear like a trinket, giving one's life and consciousness an outer semblance of "style." In a sense, decoration teaches one to lie to oneself about one's life, and to falsify one's experience in general.

The three stages in the development of the decorative are clearly related. Thus, repetition mechanizes style into design so that it can be used felicitously, which makes it fashionable. Repetition drains the struggle out of style by making it a matter of "outer" rather than inner necessity. More precisely, repetition makes overly explicit the implicit tensions within a style by fixing them in a pattern. The tensions are, as it were, overly-articulated, precipitated out of the dialectical process the style always is; decoration works

with this residue. It is systematized into a pseudo flow of "artistic" nuances, an easy differentiation of surface. In essence, equivalence becomes similarity, and with that the original dialectic of the style loses its point, and its unity loses all charge. This makes the style accessible, and so acceptable; it becomes socially legitimate—and at the same time aesthetically insignificant. For Greenberg, what is above all lost in the inevitable move from style to stylization, from decorative unity to decorative design, from organic to mechanical art, from a difficult to an easy aesthetic experience, is the sense of risk, uncertainty, and possible failure at every step of the process of artistic creation. Decoration makes it seem easy to make art. Decoration seems so lacking in risk that it makes artistic creation seem automatic once triggered, and without any particularly telling consequences once complete. Style seems a rubber stamp any artist can make "impressive," as though the look that resulted was the point of art rather than its leavings.

Let us examine in detail Greenberg's account of the decorative stages.

1. Without mincing words, Greenberg asserts "repetition is death."[14] It makes the unfamiliar familiar without putting one to the trouble of understanding it. Repetition is alien to all that art stands for—transcendent freshness, dialectical unity. It reduces experience of art to the shortest route between the obvious work and known feelings. Repetition goes hand in hand with "the refusal of new impressions and influences," which is the ultimate decadence, as well as with provincialism.[15] "The adventures and gambles of modern art" are replaced by "obsessive rhythms and the inability to be more than decorative."[16] "Design," in which "formal relations are transparent and predictable," replaces style, in which formal relations are unpredictable and thus obscure, and are created as much by the viewer as the artist.[17] Design spares the viewer the trouble of experiencing the work deeply; there is in fact nothing deep or mysterious about it to experience. Style, on the contrary, forces the viewer to re-create it if he is to grasp it at all.

Artists as major as Wilfredo Lam and as minor as the woodcarver Nicholas Mocharniuk can be "captured too readily by facile and decorative rhythms."[18] Their art reduces to the "elemental and static simplicity of decoration," i.e., to simplicity without density.[19] It is worth noting that the decorative nets an enormous diversity of artists for Greenberg, as if to say that no modern artist is immune to it. Of all artists susceptible to the simplemindedness of the decorative, Greenberg most faults Naum Gabo and Josef Albers for "that repetitiousness of rhythm which so often goes with excessive taste" and "tends to declare itself as the surrender to decorativeness."[20] It is perhaps because their art is transparently mechanical that they fall easy victims to Greenberg.

> Gabo's objects, small in format and excessively limited by the notion of neatness, exhaust themselves too often in the point they make of symmetry; and their lightness, fragility, and transparence tend to be mechanical rather than felt out, the automatic results of an aesthetic code that precipitates itself in repetitious arabesques akin to those of penmanship exercises. These weaknesses, the weaknesses of decoration, are made very evident in some small paintings by Gabo.[21]

As for Albers, "Alas, Albers must be accounted another victim of Bauhaus modernism, with its doctrinairism, its static, machine-made, and logical art, its inability to rise above merely decorative motifs."[22] It is interesting that Greenberg's proposed solution—"to dissolve the ruled rectangles"—turns Albers into Rothko, i.e., into a field painter.

2. Although repetition can result in "violent decoration," as in Van Gogh,[23] it usually results in something far tamer, viz., an art "of the felicitous and of good taste."[24] The point of repetition is to give the illusion of ease of handling—of easy mastery where in fact there is only difficulty. It aims to show that a style one thought was original is in fact ordinary, if not without some subtlety to make it interesting. Its felicity discovered, the style is understood to be the product of "good taste—a good taste already established by others."

In a sense, the fact that any style can be reduced to the decoratively felicitous shows that no style can escape becoming an object of taste, and thus conventional.

Again, the net of felicity catches many artists, a small fish such as the English abstract painter John Tunnard and a big fish such as Calder, whose "shapes and especially his color stem entirely from the works of Picasso, Miró, and Arp."[25] However brilliant, decorative felicity is a sign of tasteful derivation from more original masters. The ability to fuse many sources is crucial to the decorative artist, since it gives him his own look of originality. His "originality" consists in finding new uses for old styles, in secondhand experience of firsthand art. Greenberg thinks that most artists do nothing more than make the difficult style of an important artist felicitous, and thus unimportant. It is easier to base one's style on somebody else's "realization," easier to be inauthentic than authentic, to take the path of least resistance and "aim at felicity . . . [rather] than complete expression."[26] It is easier to assume somebody else's identity than to forge one's own. For Greenberg, most artists lack an independent identity. They are at best evangelists of good taste, creating a socially attractive decorative look.

One of Greenberg's major disappointments is Robert Motherwell. As the Romans spread or universalized Greek style, slightly vulgarizing it in the process, so Motherwell spread and "civilized" modern style, overrefining it to the point of felicity in the process. One might say that he acculturated it into a climate of visual opinion, so that it became a standard of decorum. All decorative art is inherently decorous, and by making modernism decorative Motherwell showed that it too was doomed to degenerate, and become imitated, diluted, and fashionable. The problem is that Motherwell seemed to have accelerated the process; he arrived at the decorative prematurely, before modernism had worked out its possibilities.

In Motherwell's painting the all-over surface becomes over-simplified and finally delicate, even anemic, rather than vigorously and rigorously conceived. Greenberg once had great hopes for Motherwell, regarding him as full of

that "ungainliness . . . insecurity of placing and drawing . . .
awkwardness" that indicate an independent artistic identity,
particularly in Abstract Expressionism.[27] In other words, his
art was at first full of dialectical struggle, an original ten-
sion which led to the expectation of an original unity. But
Motherwell became an imitator of Picasso, producing an art
that "poured too directly from post-cubism." Motherwell
helped make Picasso respectable by showing that even his
most violent conceptions could be assimilated by good taste.
Like any artist who "looked to the past for qualities of sen-
timent and for formal schemes by which to assure . . . unity
and effect" Motherwell came to produce an art "of surfaces
. . . ornamented instead of painted into a picture."[28] His
work was full of "chic and facility" rather than original
unity and fresh feeling.[29] The decorative is an art of the
already achieved, warmed over so that it seems appetizing,
but far from hard on the palate.

For Greenberg, the decorative artist is especially damned
because he is just that, viz., an artist, rather than a painter
or sculptor—rather than someone who respects his me-
dium. What the decorative artist above all does not under-
stand is that "art is a matter of conception and intuition not
of physical finish."[30] That is, art involves understanding of
and response to the medium, not a superficial grasp of its
obvious characteristics. Playing his role of safekeeper of
aesthetic virtue, Greenberg angrily condemns the decorative
for the violence it does to art by reversing its priorities. By
being reduced to "surface felicity,"[31] the ideas and intui-
tions that went into its creation are ignored. It is interesting
that polyphonic field painting, which Greenberg endorses
for its conception, can be evaluated almost entirely in terms
of its surface felicity. It seems to tread a fine, almost imper-
ceptible line between conceptual and physical values. But
for Greenberg the uniqueness of its conception is missed
only if one ignores the historical process that led up to its
surface look.

Greenberg thinks he can unhesitatingly distinguish be-
tween mere surface felicity and an originally conceived art.
The former refines the conception of another artist into a

look, or else simply takes over his surface and regards it as
a look. The latter goes through a process rather than ap-
propriates the result of someone else's work. Thus, he
thinks that Ben Shahn simply appropriates, although not
without tastefully enlivening it, the look of photography,
which for Greenberg is a medium in which surface can
never have density.[32] Photography is thus well suited to
produce a decorative effect, when it is not overendorsing,
as it were, a content. Similarly, Chirico produces "elemen-
tary interior decoration," because style for him is nothing
more than "a decorative convention."[33] Motherwell is a re-
current target, since he has an "archness like that of the
interior decorator who stakes everything on a happy plac-
ing to the neglect of everything else."[34] Motherwell's
"tricks" mask the worst crime, in fact the cardinal sin of the
decorative artist, his tendency "to carry out ideas for which
the emotion was lacking to begin with or failed en route."
Decorative felicity is not simply a venial sin that can be
overlooked, but must be decisively condemned, for it totally
misleads as to what art is about, viz., emotional power and
respect for the medium. As noted, the decorative makes it
seem as if anyone could make art with a little technique;
this is also part of felicity. Another part is the way the dec-
orative leads people to believe that art is neither a response
to resistant content nor itself resistant. In fact, that art is
altogether without content, or without a significant, original
relationship to content. For Greenberg, when an artist has
only felicity, he "does not say enough yet to be impor-
tant."[35] Like Theodoros Stamos, he may achieve "a decora-
tive and faintly academic slickness and syrupy grace," but
that does not mean that we should give him our unqual-
ified attention.[36] Greenberg thinks that "felicity of taste"
can be "so intense and ... applied to a mode so difficult
that it becomes practically equivalent to originality," as in
the case of Ben Nicholson.[37] He also thinks that "strength"
and "felicity" can go together, as in Adolph Gottlieb's paint-
ing.[38] Greenberg thinks, however, that "felicity and sure-
ness" usually substitute for "strong force or a radically in-
dependent approach."[39]

3. According to Greenberg, fashion means to have an un-conventional effect by conventional means, and it will use any combination of such means to achieve its effect. In general, the decorative attempts to standardize, to profes-sionalize, and to commercialize a style (all are correlative)—in a word, make it fashionable. Fashionable decoration is akin to academic assimilation and, unexpectedly, implies a provincial attitude to art.[40] The provincial, the academic, and the fashionable want the look of style without the vi-sion that created it, the triumph of art without its intention. They want the control that style signifies without con-sciousness of the feeling controlled, or the struggle to achieve control. They do not want signs of work, any indi-cation of the ugliness and awkwardness of effort, only the utopian grace, perfect form, and seeming beauty of the re-sult.

For this reason decorative art is usually created by "quick-change artists who orient themselves toward worldly public taste and predigest their betters for stylish consump-tion."[41] Their "ornateness of color and paint matter is, even as ornateness, mechanical, manufactured; it is the notion, the advertisement, the intention, not the reality of the qual-ity itself."[42] As noted, even such great masters as Braque can succumb to ornamental mechanization of style. It is a danger accompanying the desire for social approval of style. In the same breath in which the style is approved it is asked to become beautiful, to simplify itself so that it can be used by life. The price of becoming normative is to experience the living death of becoming decorative, i.e., a mere back-drop or "atmosphere" for presumably more important events than works of art. This is life's revenge on art: after art has "renounced" life for utopian equilibrium, life assimi-lates this equilibrium as a minor, redundant moment in its own momentum.

A major example of such revenge and social irony for Greenberg was the 1948 Whitney Annual, where the "trend toward an 'attractive' abstract art" led to "a neutralized, easy-to-accept abstract art, an ingratiating, pseudo-advanced

kind of painting whose color and, to a lesser degree, design are kept academic enough to attract and charm people who do not otherwise take to non-representational art."[43] In essence, "the cultural significance of the felt necessity to prove oneself in the field of the abstract" led to the production of lovely, lazy abstract art. Again, Stamos, with "his sickeningly sweet, inept, and utterly empty painting," borrowing "from the lower registers of William Baziotes, a serious and vastly superior artist," is for Greenberg the "hero" of such fashionably attractive abstraction. Calder also indulges in it, as does Noguchi, both with less disastrous if still undesirable results. Once again, "the 'modern' is treated as a convention with a closed canon of forms," one of which, "the emphasized contour," they use decoratively.[44] But Miró and Arp, not Calder and Noguchi, did all the original, difficult, "experimental" work necessary to "rescue" the contour from Cubism. Calder and Noguchi simply made it decoratively effective by means of "excessive polish and smoothness of surface, an excessive clarity and precision of drawing."

Greenberg makes his main point over and over again—relentlessly, consistently, in the face of a wide range of abstract art. The decorative artist does not do the seminal, intuitive work of art. He does not even carry the concepts of a style to their logical conclusion, drawing out its consequences in the course of exploring it for new possibilities. Rather, the decorative artist appropriates the style as a look, putting a "finish" on its raw accomplishment. In a sense, decorative artists specialize in what the Italian Renaissance called *facilità*: the creation of a work which looks as if it had not been worked at. They believe, in Castiglione's words, that "we may call that art true art which does not seem to be art; nor must one be more careful of anything than of concealing it, because if it is discovered, this robs a man of all credit."[45] The original modern artist, on the contrary, does not think his work is robbed "of all credit" if it shows signs of its labor, but rather gains in value. The modern point is to show more rather than less of the creative strug-

gle, so that its intention becomes explicit. For the modern artist, the work records the experience of the creative process. The work is not meant to give the illusion of being spontaneously and felicitously generated. The modern decorative artist sees the work in the traditional way (which is why he is not truly modern). For him, all traces of the dialectical drama responsible for the work must be repressed, so that it seems to have been born fully formed, in complete maturity of being, as if sprung from a god's forehead and so itself divine. Process smells of hard, sweaty, vulgar work; the decorative artist is only interested in its product, which his "art" perfumes. Greenberg acknowledges the divine touch of many decorative artists, but asks "Where is [their] strength? Where are [their] profundity and originality?"[46]

For Greenberg, great or high art, with its authentic style, fuses original feeling and original form in original unity. As we have seen, he faults many artists for lack of original feeling; Motherwell is *the* case in point. He also faults many artists for lack of original form—for not even understanding what it might mean. For Greenberg, Marsden Hartley is an important American example of an artist with powerful original feeling but with the "characteristic" misunderstanding of modern art as "stylization . . . that sad misapprehension of 'modernistic' art under which so many of the first attempts to acclimatize post-impressionist tendencies over here [in America] were made."[47] In particular, Hartley regarded cubist style as "something decorative, to be *applied*. The organic, internal necessities from which cubism, and nothing else, had to issue were not felt." The absence of internal necessity led Hartley to conceive of space decoratively, thus denying its resistance, through his "habit of reducing the salient incidents of surface as well as form to drastically definite and monolithic silhouettes."

Another artist who did not understand that internal necessity determined original form was Roger de la Fresnaye, "one of the first, along with Delaunay, to explore the possibilities of cubism as quasi-abstract decoration."[48] Style

could be refined into decoration "when the discovery and adumbration of that which still constitutes the essential elements of . . . style were completed." It is then that style can be made "elegant . . . cheerful," "softened and prettified." For Greenberg, putting style to decorative use is the work of "a feminine sensibility," one sensitive to convention. Of course, Greenberg is himself conventional in his conception of the feminine as "quick to grasp the point of the new style and, in grasping it, to suppress all struggles and resistances through which it had originally been developed." The feminine, he seems to argue, does not like creative suffering, but prefers the shell of creative form, which it facilely refines—polishes into a felicitous surface. The feminine prefers the emptiness of a look to the fullness of a struggle. In any case, De la Fresnaye, for all his feminine sensibility, "came so early that he could not avoid a certain minimum of struggle." Fortunately for him but not his art, this minimum of struggle was muted by a maximum of taste, which always destroys energy, relaxes tension: "What was lacking was a surplus of energy above and beyond that embodied in his taste, superlative as that was."

Calder and Stuart Davis, Greenberg notes, had the same superlative taste, which also permitted them to use Cubism "as a decorative facade rather than as a means of transforming space integrally." In other words, taste represses integrative intensity or transformative power, and leads to an art without strain—a cheerful art. The attempt of De la Fresnaye, Calder, and Davis to "make modern art cheerful," and so likable and fashionable, "shows that eminent capacity of provincials for tasteful adaptation and also the felicity permitted by the un-obsessed mind." Greenberg seems to admire this felicity when, as in the case of his three cubo-decorative artists, it is "prodigious." But from their ability to "generalize and make immediately pleasing what more seminal artists produced at the cost of strain and frequent error" Greenberg draws two morals, as he calls them. One is that "taste is not enough for a lifetime of art." In other words, their art simply does not go far enough, or

require much development, because its only fuel is its good taste. The other moral is more complex:

> The only salvation I can suggest for artists such as Davis, Calder, and De la Fresnaye is that society give them fixed, exactly defined tasks that require them to fit their cheerfulness and discretion into the general decor of modern life in a systematic way. Let Davis and Calder create an atmosphere in which to move, not sole works of art. There are the examples of Boucher and Fragonard, whose spirit their own resembles.[49]

With this suggestion Greenberg returns to the "fatal ambiguity" in decorative easel painting, where the decorative is the sign either of new pictorial unity or its degeneration. It can be as much deplored as desired. In general, the decorative brings to a head the problem of the relation of art and life, and Greenberg is not alway certain on which side he stands. Throughout his career he has scorned those who think art the most important activity in life[50]—that is, connoisseurs who live only for aesthetic experience, and overrate it with respect to other experiences, and who in fact seem to become incapable of other experience by reason of their preoccupation with aesthetic experience, which alone has savor and intensity. Thus, Greenberg is quite capable of taking a larger point of view than that of art, in fact the point of view of life. He can argue that to live only for art is to become smug toward life, imagining that one has escaped its problems, and he can agree with Karl Marx and with Hans Hofmann, who "anticipates the disappearance of works of art—pictures, sculpture—when the material decor of life and life itself has become beautiful."[51] Decorative art then comes into its own, as a kind of popular art. It becomes emblematic of a good life in a good world, or at least of the revolutionary transformation of life for the better by artistic purpose.

At the same time, Greenberg doubts that art can truly transform life for the better, because he knows that by its very nature art works through "sole works of art." These can be fully experienced only by aesthetically oriented indi-

viduals, for whom aesthetic experience is an integral part of life. Whatever sociopolitical or ethical effect art may have depends on these individuals, and it seems that they must be indifferent to the sociopolitical and ethical to experience aesthetically. Attention to such realities in fact seems to diffuse aesthetic experience, which has its own strenuous demands. Art cannot be spread everywhere in the world, as decorative art attempts to do, because the creation and experience of art demands density of feeling, which only the single work can sustain and evoke.

In general, collective beauty, the domain of the decorative, is quite distinct from the beauty that individual works articulate. Spread thin on the social landscape, beauty loses its power to individuate or, what is the same thing, becomes mechanical, a decor one can take or leave, for it has nothing compelling about it. It lacks an inner reason for being. It has only the necessity conferred upon it by exhibition, an external necessity. Its sheer power of display is its reason for being, and its tasteful materiality reduces to the mechanism of this power. Moreover, for Greenberg there is a profound paradox at the heart of every utopian attempt to make life art, for the attempt mocks and blinds us to the realities of both. To attempt to make life beautiful is to attempt to give it an equilibrium or harmony inherently impossible to it by reason of its dynamically historical basis. And if art works to make life beautiful, i.e., means to be of direct service to life, art will become shallow (decorative). For it will lose its roots in personal, particular experience of life's disequilibrium, as well as in personal experience of a particular medium. The utopian purpose of decorative art is unrealizable because beauty requires another medium than life, as well as full experience of life's disharmony. The decorative artist does not understand that most excruciating and subtle kind of suffering, sensitivity to life's diverse disharmonies. This lack of understanding is, perhaps, the deepest expression of decorative art's false consciousness, its naïve sense of the reconciliation possible between art and life, and within life.

The problem of art is to compress or concentrate in a medium alien to life intense experience of life, "transcendentalizing" this intensity by making it the basis of unity. Disequilibrium has a chance to become equilibrium in the confines of and under the unnatural conditions of the medium. But when life is understood as experience and as spontaneously (rather than dialectically) converting to art, then life and art are confused. When life is understood to be able to save itself from its own disequilibrium by becoming aesthetic, its nature is falsified. Such confusion and falsification lead to the belief that dialectical conversion is unnecessary, and the feeling that life, after all, is beautiful. It is out of this naïve feeling that decorative art develops, in an attempt to confirm it. Decorative beauty is based on sublime confusion; it is ultimately less a matter of artistic beauty than of self-assured life, a testimony to the power of convention to convince us that all's well with the life-world.

To escape the decorative, with its utopian pretension of generalizing beauty, which mocks art and life, Greenberg insists that particular works of art alone can have beauty. Greenberg's conception of the decorative as a false mediation of beauty—as a quality repeatedly found in the life-world rather than freshly invented in the art-world—can be taken as a critique of any aesthetics, including Kant's, which admits of beauty—i.e., aesthetic unity—in nature. Beauty is something which is arrived at, by the "work" of art, rather than spontaneously received from life. Transient experiences of equilibrium in life or nature are not denied by Greenberg, but are not to be understood in aesthetic terms. Aesthetic utopianism, which insists that all experiences of unity are aesthetic, or that there is an easy continuity between aesthetic experience and life experience, is replaced by aesthetic realism, which insists that aesthetic unity is mediated only by individual works of art. They alone can make equilibrium a "pleasurable shock" rather than an ornate illusion, or an eternally tentative ideal. They alone can realize unity, in a recoverable way. The uniform mood the decorative means to impose on life undermines the particu-

larity of such unity, and thereby the particularity of the emotion it means to mediate. Nonetheless, transcendentally understood, as it was by certain masters, the decorative can become the sign of realized unity and emotion, especially their simultaneity. Thus, Greenberg celebrates the decorative in Gauguin's art,[52] the "large, monumental kind of decorative painting" Bonnard produces,[53] and even speaks of Cézanne's attempt to emulate "the decorative masters" Rubens and Veronese.[54] For Greenberg, modern art can show us "how intense and profound sheer decoration, or what looks like sheer decoration, can be"[55] when we think of the decorative not as an environment for life but as the fullest realization of modernist practice. It in fact can articulate what is most immanent in modernism, which "by reconstructing the flat picture surface with the very means of its denial" achieves a "transfigured kind of decoration."[56] But if modernism meant decorative transfiguration to beautify life, modernism would never have worked.

In the end, Greenberg is prepared to celebrate any artist whose work achieves the decorative profundity of pure art, however unwittingly or obliquely it is realized. Indeed, such unconsciousness or indirection makes the transfiguration more intense.

> But for all that, the power of Beckmann's emotion, the tenacity with which he insists on the distortions that correspond most exactly to that emotion, the flattened, painterly vision he has of the world, and the unity of this vision—so realizing decorative design in spite of Beckmann's inability to think it through consciously—all this suffices to overcome his lack of technical "feel" and to translate his art to the heights.[57]

For Greenberg, Paul Klee is another German artist one does not regard as decorative, yet whose highest results are achieved through the decorative.[58] Since the Germanic conception of pictorial art is essentially literary—insisting on the illusion of life—German artists are likely to be decorative in a devious way, for they must work, often uncon-

sciously, against the grain of their culture. This, until Abstract Expressionism, was also true of American art, another provincial art without a decorative ideal, which, for Greenberg, seems at times to epitomize what it means to make civilized high art. Thus, he acknowledges a "bias . . . against all anti-decorative, non-Mediterranean conceptions of pictorial art," against painting which "seems to belong too much to the province of poetry or music, and beyond any 'art of space.' "[59] (The Mediterranean world is again seen as setting the standards of civilized art, reiterating an old cliché that has been the basis for much elitism.) While poetry or music may awaken a provincial artist to the decorative ideal of pictorial art, they do not, strictly speaking, articulate that ideal, or at best present it metaphorically. As such, they remain "literary," which for Greenberg is irreconcilable with and a threat to modernism, in that "literary art" is less interested in the medium than in the "surplus of realism" that conveys life. Thus, while poetry or music (especially music, for Greenberg), can evoke the decorative ideal, there is no guarantee that they do not deviously backtrack to a dramatic or expressionist ideal of art. In general, all that Greenberg dislikes in visual art is summarized for him under the rubric "literature," a condition in which a visual art is never generically true to itself, and which gives one the illusion that it can satisfy contradictory purposes.[60] The literary misleads one into thinking that an art can be high and popular at the same time, or that the qualities that make it high and those that make it popular are one and the same.

Decorative art can be high art, and it can be popular art, but not for the same reasons. Folk art[61] and naïve art,[62] for example, can be regarded as both popular and high, but Greenberg does not think that they can actually be experienced as both at once. Culturally understood, they were intended to be popular, but in the light of modernism, which makes one sensitive to their decorative qualities, they can be viewed as high art. That is, in the perspective of the ideal of purity they lose whatever explicit life purpose they had

and acquire the *virtù* of abstractness. They seem to be able to make us the gift of a powerfully dialectical unity.

In the last analysis, Greenberg understands the difference between high decorative art and popular decorative art, between abstract modernist beauty and the beauty of fashionable decor, as emblematic of a tension within the aspiration of abstract art itself. There is a "contradiction between the architectural destination of abstract art and the very, very private atmosphere in which it is produced."[63] This paradox may finally kill abstract painting. "Thus, while the painter's relation to his art has become more private than ever before because of a shrinking appreciation on the public's part, the architectural and, presumably, social location for which he destines his product has become, in inverse ratio, more public." This is another example of the irony that dialectical conversion creates. For Greenberg, there is no way out of the paradox. Even if the public accepts the "architectural destination" of abstract art—as, in fact, it seems to have—and abstract art is grandly displayed on a utopian decorative scale, abstract art, to remain viable, must remain private, i.e., it must remain rooted in private experience. Architecturally generalized, it is in danger of losing its emotional power. In the architectural ambiance, its inner necessity is lost, or at least does not seem so urgent and concentrated. In the public, architectural context that it has itself come to expect, abstract art is in constant danger of becoming facile design, and thereby sentimental. As Greenberg says, modernist abstract art originated in the attempt to "*meet*" a surface rather than to describe it, and in the architectural context abstract art tends to describe the context rather than to resist it.[64]

"The difficulty which besets the abstract painter in so far as he wants to create more than decoration is that of overcoming the inertia into which his picture always risks falling because of its flatness."[65] As noted, it is a serious mistake to suppose that Greenberg wants flatness per se; in fact, in its "unadulterated" state, it is completely inert for him. That is, it does not breathe. Unfortunately, the architectural desti-

nation of abstract art, implicit in the art itself, tends to re-
store the inertia of its flatness, i.e., reduces the work to an
unqualified flatness. The architectural context does this by
making the flatness matter-of-fact—reducing it all too suc-
cessfully to the wall—and thereby making it "literary," i.e.,
the flatness of the abstract work simply illustrates—mechan-
ically refers to—the flatness of the wall. That is, the flatness
can be referred to two mediums, architecture and painting.
Cross-referenced, it loses all modernistic point. Thus, ar-
chitecture emerges as abstract art's greatest threat—one
might almost say, its temptation to suicide. Going public so
obviously, abstract art can easily become kitsch, which "pre-
digests art for the spectator and spares him effort, provid-
ing him with a short cut to the pleasure of art that detours
what is necessarily difficult in genuine art."[66] Abstract art,
which assumes "discontinuity between art and life," can, by
becoming architectural ornament, reveal a less than subtle
continuity between them.

CHAPTER 5

American Abstract Art

The cause of American art, particularly "the probable future of abstract art in this country," is central to Greenberg's thought.[1] American abstract art is the practice that correlates with his theory—the test case that proves the theory's modernist point. In fact, it can be argued that his general vision of modern art—his attempt to articulate its norms, and on this basis to determine the good and bad in it—means to make American art self-conscious enough to transcend its provinciality and sophisticated enough to outdistance modern European art. In a sense, Greenberg has done as much for the development of American abstract art as any artist. Greenberg's importance as a working critic,

87

rather than a philosopher of art—to recall the distinction he made in his review of Berenson—rests on the almost missionary zeal with which he has argued the case for abstraction in American art.

By late 1947 it was clear to Greenberg that "the rising general level of advanced or 'radical' art in this country" was "on the point of becoming a substantial fact." Hand in hand with this rise went "the even more rapidly declining general level of the standard expressionist-impressionist sort of painting," and the recognition that "descriptive art is pretty well finished." In fact, "the growing inferiority of the one serves to make clear the air for the other."² Thus, as might be expected, Greenberg has understood Abstract Expressionism more in terms of abstraction than expressionism. In fact he has argued vigorously, even vehemently, against an expressionistic understanding of it as altogether betraying its artistic purpose and historical role in the development of modern art.³ In any case, his participation in its development was not only intellectual, involving a defense of its assumptions and methods, but personal, especially in the 1960s. He had direct influence on the reductionist direction David Smith's sculpture took,⁴ and on the post-painterly abstraction of such artists as Morris Louis and Jules Olitski.⁵ Abstract Expressionism arose without the help of any one critic, but it is no exaggeration to say that post-painterly abstraction was encouraged, even prompted and named by Greenberg, who was determined to support as completely pure or modernist an art as possible—an abstraction altogether free of expressionist overtones.*

*In the words of Sam Hunter in *American Art of the 20th Century* (New York, 1973, p. 234), Abstract Expressionism gave "primacy to the record of the working process"—"the creative act" itself became the "primary expressive content" of the work of art. In painting this meant that "special importance" was attached "to speed of execution and autographic gestural marks." To articulate these marks, the "technique of dripping and flinging paint on the canvas" was used. In post-painterly abstraction there was the same insistence "that the painting be experienced urgently as a unified action and an immediate, concrete event," but a suppression of gestural marks, an elimination of flung paint. As Hunter says (p. 376), post-paint-

Above all, Greenberg made qualitative distinctions among American abstract artists in an effort to keep the movement as a whole on its toes and with the hope that it would never lose sight of its highest possibilities.

Moreover, Greenberg has always been ready to praise American art in general—something other advocates of modern French art and Cubism have not been quick to do—however much he has been unhappy about many of its products. Whatever he may think of their individual pictures, he likes the mentality—the straightforwardness—of Eakins and Homer, the nineteenth-century American masters of "fact." He thinks this mentality can be renewed in the twentieth century: quintessentially modern, it emerges more intensely and obviously than ever in American abstract art's feeling for the fact or literal reality of the medium. Greenberg views the nineteenth-century feeling for fact, and the sense of vitality and directness this feeling gives, as not only sustained and refined by twentieth-century American abstract art, but as affording it an opportunity to become more "open" and vital than modern European abstraction. The extra energy afforded by the provincial belief in fact became a source of extra sophistication in modernist practice. In general, facts are not simply given for the American, but have a life of their own. For Greenberg, the best American art discovers the life in the seemingly inert fact of the medium.

Eakins and Homer are the American equivalent of Courbet. All three have a feeling for "the physical" that reflects "the conscious and unconscious positivism that informs the bourgeois-industrial ethos."[6] For Greenberg, "positivism or 'materialism'" has been French painting's "center of gravity" since Courbet. Positivist painting involves the pursuit of "immediate sensation" and a correlative "drastic reduction of the associations bound up with the visual act." In other words, it involves an involuntary movement toward abstrac-

erly abstraction involves an "anti-Expressionist reaction . . . based on a new regard for formal ordering, and a classical sense of restraint," which nonetheless "did incorporate the large-scale canvas and something of the heroic spirit" of Abstract Expressionism.

tion. For Greenberg, twentieth-century American abstract art stands in crucial relationship to this movement, for American abstract art came to the rescue or was the last hope, as it were, of an exhausted European abstraction. At a seeming standstill, European abstraction, when it did not institutionalize and popularize itself by becoming mechanical and overdetermined, as it did in the Bauhaus, turned to expressionist-surrealist means to become vital, as in Picasso's case, or became what Greenberg calls a luxury art. American abstraction worked its way out of all three cul-de-sacs.

American abstract art, from Greenberg's point of view, could only develop after European abstraction had become decadent—had failed to revive or to recover its purist ideals after attempting to rationalize, romanticize, or glamorize itself. If abstraction had not developed in any one of these decadent directions, which in a sense firmly established it as a fact of artistic life, its challenge would not have been accepted by American artists. For until the postwar period American art was at cross-purposes with itself, which is perhaps what stifled it except for a few incidental cases. On the one hand, it was determined by provincial respect for and energetic response to fact. On the other hand, it was dominated by a kind of conservative sophistication, which led it to use only established—borrowed—styles. In European abstraction it found both a borrowed style—that it was established was proven by the fact that it had already become decadent—and one that dealt with the "matter of fact" of art. It was a style that was accepted, with whatever difficulty, because it was obviously materialistic and obviously traditional, even though that was a matter of what Harold Rosenberg called, in his book with that title, "the tradition of the new." Thus American art could invest new energy in an old style, which is what it had always been best at doing.

Greenberg, incidentally, acknowledges—without apology—the provincialism of American art. He views provincialism, with its raw energy, as providing advantage as much as, because of its ignorance or mechanical (however felicitous) rendering of known styles, a disadvantage.[7] (In line with this, Greenberg endorses Matthew Arnold's view

that Americans tend to overpraise because of their provincialism.[8] This becomes a general critical principle: if Greenberg does not overpraise, presumably he is not provincial.) In general, Greenberg believes that a provincial art takes its point of departure from what has "already taken safe and calm place in the pantheon of art," rather than struggling to achieve original art.[9] At the same time, simply by reason of the energy with which it appropriates the already acceptable, provincial art, however unwittingly, uncovers new possibilities in the old art, transcends the stereotype of safe art, and takes unexpected and inspired risks, if only because of its awkwardness. The irony of the development of American abstract art is that it totally reworks European abstraction while trying to assimilate it. American abstract art does not simply revitalize European abstraction, but recreates it from the ground up. The provincial's intense response to a known art—all too well known in Europe by the 1940s—fomented an artistic revolution.

Milton Avery and Arshile Gorky

For Greenberg, Milton Avery and Arshile Gorky are early heroes of American abstract art because of their energetic response to European abstraction. They look like assimilators, but they are the vanguard of a revolution: because they are transitional, Greenberg is not always certain which they are. For a long time Greenberg saw only the European Gorky, and doubted his importance for American abstract art. Yet Gorky's abstraction was as American as Avery's. Both loved and learned from European abstraction, and even seemed to copy it without changing it, yet in the end they completely redirected it by making it more materialistic than it ever seemed—than seemed possible. Avery is transitional from Matisse to Still and Rothko, while Gorky leads from Picasso and Miró to Pollock and de Kooning. They confirm the tradition of the new, i.e., by following the new art they made it a tradition. At the same time, they make its modernist principle—its preoccupation with the medium—transparent. Modernism, implicit in

European abstraction, becomes explicit—"open"—in American abstraction. Gorky and Avery work their way from an expressive symbolism, rooted in naturalism, to an expressive modernism still partially obscured by European symbolist and naturalist purpose. They already show a characteristic American note of "eccentric abstraction," to generalize a conception applied to a later art.[10] In Gorky's case the eccentricity is supplied by a "bitter" tone; in Avery's case it tends to be amiable and gentle. In any case, the heavily emotional overtone makes the abstraction personal, almost radically subjective—gives it symbolist or expressionist import. Their art implies a reduction to primitive selfhood correlative with the discovery of primitive nature, and as such prepares the way for modernist reduction to the medium, which in their work is shown to be a kind of primitivism. For Greenberg, this makes their art all too ambiguous, yet archetypically American.[11]

European Aesthetic Hedonism

Greenberg traces one aspect of the degeneration of European abstraction to about 1920, when "the positivism of the School of Paris, which depended in part on the assumption that infinite prospects of technical advance lay ahead of both society and art, lost faith in itself. It began to be suspected that the physical in art was as historically limited as capitalism itself had turned out to be."[12] This basic change in attitude, from optimistic to pessimistic positivism (and capitalism)—Greenberg thought that "Mondrian looked like the handwriting on the wall"—turned the School of Paris toward hedonism. It "began to emphasize the pleasure principle with a new explicitness." That is, it began to fake optimism, using the style of optimistic positivism to create a new, abstract *joie de vivre*.

> The best French painting no longer tried so much to *discover* pleasure as to *provide it.* But whereas the literary Surrealists and the Neo-Romantics, whose pessimism smacked more of cynicism than disillusionment, conceived of pictorial pleasure as piquant illustration, Matisse,

Picasso, Braque and those who followed them located it
mainly in the exhilarating and more physical facts of lus-
cious color, eloquent surfaces and decoratively inflected
design.

They kept their art from becoming crypto-kitsch only be-
cause, unlike Surrealism and Neo-Romanticism, which are
blatantly kitsch for Greenberg, they kept it discontinuous
with life. By insisting on the pleasures provided by the
physical medium, they never directly expressed their pes-
simism. The pure pleasures of pure art alone mattered, an
aesthetic hedonism functioning as a diversion from existen-
tial pessimism. Indeed, the purer the aesthetic pleasure and
the art, the more dubious the pessimism seemed. Existential
pessimism was dialectially converted into aesthetic hedon-
ism: yet the desperate thoroughness of the hedonism sug-
gested the strong current of the pessimism.

For Greenberg, the aesthetic hedonism of French art in
the period between the world wars, for all its "controlled
sensuousness and careful sumptuousness," indicated a dete-
rioration of artistic values: it represented purity gone to
seed. Its unequivocal celebration of art did nothing to al-
leviate this. While all " 'luxury' painting," as Greenberg calls
it, exploits immediate sensation, its mediation of feeling
leaves something to be desired. Luxury art has always been
a kind of defiant, exotic mask on seemingly ingrained pes-
simism, a kind of aestheticizing of despair to escape aware-
ness of its mundane cause. One might even say it is a kind
of comic response to time, comic because it attempts to
outwit what cannot be. As James K. Feibleman says, "the
Renaissance saw the beginning of a new preoccupation: the
problem of time. If the vivid qualities and experienced sen-
sations of this life were real, why did they pass so quickly?
. . . the business of time . . . is to play one vast and continual
prank upon everything actual and finite."[13] The artistic re-
sponse seems to be to intensify the sensations as much as
possible—to make the art so obviously vivid that it seems to
transcend time. Luxury art means to make sensation mem-
orable—a contradiction in terms.

Greenberg is not unaware of this meaning, but for him

the decadence of luxury painting is only indirectly connected with its "sensationalism." That sensationalism affords a pseudo plenitude of presence; authentic plenitude of presence comes of unswerving truth to feeling. Because luxury art vacillates in its truth to feeling—equivocates about existential truth—it implies an "unhappy consciousness." Its power of dialectical conversion is uncertain, and its overripe surface ultimately suggests a diminished emotion. In fact, its voluptuousness seems to force feeling, as if to preclude an emotional vacuum, making luxury painting inadvertently "literary." Feeling is no longer honest and direct, and therefore awkward in effect; elegance of effect now seems to determine feeling—more precisely smooths it. In becoming harmonious, feeling becomes false to its original pessimistic content. The feeling that brought luxury painting into being is betrayed by the virtuosity of the painting itself.

In sum, for Greenberg luxury painting is in bad faith, and a source of false consciousness, because it is not true to its underlying feeling. Greenberg seems to think that since 1920 French painting has generally been luxury painting, becoming increasingly decadent and stifling—after World War II, it no longer even "breathes." French painting's pursuit of pleasure is in effect a last efflorescence of that earlier fullness of feeling it had in Fauvism and especially Cubism, the final blossom of an earlier optimism no longer accurately reflecting the felt facts of life. Luxury painting, in other words, no longer accomplishes art's distillation of true feeling, but manufactures false feeling in the name of a lost ideal, a golden age. What alone redeems it for Greenberg is its feeling for art, its giving its all to art, i.e., its narcissism. In 1947 Greenberg wrote: "Art, which succeeds in being good only when it incorporates the truth about feeling, can now tell the truth about feeling only by turning to the abstract."[14] By 1920 the School of Paris had stopped telling the truth about feeling, and by 1940 abstraction was almost completely bankrupt. It seemed to have nothing new to say, which became all too obvious after World War II.[15] Even the aesthetic well-being it provided

amounted to idolatry of a past. Matisse, Picasso, Braque, even Mondrian, had become traditional for Greenberg, their art a luxury which no longer spoke for real feeling. Indeed, it no longer even spoke for the old ideal of dialectical equilibrium. Luxury painting simply articulated the hedonism of late capitalism, hiding from itself the shocking experience of its own limits.

Abstract Expressionism

It remained for postwar American abstract painting—"the best pictures of Gorky, Gottlieb, Hofmann, Kline, de Kooning, Motherwell, Newman, Pollock, Rothko"—to break through to the truth about feeling, to show that abstract art was still the only way to tell the truth about feeling in a late capitalist world. Only the Americans could produce good art on the basis of open pessimism. American Abstract Expressionism was able to articulate the pessimistic materialism that the School of Paris luxury painting repressed with its aesthetic optimism. Because of its truthfulness, its respect for the facts of feeling, Abstract Expressionism was able to achieve that "plenitude of presence," that freshness which, as Greenberg writes, is not "a newfangled thrill, but something whose equivalent I find in the successful art of the past."[16]

But there is a snake in the paradise of Abstract Expressionism, a lure to bad art almost as strong as the lure to good art. Alongside the good angel of cubist-inspired abstraction, the bad angel of Surrealism and Neo-Romanticism presides at its birth. While Greenberg approves of its "fresher, more open, more immediate surface"—"the surface manages somehow to *breathe*"—he disapproves of Abstract Expressionism's literary tendencies. In fact, for Greenberg Abstract Expressionism brings to a head *the* major conflict of twentieth-century art, that between cubist-inspired modernist abstraction and the neo-representational literary art of Surrealism and Expressionism and their romantic derivatives. It is a conflict between an art respon-

sive to and immersed in the physical medium, and an art essentially if deviously illustrative. The conflict can be traced back to Berenson's "distinction between the illustrative and 'decorative' or non-illustrative," which Greenberg clarifies into the distinction between descriptive and abstract art. This in turn leads to his distinction between charming art and pure art, which can be traced back to Kant's distinction between interested and disinterested art—between an art of involvement, such as Van Gogh's, and an art of detachment, such as Cézanne's.[17] Like Berenson and Kant, Greenberg favors disinterested, abstract, pure art—an art, in fact, which truly realizes the nature of art, expresses its essence free of the accidents of personal and cultural existence. In other words, an art for art' sake. Abstract art does what art is truly supposed to do, viz., transcend life, refine its charge and clarify its purpose—articulate in a pure way its general sense of purpose, free of any particular purpose. As such, abstract art is classic art, for it impersonally fulfills the general purpose of art, while Surrealism and Expressionism are romantic art, in that they give freer rein to personal and cultural factors. Where a classic art deals with these indirectly, through the veil of transcendence, a romantic art means to deal with these as directly as possible, without thereby destroying the art in art, although at times it seems willing to do so.

Greenberg concretizes Berenson's and Kant's conceptual distinctions by giving them perceptual point in a contemporary context of art. Enriched by this contemporary reference, the distinctions organize the development of modern art into a clear pattern of possibilities. In other words, Greenberg makes the distinctions immediate and specific, and shows modern art's philosophical import. His sense of the alternatives open to modern art, and his "bias" in favor of Mediterranean abstraction, have less to do with naïvely enthusiastic partisanship than with philosophical analysis— less to do with personal endorsement of any particular art than with a general sense of what is at stake in art per se. Greenberg's partisanship is always on principle, not for

romantic reasons. That his defense of abstraction is not ar-
bitrary and unreasoned, nor simply a matter of riding a
rising tide, is made clear by his insisting that abstract art is
not the be-all and end-all of art, or the only kind of good
art. Rather, he views it as fulfilling the general end of art
more than any other kind of art existing in the present
period. It is not that abstract art is dialectically necessary, in
some facile reading of history, but that its emergence force-
fully clarifies the essential aesthetic purpose of art, which
tends to be swamped by personal and cultural attention.
For Greenberg, the key distinction is between art's universal
aesthetic potential and its personal and cultural reality. The
latter must be cleared away that the former may be felt. It
was abstract art which renewed this universal aesthetic po-
tential in our day, whatever the personal and cultural con-
ditions of its origination. Whatever charm, signs of worldly
involvement, descriptive innuendos—life references—it has
are incidental to, or at best the launching pad for, its
aesthetic power.[18]

To repeat, Greenberg's criticism can be understood in
terms of his advocacy of cubist-derived abstraction and his
antipathy for Surrealism and Neo-Romanticism (including
Expressionism) or any combination of these two kinds of
modern literary art.[19] At the same time, it must be remem-
bered that Greenberg has asserted that "literature as such
has never yet hurt a work of pictorial art; it is only literary
forcing which does that."[20] Literary forcing attempts to force
feeling; it is what kitsch is all about. For Greenberg, what
complicates the conflict between abstraction and Surrealism
and its derivatives is that American abstract art seems at
times to be simultaneously abstract and to force feeling (i.e.,
to be literary, not simply literature), and as such to come
dangerously close to kitsch. From Greenberg's point of
view, Abstract Expressionism, because of its surrealist-
expressionist overtones, does not seem as completely mod-
ernist as post-painterly abstraction. And what further
complicates the matter is that the surrealist-expressionist
dimension of Abstract Expressionism is a direct conse-

quence of its American character, not simply a European hangover. The "Expressionism" of Abstract Expressionism does justice to American truth to feeling or honesty of feeling, just as the abstraction of Abstract Expressionism does justice to the American feeling for fact. In both cases, the American sense of directness seems to give rise to literary forcing. For to be true to feeling one must present it with as little interference—as innocent of style—as possible, just as to show one's feeling for fact one must plunk it down with no comment, without interpretation. (Greenberg is in this sense, incidentally, very American in his art criticism, with its outspoken feeling and opposition to hermeneutics.) Now the problem is, as Greenberg recognizes, that even for an American art, style is inescapable, so that the ambition to be uncontaminated by style, to be totally sincere—the aspiration to complete honesty and obviousness of intention—makes an art seem either expressionistic, i.e., guilty of forcing feeling, or inert, i.e., all too matter of fact. Style is necessary to sustain strong feeling as much as it is necessary to mediate and control fact; style does not necessarily mean insincerity, compromise, weakening of will. The paradox of Abstract Expressionism is that it seems simultaneously artless, an honest expression of intense feeling, including feeling for the medium, and a sophisticated expansion of the Mediterranean ideal of painterly style.

Greenberg does not try to explain away this aesthetic paradox, but confirms it by showing it to be culturally characteristic. (He tends to do this whenever he is confronted by impurity in aesthetic experience. By tracing the impurity to a cultural source, he prepares for its elimination—for further reduction to purity—both in the developing art and in aesthetic experience.) In the abstraction of the thirties the American revulsion against style as an unnecessary luxury handicapping honest feeling or sincerity is contradicted by American aping of European abstract manner, leading to the development of that kind of elitist derivative culture Emerson rebelled against. In Abstract Expressionism, American sincerity and concreteness—they

correlate—and a European abstract manner finally fuse. Abstract Expressionism is that truly rare thing, a sincere style, i.e., one which is emotionally accessible to all and at the same time aesthetically exhilarating. It is, in a sense, democratic abstract style. It reconciles sincerity and modernism under the auspices of the romantic conception of raw physical nature as a symbol of sincerity, as well as the fundament of experience. Nature's physicality bespeaks modernist intentions, and its universal accessibility, if only through the unconscious (emotionally), bespeaks democratic sincerity. It is the naturalistic reference that Greenberg simultaneously accepts and rejects in Abstract Expressionism—accepts in principle and rejects when it interferes with manner, forcing feeling, romantically evoking literary associations. Greenberg rejects all such literary forcing of abstract art, but he does not deny that the decorative transcendence of Abstract Expressionism originates in a literature about nature, a literature which exists in the name of sincere feeling. That this feeling is pessimistic can be viewed as incidental to its use of nature—considered a place of terrifying metamorphosis or imbalance, whether delicate or monstrous—as a vehicle.

The Role of Expressionism and Surrealism

Let us return to Greenberg's rejection of expressionist-surrealist or romantic methods in art. This rejection is untenable and ultimately unrealistic, or at least inadequately formulated. Greenberg's own belief in the necessity of truth to feeling in the best art contradicts his rejection of romantic intention, which every effort at truth to feeling implies. Without that intention, Abstract Expressionism would never have freed abstract art from luxury painting, making abstraction once again the sign of essential feelings. Without that intention, abstract art easily reduces to a marriage of convenience uniting physical eloquence and sentimentality. Greenberg is not unaware of this point, but he deals with it obliquely. He regards the American desire for di-

rectness and truth about feeling as essential to good art. At the same time, he thinks the romantic way of achieving such truth can be overplayed, leading to emotional extravagance. Romantic excess of feeling is just as dishonest or insincere, because it plays feeling false, as is its repression by luxury art.

Romantic methods tend to become arbitrarily innovative rather than a means of mediating true feeling. Romanticism is always dissatisfied with its methods, and leads true feeling to overstate itself—to express itself arbitrarily—rather than to understand itself in clear artistic terms, submitting to the logic of the medium to make its case. Romanticism does not know how to work through the medium without violating it, and in fact seems to disapprove of any limiting conventions, any fixed rules of procedure. For romanticism, the conventional medium can never adequately convey feeling, for by its very nature that medium tends to inhibit rather than exhibit emotion. Of course, a myth of free expression is operational here, a myth which, for all its naïveté, shrewdly keeps feeling honest and intense. And yet, for Greenberg, unchecked by the myth of modernism, the myth of free expression leads art into visual adventurism—to a sense that there is no fact to resist feeling nor form to contain it. Where classicism speaks for fact and finite form—a kind of reality principle—romanticism speaks for feeling and its seemingly infinite power of transformation of fact and form, a kind of pleasure principle. For Greenberg, Abstract Expressionism is a remarkably happy marriage of both. Its modernism is driven, yet matures emotion.

Thus, as might be expected, Greenberg sees American abstract art in a dialectical way. He thinks that in much of it "the rules laid down by the epigones of cubism are a little too carefully observed. Some of the animation that comes with surrealism is needed."[21] At the same time, abstract art can make an "error . . . in pursuing expressiveness and emotional emphasis beyond the coherence of style."[22] For Greenberg, this error, "made so frequently by Picasso since 1930," has "been established as a canon by the latest gener-

ation of French painters." The error leads "into an aca-
demic trap: emotion is not only expressed, it is illustrated.
That is, it is denoted, instead of being embodied." Green-
berg is talking about Rufino Tamayo, but he is dealing with
a general problem that he felt the emerging American ab-
straction faced.

> Instead of dissolving his emotion into the abstract ele-
> ments of style—which is what the old masters and Dela-
> croix did just as much as the cubists—and renouncing any
> part of feeling that his style cannot order and unify,
> Tamayo, like Picasso in his weaker moments, localizes the
> excess emotion—the emotion that his artistic means is not
> yet large or strong enough to digest—in gestures, the
> grimace on a face, the swelling calf of a leg, in anatomical
> distortions that have no relation to the premises upon
> which the rest of the picture has been built. This amounts
> in the last analysis to an attempt to avoid the problems of
> plastic unity by appealing directly, in a different language
> from that of painting, to the spectator's susceptibility to
> literature, which includes stage effects.

But of course the expressionist artist does not want "artistic
means . . . large or strong enough to digest" excess emo-
tion, for it is just this excess which is his subject matter. He
wants the breath of life, and he does not trust art to give it
to him on its own. Greenberg understands this attitude to
result from involvement in "current events." It is essentially
a "moralizing" response to life—an attempt, through emo-
tional arousal, to influence it. For Greenberg, a true artist
does not want to influence life, at least not directly, but to
distill it into transcendental art. The expressionist artist
does not want such an artistic interpretation of life, giving it
aesthetic validity, but an art which can change life. From
the expressionist point of view, the aesthetic validation of
the life-world, achieved by giving it an abstract style, simply
confirms its givenness, gives the status quo a fresh new sur-
face rather than rips away its skin to sight its depths. "In
the face of current events painting feels, apparently, that it
must be more than itself: it must be epic poetry, it must be

theater, it must be rhetoric, it must be an atomic bomb, it must be the Rights of Man." Such emotional honesty— commitment—is for Greenberg totally ineffective unless it "will fight through to a [stylistic] clarity."[23] Thus he is quick to respond to such artists as Hyman Bloom, whom he thinks are true to feeling. But he is as quick to drop them as not fulfilling their promise when they do not produce an original style. Truth to feeling is a sign of promise, not of fulfillment. Only when direct emotion has become aesthetic exhilaration has it realized its potential, truly shown its significance for art. In general, Greenberg finds American abstract art all too ready to be diverted from classic artistic purpose by romantic deviance—by an emotionalism which tends to become rank because it idolizes excess for its own sake. Thus, whereas in 1947 Abstract Expressionism shows a classic "plenitude of presence," in 1949 Greenberg faults it for an increasing romanticism, a willingness to go off the expressionist deep end.

> An expressionist ingredient is usually present that relates more to German than to French art, and cubist discipline is used as an armature upon which to body forth emotions whose extremes threaten either to pulverize or dissolve plastic structure. The trend is broad and deep enough to embrace artists as divergent in feeling and means as the late Arshile Gorky, Jackson Pollock, Willem de Kooning, David Smith, Theodore Roszak, Adolph Gottlieb, Robert Motherwell, Robert de Niro and Seymour Lipton.[24]

The Modern Baroque

It is necessary to discuss the conflict between pure or abstract decorative style and literary or emotionally oriented style—between style as *the* fact of art and style as a poor vehicle for feeling—in greater detail, for it is central to Greenberg's general way of thinking about art as well as to his analysis of American abstract art. Greenberg's sense of the dialectical relation of feeling to style has been discussed

in the chapter on unity. But his sense of this relationship becomes fully clear only when it is recognized that it is not emotion per se that troubles him, but excess emotion, or "baroque extravagance," as he calls it at one point.[25] He regards such exuberance as inevitable in our age, a direct result of the collapse of a possible "pastoral mood," which, as Greenberg says, "is mistaken for the 'classical.' "[26] The pastoral

> depends on two interdependent attitudes: the first, a dis- satisfaction with the moods prevailing in society's centers of activity; the second, a conviction of the stability of soci- ety in one's own time. One flees to the shepherds from the controversies that agitate the market-place. But this flight—which takes place in art—depends inevitably upon a feeling that the society left behind will continue to pro- tect and provide for the fugitive, no matter what differ- ences he may have with it.

But, continues Greenberg, "this feeling of pastoral security has become increasingly difficult to maintain in the last two decades," and "the dissipation of this sense of security . . . makes the survival of modern avant-garde art problemati- cal." Expressionism, Surrealism, and other neo-romanti- cisms attempt "to relate art to the current crisis," but the problem "is that they stay falsely pastoral in resorting to styles of the past in order to make emotions about the pres- ent plain and explicit." "Such one-time cubists or near- cubists as Picasso and Lipchitz" also rush into the vacuum created by the collapse of pastoral security. Like "surrealism and neo-romanticism, their reaction takes the form of the baroque, but it is a more profoundly disquieted baroque, less archaeological, more at odds with itself, and crowded with disparate elements."

These masters give license to a radical emotional truth- fulness which uses various styles at will—"Lipchitz's [style is] an attempted fusion of Bernini's chiaroscuro with expres- sionism"—for visionary ends. The modern baroque at- tempts to give visionary expression to an apocalyptic emo- tion aroused by disappointment with society. It disguises

society's and art's own insecurity behind a rush of violent, all too evident emotion, which both echoes social and artistic instability and gives a new sense of fullness, in fact, forces fullness, plenitude of presence. Insecure with any style, and insecure with the very idea of style, for art is no longer a refuge from reality for it, baroque modern moves to the edge of visual chaos, bespeaking the emotional chaos that is at its core. In the modern baroque, art no longer "relieves us of the pressure of feeling" but increases it.[27] What especially disturbs Greenberg about the modern baroque is that it makes a mockery of the classic cathartic purpose of art. While "catharsis leaves us no wiser than before" about life, it drains the excess emotion interfering with its harmonious functioning. But the modern baroque tends to drain all emotion, the vital blood that circulates in the complex system of life, thus ultimately robbing us of all our energy, and leaving us more stupid about life. For Greenberg, art "explains to us what we already feel, but it does not do so discursively or rationally; rather, it acts out an explanation in the sense of working on our feelings at a remove sufficient to protect us from the consequences of decisions made by our feelings in response to the work of art." But the new baroque art, because it does not "explain to us what we already feel . . . at a remove," but simply asserts feeling as passionately as possible, undermining all detachment and self-contemplation, cannot "protect us from the consequences of decisions made by our feelings in response to the work of art." On the contrary, it arouses feelings that seem altogether out of control, and as such suggests that the decisions of our feelings, whether in response to the work of art or not, can only have disastrous consequences. Modern baroque suggests that modern life is essentially irrational and that art can do nothing to transcend that irrationality, only flow with it, as it were. By refusing, in effect, to act out an explanation of our irrationality, or by implying that it is so generic that it is impossible to do so, modern baroque gives irrationality full license to wreak havoc on our lives. By giving our own chaos back to

us, modern baroque confirms its rule. It represents disequilibrium, rather than any compensating ideal of equilibrium. Modern baroque thus denies the transcendental function of classic art, which even pastoral art held to. For Greenberg, such denial means the eventual withering of art at the root, and the ultimate inescapability of modern existential insecurity, with its accompanying arbitrariness and sense of life's absurdity.

With the appearance of the modern baroque, an art of uncompromising explosive openness about emotion, the distinction between disinterested and interested art collapses. As has been noted, this Kantian distinction is the source of Greenberg's distinction between pure and expressionistic style. All art, because of the crisis of insecurity gripping our civilization, must become "interested," make itself humanly "responsible" and responsive. Such interested art will be aesthetically judged as a species of "charm," to use Kant's word.[28] Its arbitrary methods and feeling of absurdity—its manic romanticism—qualify the word anew. But its importance to itself rests on the fact that it took an emotional, in effect moral, stand, in an effort to "act" on modern life. Of course for Greenberg art in the first place was never meant to change life, but to make feeling about it bearable. Art, for him, was never a form of moral action—its emotion was never meant to inspire us to renewed worldliness—but of detached reflection.

Thus, for a long time Greenberg thought of Gorky, and many lesser abstract expressionists, as capitalizing on "a surrealistic version of charm."[29] The direct expression of insecurity or anxiety produced a "charming" rather than aesthetically moving image, another example of the irony attendant upon dialectical conversion. Energy—no matter how much a sign of *terribilità*—uncontained by form seemed dissipated, and charming in its dissipation. Nonetheless, the modern baroque persists in attempting to show that art is not only rooted in life, but in spontaneous expression. In contrast to aestheticism, it alone seems to "care," to want the fullness of life, which it assumes is the only source

of—the only significant—fullness. But as Greenberg says, "the truth is too full to be pure," and art is too pure to be as full as the truth about life.[30] Art that attempts to be as full as the truth, in defiance of the limitations of the medium, is no longer art, for it can no longer make a transcendental point by submitting to those limitations. Art can never be fully true to life—although it necessarily keeps an inward connection to it—for it must also be true to the medium, if it is to be true to itself.

Greenberg never forgets that life, and feeling about life, are always larger and fuller than art, and that just as feeling about life is an abstraction from life, so art is an abstraction from feeling about life. At the same time, Greenberg insists that life, and feeling about life, are unmanageable, even incomprehensible, without art. In a sense, the modern baroque, which means to present life and feeling in all their ungovernable incomprehensibility, does away with the need for art, for the madness of life and feeling are irreducible in baroque terms. Greenberg is aware, however, that more is at stake in the modern baroque than a life crisis. It is also a response to an art crisis: it arises at the moment when abstraction seems to have become a convention, a static *fait accompli*. The modern baroque not only lets life rush into art with a roar, but lets art transcend its own obsolete or frozen means. Greenberg is of two minds about the modern baroque. He deplores it as a threat to the essence of art, and he welcomes it as a revitalizing, invigorating factor.

Disassociation of Sensibility

Thus, Greenberg willingly accepts "exhibited emotions"[31] when a known style has become an inert cliché. Baroque emotion ultimately has more to do with the situation of an inert art than it has to do with that of an unstable world. While Greenberg seems to devote himself to the means by which modernism develops, such as the expressionistic use of "pure color as the means to form," he is also aware of

the fact that after a certain amount of use these means lose their point and seem sterile. Their use becomes academic rather than advanced, uninspired rather than aesthetically surprising, monotonously repetitive rather than singular.[32] They lose authority, authenticity, and individuality, and become commonplace and fashionable. When such conventionalization of style is complete, style and feeling diverge; what Greenberg, following T. S. Eliot, calls the "disassociation of sensibility" occurs.[33]* Form comes to seem mechanical and intellectual, even a matter of arbitrary invention, and feeling comes to seem forced, in effect an arbitrary evocation. The work loses organic unity, becoming at best a virtuoso performance. Now the stops of form, now those of feeling, are pulled for all they are worth. The best art, of whatever period, never suffers from disassociation of sensibility. "At the sight of the cubist paintings of Gris, Picasso, and Braque, one wonders how it was ever possible to say that cubism is a dry, 'intellectualized' art without emotion, for these pictures with their brown tones and vibrating planes communicate the pathos of their moment and place with an eloquence more than equal to that of Apollinaire's poetry."[34] It is only when style is regarded as an external, applied technique rather than a subjectively arrived at form that it ceases being a medium for emotion. "The first American modernists," such as Georgia O'Keeffe, "mistook cubism for an applied style," achieving the same slick and tricky results as European "applied" artists, such as Henry Moore.[35] For Greenberg, the only antidote to disassociation of sensibility—the only thing that can restore the unity of form and feeling—is "obviousness of emotion." Expres-

*As conceived by Eliot, the disassociation of sensibility means divergence of thought and feeling. Greenberg regards abstraction as a kind of thought about artistic fundamentals. In its seminal phase, such thought never diverges from life feeling. On the contrary, feeling is articulated with such subtlety that it acquires a credibility beyond all expectation. But when stylistic thinking succumbs to its own conventions—seems no longer capable of transforming them—life feeling separates from it, and becomes either inert or exuberant, i.e., academic or baroque.

sionistic depth is the only antidote to stylistic obviousness—
to flashiness, charm, facility, and all the other attributes a
style acquires when it is arbitrarily applied, when it is ma-
nipulated rather than originated. Writing about Gerhard
Marcks and Wilhelm Lehmbruck, he asserts that

> the obviousness of emotion in German Expressionism is
> not as much a liability as we used to think. Nor is the
> danger of sentimentality as great as it used to be—at least
> not when compared to that of slickness and trickiness. It
> might be well for a change to invoke some "Nordic
> depth" against the flashiness of artists like Marini and the
> Giacometti of the second phase, or the all-American,
> streamlined quaintness of a Ben Shahn.[36]

Thus a kind of paradigm of creativity emerges in Green-
berg, plotting the relationship of form and feeling. The
task of art is to create sensibility, i.e., to associate particular
feeling with particular form so that the latter unmistakably,
persuasively conveys the former. But once created, the style
which articulates the sensibility becomes a look which can
be manipulated independently of it. The style can be used
to create effects alien to the emotion it embodies. It be-
comes purely instrumental, and its original overtone of feel-
ing—or "resonance," as Greenberg calls it at one point—
diminishes, and is finally altogether drained off by the
generalization of the style, making it easy to apply. Forceful
feeling becomes slick sentiment, or is entirely forgotten,
and the style, as well as the sensibility it articulates, becomes
bankrupt. To continue to have "effect," it becomes a stunt,
then a gimmick. For Greenberg, only the direct expression
of emotional depth can renew sensibility, work against the
grotesqueries of decadence. Only raw emotion can make art
"difficult" and "transcendental" again, beyond the reach of
the slickness that creates the illusion of universal accessibil-
ity, the magic trick of good design. When a sensibility is
played false by its followers, when it becomes fashion-
able—emotionally shallow—only fullness of feeling can aes-
thetically surprise, can authentically inspire. For Greenberg,
disassociation of sensibility results in the belief that "art can

get away with anything because there is nothing to tell us what it cannot get away with—and there is nothing to tell us what it cannot get away with because art has, and does, get away with anything."[37] For Greenberg the only thing it cannot get away with is faking depth of feeling. Our own depth of feeling for art discovers the fraud. In general, Greenberg accuses American art after Abstract Expressionism—even, it seems, the post-painterly abstraction he endorses—of arbitrariness, the feeling that anything goes. This feeling, a consequence of the disassociation of sensibility—the divergence of "unviable passion" from the "purity of a style"[38]—is taken as the source of originality, and the point that advanced art makes.* Only depth of feeling stops the feeling that anything goes.

In a sense, the whole enterprise of art is a matter of dialectical proportion for Greenberg. When art gets out of hand, and becomes simultaneously arbitrary and conventional—so that any conventional thing can be taken as art, as in Duchamp's use of the ready-made—art can be itself again only by becoming profoundly emotional. And when emotion gets out of hand, becoming bizarre and excessive, as if to be emotionally intense is enough to make art, as some expressionists think, the modernist assertion of purity restores art to its essential purpose. Greenberg never allows the unmediated extreme—which because it is unmediated appears irrational and gives rise to the arbitrary—to usurp the whole of art. Form without feeling leads to arbitrariness as much as feeling without form. For Greenberg, if art is not dialectical, it is arbitrary, and ultimately chaotic.

For Greenberg, "tautness of feeling," which "characterizes

*When for whatever reason the dialectical conversion of passion into style does not succeed, an aura of arbitrariness results. Willfully arbitrary art is reluctant to make the transformation, remaining perversely and pointedly stuck at its point of origin in life. Greenberg never asks why such art develops (Pop art, e.g.). He never asks after the art-world and life-world conditions that interfere with the transformation of life into art, making it a point of honor among some artists "arbitrarily" to insist on the dominance of life over art in their art.

what is strongest in post-Cubist art"—treading a fine line between luxury art and Bauhaus mechanization of abstraction—serves to remind us of artistic dialectic in decadent, postpastoral, absurd times. Such tautness reverberates through the entire work, signifying a striving for new formal coherence and an effort to control emotion. The discovery of its necessity as an aesthetic transformation of insecurity, making it more bearable, frees us from the tempting decadent idea that form can be arbitrarily created and that emotion is limitless and expendable, lavishly self-renewing. Striving for tautness, which always has an air of desperateness about it, can cause "strain" and "fatigue." It is the source of the unevenness of the post-1920 work of Picasso, Braque, Matisse. But for Greenberg it is the only alternative to decadent slickness and trickiness, facile manipulativeness, the false self-assurance of arbitrary art. Tautness of feeling is the only way that a style which is in danger of becoming felicitous can restore its "moment and place."

From depth of feeling to tautness of feeling—from an economy of abundance to one of scarcity: however much there is of it, as long as feeling is handled with economy, contained by style, art is secure. For Greenberg, Abstract Expressionism, particularly the work of Pollock, represents a renewal of cubist depth of feeling without the loss of style. Pollock's art takes us back from the brink, the edge of emotional emptiness that post-cubist tautness of feeling signaled. This is why Greenberg compares Pollock's art to Cubism, as when he asserts that Pollock's *Gothic* (1944) and *Cathedral* (1947) resemble "Picasso's and Braque's masterpieces of the 1912–15 phase of cubism. There is something of the same encasement in a style that, so to speak, feels for the painter and relieves him of the anguish and awkwardness of invention, leaving his gift free to function almost automatically."[39] It is not simply that, for Greenberg, Cubism is the touchstone by which all new style is measured, but that it was the first modern art to set a standard of honesty to modern feeling. Pollock measured up to that standard as few other artists did, including artists directly associated with Cubism.

Chagall is the case in point for Greenberg. Originally willing to submit his admirable awkwardness—a sign of his emotional honesty—to Cubism's "aesthetic discipline," Chagall came to "emphasize the uniqueness of his personality" at the expense of the discipline.[40] His art is thus not "eligible to take its place in the social order called beauty." For Greenberg, the importance of Pollock is that he did not succumb to his personality, as many post-cubist artists, especially those under surrealist influence, were tempted to do. Greenberg celebrates Pollock as a return to authentic art, despite strong temptations to the inauthentic. Thus Greenberg comes to talk more of Pollock's modernism than his emotion. "As is the case with almost all post-cubist painting of any real originality, it is the tension inherent in the constructed, re-created flatness of the surface that produces the strength of his art."[41] In Pollock's case this meant working "with riskier elements—silhouettes and invented ornamental motifs"—than post-cubist painting was accustomed to. Nonetheless, Pollock was able to "integrate the plane surface with astounding force," a force all the more astounding because it was the result of working with elements that tend to disintegrate the plane surface. It is the reach of Pollock's dialectic that makes him unique for Greenberg, who prefers an art that risks and triumphs over conflict to one that plays it safe with known resolutions. The tensions of such an art make its acceptance difficult. To counter the insecurity that its energy causes, the art is regarded as arbitrary and aesthetically nonsensical. A more obviously resolved, controlled art is preferred to it. In 1967 Greenberg wrote:

> It is only in the very last years, really, that Pollock's achievement has ceased being controversial on the New York scene. Maybe he had "broken the ice," but his all-over paintings continued to be taken for arbitrary, esthetically unintelligible phenomena, while the look of art as identifiable in a painter like de Kooning remained the cherished look. Today Pollock is still seen for the most part as essentially arbitrary, "accidental," but a new generation of artists has arisen that considers this an asset

rather than a liability. By now we have all become aware that the far-out is what has paid off best in avant-garde art in the long run—and what could be further out than the arbitrary?[42]

Arbitrariness

The irony is of course intentional. Pollock is in no way arbitrary, although he seems to carry us to the brink of arbitrariness by reason of the originality of his feeling and style. It is another case of dialectical conversion in action, a new order of art again being mistaken for the arbitrary, the modern form of disorder. For Greenberg the arbitrary, a species of the accidental, is a way of "standardizing as a category," institutionalizing "newness, innovation, originality itself . . . originality for its own sake."[43] It is a way of being original on the cheap, with neither feeling nor stylistic achievement. It is a way of being original without effort, and in modern art *the* inauthentic method of achievement.

For Greenberg the whole issue of arbitrariness, a phenomenon of modern art and life, is absolutely crucial. Without the ability to discriminate between the arbitrary and the achieved, one cannot make the most elementary distinction necessary to modern criticism, that between art and pseudo art. The difference between them tends to be blurred by the modern emphasis on novelty as such. Initially, Greenberg shows what can only be regarded as a certain sympathy for the pursuit of the arbitrary. It originates as another aspect, perhaps the final embodiment, of romantic intention. Thus he traces its artistic origin to Picasso, where it makes its appearance as a means of arousing emotion at the expense of style—excess emotion that deliberately disintegrates style.[44] In a review of William Steig's *The Lonely Ones* he views the resort to the arbitrary as a desperate means of unburdening the heart, and as an articulation of its character in its loneliness.[45] In general, he thinks arbitrariness in art reflects our age's attitude to, even concept of, emotion.[46] It is an expression of hysteria or unchecked

emotion, which is the only way it seems viable to us, or perhaps the only way it can make itself heard in a democratic world.[47] The arbitrary seems a way of outshouting the emotions of others, almost so that one's own emotion can be known to itself. This cultural, existential origin of the arbitrary comes to seem, however, incidental to its conscious use as the basis of creativity. Indeed, according to Greenberg it has been assumed, since Duchamp, that to be arbitrary is to be creative—that it is an achievement to be arbitrary. To be creative means to take a chance for no apparent reason, to risk without expectation of or even interest in results.

> Conscious volition, deliberateness, plays a principal part in avant-gardist art: that is, resorting to ingenuity instead of inspiration, contrivance instead of creation, "fancy" instead of "imagination"; in effect, to the known rather than the unknown. The "new" as known beforehand—the general look of the "new" as made recognizable by the avant-garde past—is what is aimed at, and because known and recognizable, it can be willed.[48]

This development seems inevitable. Invoking the law of dialectical conversion, Greenberg writes:

> Opposites, as we know, have a way of meeting. By being converted into the idea and notion of itself, and established as a fixed category, the avant-garde is turning into its own negation. The exceptional enterprise of artistic innovation, by being converted into an affair of standardized categories, of a set of "looks," is put within reach of uninspired calculation.

Angry at this situation, Greenberg exclaims: "As if genuine originality in art could be envisaged in advance, and could ever be attained by mere dint of willing. As if originality had not always surprised the original artist himself by exceeding his conscious intentions."

For Greenberg, de Kooning, with his "cherished look," signals the standardization of abstract expressionist originality, reducing it to matter of calculation. But de Kooning is

the least of the obstacles American abstract art has to face. De Kooning is essentially a neo-romantic for Greenberg, using accident to make the erotic more "effective" and unfamiliar.[49] His art has not yet succumbed, however, to disassociation of sensibility; it is not self-consciously arbitrary. In general, Greenberg denies that Abstract Expressionism is arbitrary, however much, like any kind of expressionism, it seems to invite one to the arbitrary, i.e., seems to invite the arbitrary release of emotion. Hand in hand with that denial is Greenberg's insistence that "Abstract Expressionism" is "very inaccurate as a covering term" for the art of Pollock and de Kooning.[50]

It was only in the sixties, after Abstract Expressionism, that American art—"Assemblage, Pop, Environment, Op, Kinetic, Erotic, and all the other varieties of Novelty Art"— "set itself as a problem the task of extricating the far-out 'in itself' from the merely odd, the incongruous, and the socially shocking."[51] This sounds like a facile dismissal of what Greenberg found aesthetically irrelevant, not to say incomprehensible and extravagant. His larger point is, however, that after Abstract Expressionism, American art became more a collective than an individual enterprise, more a matter of ideology than of synthesis of form and feeling. It became less something that was worked out than something that was categorically given. Thus, the true meaning of artistic advance was lost. The idea that it meant going far out confirmed the loss. Greenberg mourns the passing not of Abstract Expressionism, but of authentic art values.

For Greenberg, Minimalism perhaps most epitomizes the loss of such values. Reluctantly, he admits that "Minimal Art has brought a certain negative gain," but he suspects "the price may still not be worth it." Minimalism takes an intellectual detour to arrive at "Good Design." It is just because Minimalism "remains too much a feat of ideation, and not enough anything else," that it becomes decorative, in the bad sense of the word, and banal. Worst of all, it lacks feeling: "Its idea remains an idea, something deduced instead of felt and discovered." Its emotionless forms testify

to its disassociation of sensibility. In general, Greenberg's cool response to much post–abstract expressionist art has to do with its inability to "move and affect." It can only "state." Thus, he thinks it flirts with kitsch. In kitsch, what is stated, whether an idea or emotion, is not achieved but received, not worked through but matter-of-factly given. It is simply a "fact of life," which art "communicates." For Greenberg, Pop art is the relatively worst offender in this respect, mediating relatively raw facts of life in a relatively standard style.

The movements Greenberg stigmatizes as far out are in fact, in his own sense of the term, expressionistic. But they exemplify a new kind of expressionism, which he does not fully grasp. It is a matter of the deadpan rather than the baroque, the emotionally stifled rather than the emotionally exuberant. Emotional poverty rather than emotional excess is expressed; the pretense of control rather than visionary release is at stake. For this new expressionism, to repress rather than to express, to constipate rather than to be cathartic, matters—not in a new effort to understate, but rather because there is next to nothing to state. The retentive mode becomes all in this neo-expressionism.

Minimalism seems the most exemplary articulation of this inverse expressionism. Inexpressivity and depersonalization, negative rather than positive emotion—or the renunciation rather than affirmation of emotion—are most characteristic of it aesthetically. One might say that indifference and depersonalization—standardization in general—are typical of American life, so that Minimalism is emotionally honest. This is not, however, acknowledged by Greenberg. He seems to suggest that, if Minimalism and Pop art are typically American—the latter by reason of its programmed or mock expressivity—they are altogether atypical as art, since they do not make more tolerable what they articulate. They do not, in other words, adequately transform and transcend their sources. Greenberg is not about to mistake the depersonalization that accompanies standardization with the detachment that accompanies transcendence. For Greenberg,

neither Minimalism nor Pop art adequately resists or opposes its life source, and so both are nondialectical and not truly high art. He is nevertheless willing to accept a minimalist mode when it seems modernist. Thus, he endorses "Truitt, Caro, Ellsworth Kelly, and Kenneth Noland" for the tautness of feeling they generate from their handling of flatness. But minimalist flatness stands to abstract expressionist flatness as post-cubist Picasso and Braque stand to Cubism. The minimalists are the decadents of American abstract art, much as post-1920s European abstraction was its decadence. Both tend to mechanize abstraction. The minimalists are the American epigones of abstraction. Their flatness does not exactly breathe; it lies there, rippling. Perhaps the most serious fault of Greenberg's overly truncated analysis of 1960s abstraction is that he is not aware that the artists he endorses, however hesitantly, are the mannerist purveyors of a new kind of luxury art. In its own restrained way, post-painterly abstraction expresses a shopworn hedonism.

CHAPTER 6

Taste and the Concept of Criticism

What it means for Greenberg to go "directly to the center of critical gravity, resorting to almost none of the subterfuges of impressionistic appreciation by which most writers on art try to evade the arduous responsibilities of analyzing it,"[1] is shown in "How Art Writing Earns Its Bad Name."[2] Greenberg suggests what ideal art criticism should be by criticizing imperfect critics, very much in the manner of T. S. Eliot in *The Sacred Wood*, only more aggressively. He criticizes in particular two kinds of imperfect critic: those who make "literary" interpretations of works of art (Harold Rosenberg is the case in point), and those who, like Lawrence Alloway and Michel Tapié, see no continuity between

117

traditional and modern art. The second type tends to see modern art as not simply novel and radical in its novelty, but as "extremist," self-consciously "freakish, new-fangled." Both kinds of critic produce a "dramatically modernistic and opaquely profound" criticism, a mystifying, "amphigoric . . . interpretation" of art which altogether ignores aesthetic issues, questions of sensibility. Both are "inveterate futurists, votaries of false dawns, sufferers from the millennial complex," and as such "comedians." They ignore any given art's roots in other art and its effort to be original as art—not as thought, nor for the sake of novelty. In general, Greenberg finds that *"avant-garde* art critics have a special weakness for the opaquely profound": the ostensible point of his article is to blame Alloway, an avant-garde futurist, for keeping alive the ideas of Rosenberg, an avant-garde "profundist," about Pollock's art. Greenberg finds Rosenberg's conception of Abstract Expressionism as action painting not only intellectually lamentable and aesthetically unverifiable, but altogether lacking in the perspective on art which can come only with taste.

Greenberg constantly laments the absence of a "matured . . . body of good taste within the art world that could call to account statements made in public about art."[3] Greenberg in general abides by this 1945 assertion. The poverty of taste "rightly" gives "art writing . . . a bad name," for it gives birth to monstrous "audacities of language and sense," "irresponsible pronouncement." In general, it produces "a compost of exalted prattle," one of many similar phrases hurled by Greenberg at Sidney Janis' *Abstract and Surrealist Art in America*. Greenberg is even more sparing of his praise with art writers than with artists. Kenneth Clark is one of the few writers he admires, for Clark escapes between the Scylla of naïve objectivity and the Charybdis of naïve profundity to "interest in the quality of art."[4] In *Landscape Painting*, not only does the quality of art mean more to Clark than "the data accessory to it," but he is in general "not afflicted . . . with that obsession with 'objectivity' that shuts off so many savants of art from a genuine experience of their subject." For Greenberg, genuine experience of art

is the essence of criticism. It is possible for the critic only when he accepts, as Clark does, "taste as his best guide." Obsession with objectivity, and the use of art as an aid to emotional and intellectual profundity—to an experience of depth outside the experience of the quality of art—are peripheral to an understanding of how "paintings work and why they look the way they do." The good art critic "does not take the *appearance* of a picture for granted," offering "standardized opinions" about it. He does not hide behind information about it, or the personal and ideologicial use to which he is inclined to put it, wittingly or unwittingly. Rather, the true critic avoids such "pusillanimity" and risks judging the picture aesthetically on the basis of his taste. Greenberg hopes, of course, that the taste is good—we will see what that means later. The point is that the exercise of taste, good or bad, gives the only proper experience of the work of art.

For Greenberg both the creation and criticism of art are ultimately a matter of experience. "Art is, of course, a reading of experience,"[5] and "the English have for a long time produced the better art critics" because of "their empiricism."[6] Such empiricism "does not permit" the critic "to overlook for too long the main point of works of art, namely, their aesthetic quality." Such quality is in fact the content of the work of art for Greenberg: "Quality is 'content.' You know that a work of art has content because of its effect. The more direct denotation of effect is 'quality'."[7] For Greenberg, T. S. Eliot's assertion that "a critic must have a very highly developed sense of fact"[8] means that he must have a very highly developed sense of quality, or be sensitive to the work of art's effect.

Taste is the instrument of such sensibility, an instrument to be refined and matured with empirical practice. But its use is never to be taken for granted for Greenberg, although he is concerned to establish a "body of good taste." This can be done by making taste historically, and so ultimately dialectically, self-conscious. Taste's operation, however—its power of aesthetic decision—when one is confronted with the individual work of art ultimately matters for Greenberg, not the work's historical location. On the

whole, "one's critical faculties would appear to function at their best when the subject is something over and done with but still close enough to the present not to be altogether devoid of its original novelty."[9] At that critical moment one is most sensitive to the work: it has not yet taken its place in history, become a part of tradition, and yet it does not seem so unusual as to appear arbitrary. The critic does not want to respond only to its novelty, to be blinded by that novelty to fundamental art values and the facticity of the work. He wants to be surprised by the work, but in response to its aesthetic effect. Novelty is a mystique which obscures quality, and while the work's historical originality and aesthetic originality are not without connection, consciousness of the one tends to undermine consciousness of the other. The work's existence as an aesthetic fact is more important than its existence as a historical fact.

Taste, however, has to change according to the changing historical facts of art. The facts of modern art demand a different sense of quality than in the past. In general, "the area of plausibility to factual, empirical reality . . . has undergone considerable change during the last hundred years and always in the direction of a narrower conception of what constitutes an indisputable fact of experience."[10] In response, "our sensibility has shifted similarly, demanding of aesthetic experience an increasingly literal order of effects and becoming more and more reluctant to admit illusion and fiction." Art's attempt "to register its own proper experience" in modern times, to deal only with "that part of experience which has to do with the making of art itself,"[11] is responsible for the "increasingly literal order of effects" in individual works. For Greenberg, "until about eighty years ago it seemed unable" to make its own making its subject matter. Since then, however, art has done so decisively and irreversibly, and in the process acquired a taut new self-identity, a new standard of integrity.

> Only by reducing themselves to the means by which they attain virtuality as art, to the literal essence of their mediums, and only by avoiding as much as possible

explicit reference to any form of experience not given immediately through their mediums, can the arts communicate that sense of concretely felt, irreducible experience in which our sensibility finds its fundamental certainty.[12]

The quality of modern art is dependent upon its ability to communicate the "literal essence" of its medium. This is the source at once of art's transcendence and its immediacy, art's individuality and its power to remind us, at every step in its perception, of general art values.

For Greenberg, mondernism recasts the history of art. The constancy of the medium becomes self-evident, as does the implication of self-reference—reference to the medium—in every work. Style becomes entirely a matter of the handling of the medium, of making it work emotionally, of making it seem charged beyond itself with a life force. It is the alembic in which life force is focused and concentrated, until it is no longer clear whether the feeling of life force is implicit in the medium or the medium is the "explication" of the feeling. From the point of view of criticism, the importance of the "modernist intention"—one might even say the modernist clarification of fundamental art values—is its function as a kind of Occam's razor, cutting away nonsensical or nonessential approaches to art, viz., any approach which does not pay attention to its medium, its particular way of revealing the medium. Aesthetic experience is premised on the assumption that the most matter-of-fact, general aspect of the work of art can become a revelation in itself, and can be particularized into a revelation of emotion—although, as we will see, Greenberg plays down the emotional effect, which he regards ambivalently.

It is this assumption that leads Greenberg to argue that Titian is "the central and perhaps supreme master of . . . five centuries."[13] "His ability to transform the canvas so completely in the interest of the illusion of mass and volume" makes him simultaneously the modernist par excellence and a master realist. He achieves illusion by "achieving" the medium, in a

rare example of the successful realization of the general dialectic of painting. It can as easily be said that Titian works through the illusion of mass and volume to consciousness of the medium as that he works through consciousness of the medium to the illusion of mass and volume. Titian's feeling for the world of real things is inseparable from his feeling for the reality of the medium.

> The principal factor in this art is color—color modulated according to a scheme of dark and light values such as is deemed best fitted to endow flat colored surfaces with the illusion of volume. Titian's color has a substantiality of texture that makes it hard to conceive that it is the product of thin layers of paint spread on a sheet of canvas; one has the impression of configurations that well up out of infinite real space—as if the reverse as well as the obverse side of the canvas had been transformed by paint. Or as if the very threads of the fabric had been dissolved into pigment so that the picture consisted entirely of paint without a supporting surface. And yet—this is the contradiction essential to the art—the supporting surface that we know to be actually there is not denied its flatness, and we feel this without feeling any the less the illusion that it is not there.

For Greenberg, the critic is expert in the way the work of art "attains virtuality" as art. Titian is truly modernist in attaining virtuality by seeming to deny one element of the medium of painting by powerfully and subtly asserting the other. So masterful is his use of paint that he makes us forget it is on a surface. In practice we experience only the paint, in "theory" we know it must exist on a flat surface. Achievement of such contradiction is the way any given art attains its virtuality. One constituent of the medium seems to work vigorously against another, establishing a dialectical whole, generating a sense of activity within the medium. It seems to breathe, as Greenberg says. The whole effort of art is to create a kind of dialectical imbalance in the medium, making its dialectical constitution clear.

Criticism must register the quality of this dialectical im-

balance, and right it, as it were, by analyzing the way it is achieved. Thus, criticism seems to demythologize the work's plenitude of effect into a function of the tension it establishes in the medium. In a sense, criticism can be understood as a kind of contradiction of aesthetic experience, for it works with a concept of the medium as well as perception of the particular work, always "measuring" the particular work's transformation of the medium against its inherent possibilities. There is a kind of dialectical hermeticism, as it may be called, in critical activity, a hermeticism which intensifies aesthetic experience and may be ultimately responsible for aesthetic exhilaration and surprise. By knowing the cause of the work's effect the critic creates a kind of tension in aesthetic experience beyond that generated by the work's own self-contradiction. That is, knowing the cause of the work's effect in some way contradicts it, makes us less susceptible to it. And yet we become, in critical activity, susceptible to our own act of contradiction, our own dialectical handling of our experience of the work—the imbalance created in our experience by our perception of the work's effect and our knowledge of the cause of this effect, an imbalance not easily righted. The tension generated by the irreconcilability of perceptual and conceptual knowledge of the work is perhaps the *ne plus ultra* of aesthetic experience, the very core of its consciousness and source of its energy.

The logic of modernist criticism is admirable in its consistency of focus, its insistent positivism, the rigor with which it pursues a dialectic of facts. Its dialectical sense of the finite constitution and effect in a simple theory of causal relationship, makes for an admirable clarity about the work of art and the task of criticism. Modernist criticism demonstrates symmetry between material constitution and qualitative effect, symmetry between art and criticism, with none of the romantic asymmetries that impressionistic criticism means to register, however inadequately it in fact does so. Nonetheless, there are still critics who pursue what Greenberg calls a "pseudo-pregnant" criticism.[14] They do not believe that there is a neat relationship, summarized by the

word "taste," between art and criticism, for according to them there is no neatness in the relationship between the material constitution of the work and its qualitative effect. Other culturally and personally determined factors enter into the equation, making a mockery of its easy empiricism. Greenberg tries to get at these other factors—to dismiss them—by characterizing them as the consequence of a conception of art "as a sheer phenomenon" rather than "as quality."[15] Even certain artists who should know better— Picasso and Pollock, for example—came to accept this view, when their sense of quality began to falter. Response to the phenomenon rather than judgments of taste comes to dominate and romanticize criticism.

In fact, we might even speak of two species of criticism, classic and romantic, the one attempting to locate and evaluate the art, the other attempting to celebrate it and the artist's person as mysterious forces of nature, rare natural curiosities, or some such thing. The one sees art as a human invention, to be measured comparatively by human standards; the other sees art as a natural expression, perhaps a miraculous mutation of nature, measureless or cosmic in its significance. Classic criticism wants to understand, romantic criticism wants to wonder and worship.

> To treat an artist as a prodigy of nature whose activity does not brook the weighing, qualifying and comparing proper to criticism is to avoid trying to place his art in relation to other art; it means exalting him as a phenomenon rather than as a master artist. And to refuse to discriminate seriously among his various works and periods is to insure that he remains a phenomenon—one whose work is received not as art, but as something that gets its value from being the product of a phenomenon, or of a personality that happens to be a phenomenon.[16]

For Greenberg, "the critic in particular is required to make himself aware of such judgments and speak of them aloud: it is part of his task and at the same time one of his credentials."[17] Clearly, the romantic critic has a different sense of the source of artistic value than the classic critic. It may be

that the romantic critic cannot tolerate the insecurity, the uncertainty, the lack of finality that the classic critic learns to live with—the constant reassessment of art inherent in the critical enterprise.

Unconscious and Preconscious Effect

But there is another source of romantic criticism, one which has less to do with heroic expectations from the work of art and artist than with recognition of the "unconscious or preconscious effect" that is part of artistic quality. Greenberg acknowledges that such effect "constitutes part of its content," but he neglects to attend to such effect, because it is not objective. That is, it is not a consequence of the material constitution of the work. Then where does it come from? While not part of the "literal order of effects," it is nonetheless an effect of the work, and so part of its quality. The moment Greenberg acknowledges it as an effect of the work it has to be more than a projection on it. It must be as inherent in the material work as the literal order of effects, if not as causally clear. Greenberg's reluctance to deal with such psychological effect shows his desire to free both criticism and art from impressionistic methods. Yet the admitted inadequacy of such methods does not deny the reality of the effect.

One would have thought it easy for Greenberg to deal with the psychological effect of the work of art, even the self-consciously modernist one. He could have reduced it simply to a nuance of the tension generated by the dialectical handling of the medium. It would have been added testimony to the energy generated by such handling—to the authenticity of its results. Psychological effect would become side effect, a sign of the reality of depth of feeling in the work, another indication of its awkward honesty. But Greenberg will never admit that psychological effect is generic to the work, essential to its quality; such effect will always be excess for him, a reminiscence of that excess of realism or excess emotion which undermines the stability of

the work of art, gnaws at style from within. Once again we see Greenberg hesitating when he confronts anything to do with depth of feeling. As we have seen, he admits it into the work of art only in an emergency, when the work is in danger of becoming inert by becoming luxurious. He will never admit of a romantic component to aesthetic experience, for it is a reminder of the way life slips out of control of art, the way life outwits and overcomes art. It is a reminder of the raw emotion that artistic exhilaration means to sublimate.

In general, Greenberg's criticism is pervaded by a Sisyphean sense of art, proposing a height it cannot sustain, converting the raw into the refined and yet still left with a residual rawness. He recognizes that art always seems to fall back to its origins in life. The more we experience art the more charged with life it seems, and the less apparent the art in it is, i.e., the less aesthetic point it seems to have. Even the abstraction in abstract art comes to be devalued as such. It comes to seem simply a veil on a feeling for life, an indirect approach to it, making it more alluring. For Greenberg, modernism is a way of reminding us of the raw artistic datum left after the art in art has been debunked, as it were, by being reduced to its life reference. The modernist conception of art is what is left after spiritual understanding of it, which includes attention to art's psychological effect, has reminded us of its symbolic value and has in general viewed it as a device for "raising consciousness." But spiritual understanding of art altogether ignores the difficulty of materially making it, of creating that kind of quality which permits us in the first place to experience a work of art as powerful—and then to misread that power as a sign of life force, when in fact it is a sign of art force. For Greenberg, whatever the problems of spiritual understanding of art, they are not the problems of criticism, which is concerned only to understand how art is concretely made, and to help it be well made. Art criticism does not need to understand the aspirations of the human spirit, or to understand art as an instrument of that spirit. As is so often

the case with Greenberg, although he shows himself "sympathetic" to the problems of the spiritualists, he ultimately has nothing to offer them, and does not sufficiently understand them.

It may be that Greenberg's sense of the ultimately ineffable character of artistic quality is a way of precluding attention to its psychological effect—an attention that must be abandoned in any case for Greenberg, because of the poor methods for following it through. Nonetheless, the *je ne sais quoi* of aesthetic exhilaration is evasive, not only because it makes the work finally inaccessible and mysterious, while celebrating its value as such, but because it overlooks explanations for the emotional effect of art which demystify it. One is the psychoanalytic explanation, which sees the creation of "effective" style as a subtle process of emotional repression. Emotion "escapes" through form which seems alien to it: it is identified with abstract or "reduced" form, even in illusionistic art. The emotion associated with the illusion is not the same as aesthetically released emotion. Without the transference of emotion from the illusion to the forms that constitute it, there is no aesthetic exhilaration. In a sense it is the artist's task to make these abstract forms concrete to consciousness while making the illusion seem abstract to it. Without this dialectical conversion there is no emotional transference. Greenberg, incidentally, seems to like an art, as his acclaim for Titian indicates, in which illusion is intact but from which abstract form seems to emerge, compounding its charge. In general, emotion expresses itself indirectly through created form rather than directly through reality or its illusion. Thus the form's unconscious or preconscious effect is simultaneous with yet not coincidental with its literal effect. Unconscious or preconscious effect haunts abstract form as much as the "surreal effect" that Hans Hofmann regarded as correlative with its literal effect. At times the two are confused, and it may be this confusion that is responsible for the concept of ineffable quality, ultimately an admission of the inability to disentangle the work of art's effects, or to adequately trace

their causes. Indeed, it is easier to find the cause of literal effect than of psychological effect. The search for the cause of the latter leads to the complexity of the artist's experience, into the privacy of his life. The idea of the ineffable may express frustration at the inability to recover convincingly such emotional sources of artistic effect. In any case, neither the spiritualist idea of the artist as a phenomenon nor the aestheticist idea of ineffable quality adequately—empirically—articulates the sources of art's psychological effect. It may be best to rest content with literal effect, as Greenberg does, for that can be empirically articulated. Beyond acknowledging the general feeling for life that goes into the particular work and the general feeling for art that emerges from it, Greenberg has little that is substantial to say about the role of feeling in art. To deal with it adequately would not only call for an expanded empiricism, but would explode Greenberg's conception of aesthetic experience.

The core of such experience is the discrimination of good and bad art—the judgment of taste, which Greenberg thinks can be objective. "Weighing, qualifying, and comparing" are not spiritual activities. They call attention to the work's objective art value, not its subjective life value. At the same time, taste's activities remind us of art's humble place in life. They preclude "art-adoration," with its astonishing lack of realism about and indulgence toward art. Greenberg surprises one with this dialectical conversion, but his attack on art adoration is as crucial to his view of art's materialism as is his attack on surrealistic and neo-romantic art.

> I am sick of the art-adoration that prevails among cultured people, more in our time than in any other: that art silliness which condones almost any moral or intellectual failing on the artist's part as long as he is or seems a successful artist. It is still justifiable to demand that he be a successful human being before anything else, even if at the cost of his art. As it is, psychopathy has become endemic among artists and writers, in whose company the moral idiot is tolerated as perhaps nowhere else in society.[18]

For Greenberg, "life includes and is more important than art, and it judges things by their consequences." For art adoration, art has no consequences, because it is absolutely autonomous; this is what makes it more important than life. But for life, which uses art as an instrument for its own ends—and, in modern life, regards art as not necessarily the best instrument—art has moral and intellectual consequences, and thus can be judged by life.

Modernism, it seems, takes a conciliatory course. That modernist art has a moral and intellectual dimension is not denied by Greenberg. But this dimension has no practical consequences, for it exists only in a general way. The modernist work reflects the spirit of our positivist age in a straightforward, uncomplicated manner. It has whatever moral attitude and conceptual concerns positivism does. Greenberg's appeal to the *Zeitgeist* becomes a way of acknowledging the life reference of art, but by burying the reference in a general sense of history and by thinking of it in an almost mechanical way he makes it, if not inconsequential, only loosely significant. In fact, Greenberg's revival of the notion of *Zeitgeist* seems, if not impressionable— the one weak moment when he is subject to impressionistic subterfuge—then a calculated appeal to our sense of the kind of general level on which abstract art "reflects" reality. The larger, more fundamental art deals only with the larger, more fundamental reality—deals only in a grand sweeping manner with reality. But this risky appeal to a diluted general reality implies that art is morally and intellectually inactive—that it is passive toward, or does not bear active responsibility for, life. For all of Greenberg's effort to show that abstract art upholds the ideal of unity or subtle equilibrium in an age of unsubtle disequilibrium, he does not deny abstract art's apparent indifference—the moral and intellectual irresponsibility of its appearance. The ideality of its unity can be interpreted romantically: the utopian effect of unity makes the art seem less disinterested than it is. In the last analysis, modernism itself seems a species of art adoration, and as such an argument for art's auton-

omy—an autonomy which implies that art cannot be judged by the standards, moral and intellectual, of life. This makes us think that art is more than it is—for fear that it is less. And it makes us think that art is more than life is—for fear that it is less. Belief in art's autonomy leads us to expect it to be arrogantly irresponsible. Positivism, whether in art or elsewhere, encourages moral neutrality and the reduction of the complex to the simple.

In any case, the autonomous kingdom of art has its own criteria of excellence or greatness, much as life, with its moral and intellectual expectations, has its standards of quality. The two of course were never really comparable for Greenberg. To misapply the spiritual standards of life to the realm of art is a serious error of criticism for him. It is the error of Rosenberg, Alloway, and Tapié, of all pseudo-pregnant, or naïvely cultural or psychological, criticism. Thus, Greenberg insists that

> it is possible to assert—and the assertion has not been effectively refuted so far—that the great masters of the past achieved their art by virtue of combinations of pigment whose real effectiveness was "abstract," and that their greatness is not owed to the spirituality with which they conceived the things they illustrated so much as it is to the success with which they ennobled raw matter to the point where it could function as art.[19]

This approaches Valéry's conception of music "appreciation": "I conclude that the real connoisseur in this art is necessarily he to whom it suggests nothing."[20] As Greenberg says, "art is essentially a matter of means and results, not of means and ends: for no one has ever been able to point out the ends or purposes of art with. . . finality."[21] Connoisseurship is indifferent to ends; it is interested only in the means and especially the sensation of quality that arises from their effective use. Criticism refines and extends connoisseurship, in the sense that criticism not only recognizes and appreciates quality, but articulates the way the means work in detail. Criticism makes us conscious that quality results from conscious artistic decisions about the

means, and is not simply given with them. Criticism can even be said to demythologize connoisseurship. By making it conscious of the source of the seemingly unconscious sensation of quality, criticism precludes any spiritual conception of that quality. Thus, criticism above all insists that artistic quality be understood in materialistic rather than spiritual terms, and that art appreciation means appreciation of the way matter is worked with in art. The spiritual appropriation of art not only masks its materialistic determination, but gives it a finality of purpose which falsifies its historical character. Greenberg's conception of criticism is essentially Marxist in the sense that criticism is at once a demonstration of the material character of art and a denunciation of its ideological masks. The spiritual approach to art, whether psychologically oriented or generally cultural, makes a fetish of the work of art so that its material origins are forgotten.

Spiritualization of Abstract Art

Greenberg believes there are two "historically compelled" reasons for the spiritualization of abstract art, perhaps typified by Meyer Schapiro's conception of abstract expressionist paintings as "spiritual objects," affording "an experience which . . . requires preparation and purity of spirit" and which is an "equivalent of what is regarded as part of religious life."[22] One reason is "the hunt for a set of oecumenical beliefs more substantial than those which society— or religion—now supply."[23] The other is the effort, which "romanticism and all the revivals of religion and religiosity since the eighteenth century" share, "to restore the validity of the data of feeling."[24] Art is supposed to do both: to generate ecumenical belief and to validate feeling. More precisely, art is supposed to preclude "that 'disassociation of sensibility,' that divergence between thought and feeling," which, according to T. S. Eliot, "began to manifest itself in English poetry with Milton."[25] The inherent spirituality of art is supposed to overcome Cartesianism and the "collec-

tive schizophrenia" it creates—as though art could heal what it first disclosed. Art can make thought and feeling converge in experience, not simply in theory. The expectation of this convergence is particularly active in modern times, when the divergence has been endured so long that it seems a decadent luxury, and when the novel kind of unity of the modernist work of art seems to prepare the way for novel unity of experience—that is, for experience that is not a consequence of collective schizophrenia—which by now seems traditional divergence. Such experience cannot be characterized as exclusively intellectual or emotional, as more a matter of mind than of body, or vice versa. In other words, modern art seems to promise a new unity of being.

While at its most expansive—when it "romantically" acknowledges psychological effect as well as investigates literal effect—modernism seems to implement this new unity. It still offers, however, a unity achieved in art, not in life. Modernism is not so expansive in practice, so that this artistic unity is even less than expected. That is to say, modernist art ultimately follows the lead of modern life, in which thought—presumably now more rational than ever—still remains enthroned. Feeling more than ever seems invalid and unobjective, as rampant as it may be. It seems more than ever irrelevant or unjustifiable, in both modern life and modernist —the ultimately modern—art. The more modernist abstract art becomes, the less essential art's traditional role as a mediator and transformer of feeling seems to be, much as the modern rationalization of life by means of science and technology seems to make feeling absurd. In absolutely pure art, feeling would be completely unspecifiable, while the thought of the medium would be not only dominant, but transparent. In general, modernism rationalizes art in the same way that science and technology rationalize life.

> Formally, the disassociation dates from Descartes' claim that the subject receives his surest guarantee of the fact that he exists from the presence of his own thought. Thought becomes the *prima facie* evidence of truth and throws out of court whatever is reported by direct per-

ception or intuition or affect without being manipulated
by the "categories of understanding." The truth is not
what is *felt* but what works and is consistent with itself.
The result is a split in consciousness, between the conative
and the cognitive, the subjective and the objective. In the
end we fall prey to a kind of collective schizophrenia.[26]

Greenberg, while seeming to accept the idea that art *might*
end the split between the subjective and the objective, in fact
reinforces the split by emphasizing the objective in art at the
expense of the subjective that *might* be in it. The surest
guarantee that art exists is the thought of the medium, mak-
ing its presence "categorical" for the subject who makes art his
object. Art must become completely knowable and objective
by concerning itself only with "what works and is consistent
with itself." The medium alone is consistent with itself; as
such it is the objective ground of art. The critic is a connois-
seur of the medium, pointing out its consistent use as proof of
artistic presence. Not inconsistent feeling, which does not
consistently work to guarantee the existence of anything, but
consistent thought about the medium works to make art.
Feeling always goes wrong, because it looks for its own valida-
tion, not the validation of the object it is directed to or the
subject it arises in—further indication that modern art *ought*
to be about the medium, not about validating feeling. Sur-
realism and Neo-Romanticism are the kinds of modern art
that mean to validate feeling and that show it as self-
validating, but for Greenberg they do not clearly emerge as
art because, unlike abstract art, they are not devoted to the
medium. For Greenberg, Surrealism and Neo-Romanticism
at their best take the disassociation of sensibility to the other
side, creating an art that is more a matter of feeling than of
thought about the medium; and Expressionism strives to
create an art of absolute feeling—a consistency of feeling that
guarantees art. He seems unaware of the fact that neither
romantic modern art (Surrealism, Neo-Romanticism, and
Expressionism) nor classic modern art (abstraction) overcome
the modern disassociation of sensibility. Although seemingly
desirous of overcoming it, he does nothing to help reconcile

modern romanticism, which in its pursuit of consistency of feeling undermines consistent handling of the medium, and modern abstraction, which in its pursuit of consistent handling of the medium undermines consistency of feeling. He allows the split between literal effect and unconscious or preconscious effect to become exaggerated to the point of seeming to be absolute and irreversible. His notion of modernist purity seems to assume that the disassociation of sensibility is here to stay.

"The circumstances of our day seem to increase the number" of artists, writes Greenberg, "who cannot feel safe in the practice of their art unless its lack of logical consistency receive the sanction of some all-embracing, extra-aesthetic authority, such an authority as would hold good for more than simply art. This authority is to be found most conveniently in the religious."[27] The religious, using universal, transcendental logic to make the illogical seem logical, seems to reconcile thought and feeling, to make the latter as valid as the former. But for Greenberg the religious does not show this reconciliation but, like kitsch art, simply states it. The religious does not do the difficult work of reconciliation, but presents reconciliation as a *fait accompli*. The religious does not even realize that any mediation is necessary; it presents the unity of thought and feeling as an immediate fact of consciousness and life. But this ignores "the pressure of naturalism with its rules of evidence."[28] The religious really effects nothing; thought and feeling diverge in it as much as they do in art. But for Greenberg art at least can have irony, that "last defense against the disassociation of sensibility," a not very good defense. For in irony thought about the medium no longer guarantees artistic existence, and is not consistent or thorough. Feeling seems to enter, but not with any depth or strength, and dishonestly, half-heartedly. Art is no longer so objectively sure of itself, although it is not altogether unsure. When it has become ironical, in an awkward effort to generate feeling—if not to force together thought about the medium and feeling for life, ending the disassociation of sensibility—art acquires an "unhappy consciousness."

It loses some of its effectiveness as art without gaining depth of feeling. It has lost certainty of its own existence, without gaining certainty about life. Abstraction comes to exist inconsistently or eccentrically, rather than as a sign of intelligence about the medium.

Whatever the problems art faces in its attempt to end the divergence of thought and feeling, it reduces to "the knowable." "We are through with the big words and what they advertise; their aesthetic credit, at least, is exhausted." One big term is "the absolute." Those who think "the knowable, that about which verifiable propositions can be formulated . . . [is] shallow simply because it can be known" think that art is a means of knowing the unknowable, "a means of attaining to experience of the absolute."[29] There is simply no evidence that art is a means of attaining to experience of the absolute, or that art is evidence for existence of the absolute. According to Greenberg, "no thinkers, as distinct from artists and critics," among the latter "the German Romantics and Rilke, George, the Surrealists and such critics as Roland de Renéville," "have ever made or taken this claim as seriously or as literally as some members of the Parisian avant-garde now seem to think—not even Schelling." The desire to attain to experience of the absolute is another ambition of feeling, an ambition which draws attention away from the material reality of art to its hypothetical spiritual possibilities. Of course, it may be an effort to contradict that reality with an exaggeration of the feeling that art might carry, in defiance of the idea that it carries none. The assumption that art is a means of attaining to experience of the absolute may be an awkward attempt to bring thought and feeling together in art, to remind us that the medium can be made to emanate more powerful feeling than is denoted by aesthetic exhilaration. Greenberg does not consider these possibilities, but then again he does not adequately consider the role of feeling in art, nor the existence of feeling as a sign of conation. Feeling is the spark struck on the flint that the medium becomes when it is worked with, but there is no tinder to light a flame.

Taste

For Greenberg, not spiritual feeling but feeling for history is essential to artistic thought as well as to criticism. A feeling for the history of the use of the medium is essential to taste. Such feeling concerns a sense of the way one artist has criticized another's use of the medium, and the progress of such reductionist criticism promotes the articulation of the medium as a phenomenon in itself. Thus the artist as well as the critic needs taste, if art is to develop. Taste is as essential to artistic creation as are paint and surface, for without the critical use of taste there will be no significant use of artistic means. The reciprocity of taste or criticism and creativity is an idea Greenberg borrows from T. S. Eliot, who thinks

> it is fatuous to say that criticism is for the sake of "creation" or creation for the sake of criticism. It is also fatuous to assume that there are ages of criticism and ages of creativeness, as if by plunging ourselves into intellectual darkness we were in better hopes of finding spiritual light. The two directions of sensibility are complementary; and as sensibility is rare, unpopular, and desirable, it is to be expected that the critic and the creative artist should frequently be the same person.[30]

For Greenberg, this translates into the view that "the essence of Modernism lies . . . in the use of the characteristic methods of a discipline to criticize the discipline itself." Modernism is "the intensification, almost the exacerbation, of this self-critical tendency that began with the philosopher Kant."[31] In art, this tendency expresses itself through the critical use of taste—a tautology, since Greenberg considers taste inherently critical.

> The superior artist acquires his ambition from, among other things, the experience of his taste, his own taste. No artist is known—at least not where the evidence is clear enough—to have arrived at important art without having effectively assimilated the best new art of the moment, or moments, just before his own. Only as he grasps the ex-

panded expectations created by this best new art does he become able to surprise and challenge them in his own turn. But his new surprises—his innovations—can never be total, utterly disconcerting; if they were, the expectations of taste would receive no satisfaction at all. To repeat in different words what I've already said: surprise demands a context.

According to the record, new and surprising ways of satisfying in art have always been connected closely with immediately previous ways, no matter how much in opposition to these ways they may look or actually have been. (This holds for Cavallini and Giotto as well as for David and Manet, and for the Pisanos as well as for Picasso as constructor and sculptor.) There have been no great vaults "forward," no innovations out of the blue, no ruptures of continuity in the high art of the past—nor have any such been witnessed in our day. Ups and downs of quality, yes, but no gaps in *stylistic* evolution or nonevolution. (Continuity seems to belong to the human case in general, not just to the artistic one.)[32]

Finally, it is taste that separates the superior artist from the academic one. "The academic artist tends, in the less frequent case, to be one who grasps the expanded expectations of his times, but complies with these too patly. Far more often, however, he is one who is puzzled by them, and who therefore orients his art to expectations formed by an earlier phase of art."

Greenberg's criticism is full of praise and blame for the taste of various artists, for taste is an essential criterion of quality. Because Henry Moore "meets our taste so ideally [he] banishes all real difficulty or surprise." He resembles "Calder, Stuart Davis, Graham Sutherland, and sundry Anglo-Saxons." Like them, he is "the sincere academic modern."[33] In contrast, David Smith and David Hare have "a certain independence of taste," which a critic must also have if he is to appreciate them.[34] Greenberg prefers their "waywardness and muscle-flexing" to "the anemia of good taste." This is true even when "the excess" is due to Surrealism, which is tolerated as a "stimulant" if not "aesthetic

perceptor," so long as it avoids academic sincerity.[35] That is, so long as it is ironical. Similarly, Matisse, "cold, undistracted, and full of arrogant purpose" in his taste is preferable to Bonnard, who "never managed altogether to transcend the taste of the milieu that sold and bought his work, a milieu that as a whole stood aside from the development of modern art after 1910 and refused to assign itself any more important purpose than the refinement of its daily life."[36] Sometimes the superior artist suffers for his advanced taste.

> Newman took a chance and has suffered for it in terms of recognition. Those who so vehemently resent him should be given pause, however, by the very fact that they do. A work of art can make you angry only if it threatens your habits of taste; but if it tries only to take you in, and you recognize that, you react with contempt, not with anger. That a majority of the New York "avant-garde" gave Newman's first show the reception it did throws suspicion on them—and says nothing about the intrinsic value of his art.[37]

And sometimes, as in Ben Nicholson's case, the artist who "tends to academicize his art somewhat by confining it within a style established in its essentials by other artists, and by subjecting it to the primacy of taste—taste over strength, taste over boldness, richness, originality," can still achieve "freshness." For "the felicity of his taste is so intense and is applied to a mode so difficult that it becomes practically equivalent to originality," especially when it is applied "without a trace of . . . inappropriate pretentiousness."[38] In general, however, once the means have been found to expand taste, "to cling to them any longer would mean to depend on taste instead of creating it."[39] Even the creator of a taste must give it up if his art is to continue to remain original.

When art is merely tasteful it is "monotonous," like "Henry Moore's tinted drawings."[40] Worse than merely tasteful art is art, such as that of Francis Bacon, which results from *"inspired* safe taste—taste that's inspired in the

way in which it searches out the most up-to-date of your 'rehearsed responses.' "[41] Worst of all is Pop art, a "diverting" phenomenon, which does not "really challenge taste on more than a superficial level." It "amounts to a new episode in the history of taste, but not to an authentically new episode in the evolution of contemporary art."[42] Also, "a vacuum of taste" can develop, which "comes in opportunely for academic sensibility that wants to mask itself," and affords avant-garde sensibility "the chance to escape not just from strict taste, but from taste as such," producing "most daring and spectacular novelties" in the vacuum.[43] Unfortunately, these novelties "come out so un-new," because in a vacuum of taste "phenomenal and configurational innovation doesn't coincide the way it used to with the genuinely artistic kind." Thus, Pop art and Minimalism are un-new. This is not simply because they work against "the classic avant-garde's emphasis on 'purity' of medium." Such emphasis "is a time-bound one and no more binding on art than any other time-bound emphasis." Thus, "there's nothing necessarily wrong or qualitatively compromising in the juggling of expectations between one medium and another," as Pop art and Minimalism do.[44] Rather, the problem in a vacuum of taste, which amounts to a vacuum of expectations, is a loss of all sense of artistic values. For Pop art and Minimalism, the meaning of taste, the difference between good and bad taste, is no longer clear.

> What's been wrong in the avant-gardist juggling of expectations is that the appeal from one frame of expectations to another has usually been away from the most sophisticated expectations working in one medium to less sophisticated ones operating in some other. It's a lesser pressure of literary taste that the Pop artist appeals to as against a higher pressure of pictorial or sculptural taste; it's a lower pressure of pictorial taste that the Minimalist artist appeals to as against a higher pressure of sculptural taste.

This results in a loss of "surprise," "an essential factor in the satisfaction of more than minimal esthetic expectations," i.e., whenever the highest quality is at stake. The greater

the quality the greater the art's "capacity to move you," and quality "depends on expectation and its satisfaction." However, while art

> moves and satisfies you in a heightened way by surprising expectation ... it does not do so by surprising expectation *in general*; it does what it does best by surprising expectations that are of a certain order. By conforming to these even as it jars them, artistic surprise not only enhances esthetic satisfaction, but also becomes a self-renewing and more or less permanent surprise—as all superior art shows.

The order of expectation that frames surprise—which expresses consciousness of the order and the energy that contradicts it without dissolving it—is historically particular, and subsumes all surprises as instances of its history. Thus, Greenberg dismisses aesthetic surprise when he emphasizes the historical order of stylistic expectation, the continuity of any particular expectation. He denies that there is "anything in the new abstract painting [Abstract Expressionism] that is that new. I can see nothing essential in it that cannot be shown to have evolved out of either Cubism or Impressionism (if we include Fauvism in the latter), just as I cannot see anything essential in Cubism or Impressionism whose development cannot be traced back to the Renaissance."[45] That is, what is at stake in the Western order of "painterly" expectations is the medium of painting itself. Each new style is a critique of the taste of the previous one, a critique of its achievement of painting. There is a community of interest in Western painting which gives order to its expectations and denies that there is anything essentially new in it. Nothing essentially new is expected from Western painting—nothing totally arbitrary can originate in it; only a clarification of what is constant and ultimate can develop in it.

Beyond that, "it is possible to say that all art is successful by virtue of its 'poetry' "[46] just as it is possible to say that all art is successful by virtue of its spirituality. Similarly, it is possible to say that all art, not just Abstract Expressionism,

involves "perilous performance, as if success in the creating of art, whether Fra Angelico's or Pollock's, could possibly not involve the peril of failure. And as if the peril had not been as great for Rembrandt in his 'performance' as for Mondrian or Pollock or Newman in theirs."[47] But all these critical approaches are absurd, for they "say hardly anything about [their] subject which is not equally relevant to Velazquez or Takanobu." For Greenberg, a work of art is successful by its realization of the expectations which exist at any given moment in the history of its order. The critic's job is to understand the order, to recognize the expectations that exist in it on principle and at the contemporary moment, and observe their realization or lack of realization. He must know the history of the order, its possibilities, and the good and bad art produced in its name. Anything else—poetry, spirit, peril—is too general to be of much critical use.

Yet Greenberg himself is guilty of overgeneralizing in his criticism. In fact, insofar as his criticism is partisan—insofar as it advocates open, polyphonic, all-over painting—it depends on his assumption that the use of oil on canvas in general is "open."[48] Presumably this assumption has something to do with oil paint's characteristic as a medium. Nonetheless, it is difficult to specify what "openness" means as Greenberg uses it. Is it a way of characterizing the kind of painterliness produced by equivalent strokes, creating a uniform, "monotonic" surface echoing the canvas's flatness? Does it have to do with some physical property of oil paint that makes it susceptible to such painterly usage? Is it the technical openness of impressionist surface generalized? Greenberg's openness is as vague and ill-defined as Sweeney's poetry, the romantic's spirit, and Rosenberg's risk. It is as universal and inherent in art as they are—or are not. Greenberg's use of openness is as undifferentiated as the more conventional use of poetry, spirit, risk, even though it is a use sanctioned by a presumed property of a kind of matter essential to painting, i.e., the very substance of its medium. Openness, while never clearly denoted, is a desir-

able quality; it comes to connote high quality. But this means that Greenberg has a mechanical conception of quality: it is simply the reflection of a physical characteristic of a medium. Why, one wonders, is the artistic revelation and aesthetic perception of openness such a superior matter? If openness is a literal effect of oil paint in its natural state, how can oil paint fail to be open in its artistic state, so to speak? Greenberg seems to be as vulnerable to "Matthew Arnold's remark on 'a tendency in Americans . . . to overrate and overpraise what is not really superior'" as he thinks other critics are.[49] Greenberg shares the American respect for fact, giving it superior status—although it is not clear that he has his facts about oil paint correct, at least as he formulates them. What really is superior about any kind of matter? Greenberg seems to believe in the old idea that "what is is good," a confusion of being and value encouraged by mystic ontologists. Is he one of them, in his worship of the physical medium? Does he overrate its value for art because of its indisputable presence?

Greenberg is on surer ground in his attempt to establish a standard for value in art when he argues that "high art resumes everything that precedes it, otherwise it is less than high."[50] But he rarely tells us how in fact it does resume everything—e.g., how Abstract Expresssionism resumes Cubism and Impressionism.[51] Perhaps he regards this as the historian's task, not the critic's. The critic recognizes the continuity; the historian, following the critic's lead describes it in detail. The critic recognizes the artist's value, the historian augments it by verifying the facts of the art. The critic, of course, must also know these facts to make his judgment of value, and link it with the order of expectation characteristic of the art. But there is a more crucial difference: the historian thinks a value-free history of art is possible; the critic thinks it is impossible. That is, for the critic we have no sense of what really is historically significant without a sense of quality. And quality is never guaranteed or consistent, but must be renewed. Quality is never settled once and for all, as the historian thinks, but is determined again, for better or worse, by each new work—a determina-

tion which seems to change the quality of existing art. Continuity with the past, then, does not mean mimicry of it, but re-creation of it under contemporary conditions of expectation. Thus, George L. K. Morris argues that Greenberg does not "indicate *in what ways* the works of our losers have declined," but simply "has cited . . . the external events that *account for* a decline already presupposed," as if it was arbitrarily presupposed.[52] In response, Greenberg argues that the losers—they include post-cubist Picasso and Braque, and Arp—are what they are because "they no longer keep on re-creating the styles they work in: they simply work inside them." As he elsewhere states, they "help create and expand the taste that enjoys" them, but make it an "a priori dogma," a "historically necessary" status quo.[53] Morris in effect wants only history, once value is established. Greenberg does not regard value as finally established—as little as he regards the purpose of art as given with any finality. Morris cannot comprehend Greenberg's assumption that the critical task is never over and done with for any artist. Greenberg does in fact indicate the way "the works of our losers have declined," but his sense of the artistic facts involved is determined by his sense of the history of quality in their art. No doubt this is influenced by Greenberg's paradigm of creativity, which presupposes inevitable decline or conventionalization of art. But the point is to spot the paradigm in operation, which the matter-of-fact historian cannot do. The critical knack is to know when an artist has made his early work a tradition, establishing a matter of fact rather than a vital continuity.

Objective Taste

This knack—the sharpness of taste—requires "an elementary grounding in aesthetics."[54] Greenberg's conception of taste is Kantian, and like Kant he believes "the problems of taste boil down to one: namely, whether the verdicts of taste are subjective or objective."[55] To have an elementary grounding in aesthetics means to recognize that "the objectivity of taste . . . is probatively demonstrated in and

through the presence of a consensus *over time*."[56] Subjective
criticism refuses to acknowledge this consensus, or to speak
in the name of a future consensus—which is why it is sub-
jective or impressionistic, i.e., "valid" only for the moment.
A subjective analysis of art—such as Rosenberg's of Abstract
Expressionism—can never ground a consensus, because
from the start it neglects to see the continuity of artistic
tradition, which is the articulation of consensus. The at-
tempt to establish a consensus about an art's quality is an
essential determinant of critical judgment for Greenberg. It
is an attempt to point to enduring continuity, finally to
guarantee quality—sustained and future recognition is that
guarantee, and the critic's vindication. In this respect
Greenberg's criticism differs crucially from that of most of
his peers, who do not expect the quality of present art to be
recognized necessarily in the future. For they assume
changing art values; Greenberg assumes them too, but al-
ways in continuity with those existing. Also, they assume
that the expectation of consensus is an argument for an
elite. The artists that are expected to last are given present
value. The expectation that they will be valuable to the fu-
ture gilds the lily of their careers in the present. In other
words, to judge in the name of a hypothetical consensus—
to make every judgment a hypothesis about future value—
establishes an all too obvious hierarchy. That indeed is
presupposition—presumption.

Greenberg, then, claims to speak in the name of what
Kant called "a *sensus communis*, a sense or faculty that all
human beings exercised similarly in esthetic experience."*
Criticism is ideally an expression of the *sensus communis*; the
critic is its spokesman. Kant "failed to show . . . how this
universal faculty could be invoked to settle disagreements
of taste . . . judgment or appreciation." Greenberg remedies
this by arguing that

*In this context Martin Duberman's idea in *Black Mountain: An
Exploration in Community* (New York, 1974, p. 208) that consensus usually
ends in "bad provincialism" rather than "community" seems an
appropriate caution about the virtues of universality.

consensus makes itself evident in judgments of esthetic value that stand up under the ever-renewed testing of experience. Certain works are singled out in their time or later as excelling, and these works continue to excell: that is, they continue to compel those of us who in time after look, listen, or read hard enough. And there's no explaining this durability—the durability which creates a consensus—except by the fact that taste is ultimately objective.

Moreover, consensus is "not only within a given cultural tradition but also across the differences of cultural tradition." Greenberg argues not just for aesthetic objectivity, but for absolute aesthetic objectivity—not just for consensus, but for absolute consensus. It is no exaggeration to say that for Greenberg the achievement of consensus becomes an increasingly exact science in the hands of the practiced critic. Is such exactness an idealistic illusion as well as a heuristic hypothesis, as Husserl showed it was in the natural sciences? Aesthetic science becomes a matter of the best taste and the best art finding each other—a reciprocity of opposites. "It's the best taste that . . . forms the consensus of taste. The best taste develops under the pressure of the best art and is the taste most subject to that pressure. And the best art, in turn, emerges under the pressure of the best taste."

The best taste, like the best art, seems to transcend history—neither one really waits for history's judgment—because they are completely objective. In the last analysis, taste abolishes history in the very act of using it, for history only confirms taste's "common sense" about universal quality. Because it is culturally unconditioned, the best taste makes a fetish of art. That is, since the best taste is essentially aesthetic common sense, it knows it is right about artistic quality, it knows it will find universal agreement for its judgment, it knows it is infallible. As such, it elevates the art it deals with into a realm of absolute quality, free of historical vicissitudes—a realm of necessity. When Greenberg says it is "wrong on the whole to try to pin the best taste of a given period to specific individuals," since "it works more

like an atmosphere, circulating and making itself felt in the subtle, untraceable ways that belong to an atmosphere," he sounds as if he is describing the condition for fetishism or art adoration—possession by art. As Marx wrote:

> In the mist-enveloped regions of the religious world . . . the productions of the human brain appear as independent beings endowed with life, and entering into relation both with one another and the human race. So it is in the world of commodities with the products of men's hands. This I call the Fetishism which attaches itself to the products of labor, so soon as they are produced as commodities, and which is therefore inseparable from the production of commodities.[57]

Art is a product of human labor which is fetishized by taste, which is inseparable from the production of art. Art apparently can only be "seen" in the religious atmosphere that taste creates for it. Typically, art is fetishized by those who do not produce it, but consume it. One might even say that tasteful fetishization makes art more appetizing than it might be if it was thought of in the context of the grubby work that produced it. (The artist who is too tasteful fetishizes rather than works his means.) Taste removes all signs of labor, conceiving the art pristinely—purely in terms of its quality, which of course depends upon abstracting it from its life-world. It can then be contemplated by the common sense of the elite. "The best taste, cultivated taste," writes Greenberg, "is not something within the reach of the ordinary people or of people without a certain minimum of comfortable leisure." Similarly, the quality of art as conceived by taste is also beyond the reach of working people. Fetishized by taste, art like taste becomes a transcendental privilege, like "the highest fruits in general of civilization, and it doesn't change the nature of those fruits, however much the human cost of them may be deplored, or however clearly it is recognized that art and culture are not supreme values."

I am reminded of Henry James's remark, on his brief return to America from England in 1906: "It is of ex-

treme interest to be reminded that it takes an endless amount of history to make even a little tradition and an endless amount of tradition to make even a little taste, and an endless amount of taste, by the same token, to make even a little tranquility." With James and T. S. Eliot, Greenberg believes that, in Eliot's words, "the emotion of art is impersonal" and that the experience art concentrates, and the "new thing resulting from the concentration . . . finally unite in an atmosphere which is 'tranquil.' "[58] Art "is not a turning loose of emotion, but an escape from emotion; it is not the expression of personality, but an escape from personality. But, of course, only those who have personality and emotion know what it means to want to escape from these things." In general, the artist has "not a 'personality' to express, but a particular medium, which is only a medium and not a personality."[59] Greenberg believes that the critic who uses taste to make objective—impersonal, unemotional—judgments about an artist's use of a medium can escape from his emotion and personality as much as the artist escapes from his by expressing the medium. And much as, for Eliot, "the more perfect the artist, the more completely separate in him will be the man who suffers and the mind which creates,"[60] so for Greenberg the more perfect the critic, the more completely separate in him will be the man who feels and the mind which judges. The disassociation of sensibility, it seems, exists in criticism as well as in art.

Taste is "proof" of mind's transcendental power, however much, like artistic creation, it is "ungovernable" in practice, "reflexive, automatic, immediate, not arrived at in the least through willing or deliberation or reasoning."[61] That is, however much it is like a flash of faith, a spontaneous conversion. The critic's unexpected conversion to consensus, the involuntary revelation which leaves him surprised by his own judgment, involves a " 'sensation' of exalted cognitiveness—exalted because it transcends cognition as such," and because the critic functions "as though . . . for the instant, [he] were in command, by dint of transcendent knowing, of everything that could possibly affect [his] consciousness, or

even [his] existence." In this "state of consciousness, not of a gain to consciousness . . . consciousness revels in the sense of itself (as God revels in the sense of himself, according to some theologians)."[62] Let us not go into the hubris of this. Suffice it to say that the ultimate critical experience of self-certain taste is quasi divine. It is not simply a transcendental experience, but proof of the critic's transcendent being, to use another Kantian distinction. Such apotheosis—the critic as the god he would like to think he is—seems to make the artist his ministering angel, and art a kind of music of the spheres only the critic can hear, a mysterious learning in which he didactically instructs his "consensus." For Greenberg criticism is "an act of intuition" that "stops with itself . . . an end in itself, contains its value in itself and rests in itself." In other words, it is the self-reflexive activity of a god, his narcissistic self-justification. Taste is the mirror the critic holds up to his perfect being, as well as the sign of his "jurisdiction."[63] (It is worth noting that Greenberg uses the language of the law to describe the act of criticism. Thus, taste gives its "verdicts" rather than makes judgments, and the critic is a kind of divinely inspired judge.) It is the divine law of art that speaks through the critic's judgments, which brings order into, even creates the world of art: "Taste, i.e., the exertions of taste, establish artistic order— now as before, now as always." Again: "Things that purport to be art do not function, do not exist, as art until they are experienced through taste. Until then they exist only as empirical phenomena, as aesthetically arbitrary objects or facts." Unless it lives in the atmosphere of taste, art has no being as such. This dialectical epistemology, incidentally, is not without validity in its assumption that the object is not really the "object" unless it is known by the subject. And the more thoroughly or attentively it is known by the subject, the more fully the object reveals its qualities.

The *"qualitative* order" taste establishes is grounded on numerous discriminations, each of which is the instrument of an absolute power of judgment. What this means is that criticism is a kind of last judgment, with any given artist

subject to salvation or damnation, i.e., in an either/or situation. Criticism functions by divine fiat: the artist is either saved by the critic's grace or damned by his power of judgment. In sum, taste functions eschatologically for Greenberg. Thus, although he says he "could cogently qualify [his] admiration for Shakespeare, or for any other great writer, and have infinite room left for praise while seeming to damn beyond redemption,"[64] in practice, when it comes to judging painters and sculptors, not writers, Greenberg operates with a less finely tuned, less cautious sensibility— with fewer *petites perceptions* than he imagines. His dialectic of judgment is less sophisticated and gracious than he gives out, if not inaccurate in many of its judgments, especially in its power to pinpoint the missing quality that keeps an artist from conclusive greatness. In general, Greenberg is too concerned to prove his criticism's power to legislate art to be generous or merciful—which is as it should be. At the same time, such an authoritarian attitude, while it shows strength of character and makes for consistency, can make the critic headstrong and subject to error. Greenberg's treatment of Gorky is a case in point. Greenberg admits that he "once made the mistake of thinking" Gorky "a slave to influences—first Picasso's and Miró's, then Kandinsky's and Matta's."[65] Such admission of error is rare, and sometimes amusing, as when Greenberg admits to errors of perception and memory, showing that even the divine have mortal weaknesses.[66] Usually, however, Greenberg does not admit to fallibility, and is not self-critical, whether in his treatment of general ideas or of particular detail. Instead, he makes his judgments with the aplomb of a deus ex machina dispensing punishment and reward. His taste is a machine lowering him to the stage of art where he resolves the action, settling all affairs. Thus, he is as ready dogmatically to dismiss an artist, finding little of redeeming value—Georgia O'Keeffe is a case in point[67]—as he is to elevate an artist, which he does with David Smith, despite Smith's energy, almost "damnably" baroque.

In either case, one wonders whether the critic's supreme

certainty—the sign of "high" criticism—is honest, or really possible, or does any good. One wonders whether it does not preempt the art it deals with, precluding a fresh vision of it, with all that implies for future criticism. Are there no other possibilities of understanding than those used by divine taste to justify itself? Does not their use intimate an absolute understanding that closes the book on an art? Is any art's quality all of a piece? Greenberg repeatedly says that it is not—his idea of a Shakespeare criticism is his best statement of this—but when he comes down to the wire, in the final judgment, i.e., when he judges in the name of future consensus, he acts as if it is. Also, one wonders whether art or criticism can or must escape from personality and emotion. One wonders whether the purity to which art escapes, and to which, by implication, criticism must aspire, is really of superior quality (not just kind) to the personality and emotion from which they escape. If, as Greenberg says, purity is a tendency, then art as such can never be fully realized; or it is in a permanently self-contradictory situation—always tainted by personality and emotion— which criticism must acknowledge and analyze. From the point of view of these doubts, Greenberg's view *sub specie aeternitatis*, as it finally turns out to be, is not the proper perspective from which to pass judgment on art. For it, after all, is a product of human labor, and is earthbound, whatever its pretensions. Art is inevitably contaminated—as it seems to be, from the viewpoint of an ideal purity—with psychological effect, not to speak of "sociological" effect, which Greenberg barely acknowledges. Its hands are always, so to speak, dirty; and so are those of criticism. This does not mean that one should go to the other extreme, and impressionistically revel in the seemingly nonaesthetic effects of art—rhapsodize about its "reality principle." One must not give up the attempt at objectivity; one must only criticize it for not being sufficiently objective, for having a limited conception of aesthetic objectivity. To expand the aesthetic situation does not mean to lose control of it, or to compromise its specifically aesthetic meaning. To recon-

ceive the aesthetic only means that the critic must become aware that art's transcendence is dialectically more complex than he imagined.

While Greenberg's materialistic modernism, in contrast to the aristocratic manner of his criticism, seems to acknowledge the concreteness, the mundane reality of art, it acknowledges art's concreteness in too literal a way. Modernism does not understand that art's concreteness is culturally intended and as such is always metaphoric. Rothko and Gottlieb acknowledge as much when they speak of their use of flatness not simply to "destroy illusion" but to "reveal truth," not simply modernist truth about the best art—its invariable attention to the conditions of the medium—but the truth about "subject-matter."[68] There is no way in which the making of art with certain material can ever be understood prima facie. The intention, as Greenberg himself called it, which means to triumph over resistant matter originates in the life-world. This makes the art work as much a symbol as a fact; its symbolic character is inherent in its factuality—vice versa?—and as such essentially influential on its aesthetic effect. Greenberg's modernism is a species of naïve realism about art; what is needed is a more complex sense of its intentions, without over-generalizing them so as to lose sight of the individual work. The ultimate question about art may not be about its means, as Greenberg thinks, but about its effect, conceived not as its end, but as its influence on our view of the life-world. As such, art is more consequential than Greenberg imagines. It may escape personality and emotion, but it cannot escape their life-world. Greenberg reduces the question of quality to a matter of artistic self-reference, one in which art mirrors its quality in its own taste. But it is in fact a question of the kind of nourishment that art gives life, the kind of sense it makes in life—the question Greenberg touched when he condemned art adoration. The question of art's life-value does not, as Eliot thinks, "halt at the frontier of metaphysics or mysticism."[69] It is evasive to say it does, as evasive as Greenberg's appeal to the ineffable. The

argument only tautologizes art's transcendental position, hypostatizes its detachment. One wonders how complete that detachment is, and what role alienation plays in its achievement. As Greenberg describes it, art seems to be constantly threatened by the loss of "abstraction." All his talk about excess emotion, excess of realism, romanticism, religion seems a defensive acknowledgment of abstraction's precariousness, which is perhaps why Greenberg thinks it needs "divine taste" to guarantee it. Nonetheless, Greenberg insists on art's essential disinterestedness, which criticism reflects—the necessity of that disinterestedness for the existence of both.

But then he says that criticism must "show something of how" "the thing imaged does somehow, impregnate the effect no matter how indifferent you may be to it," and to show this "with relevance to the quality of the effect."[70] Unfortunately, his criticism does not do this, unless one counts his reference to modern art as a reflection of the positivistic *Zeitgeist*, which is too general to show concretely how the thing imaged impregnates the effect of its image—how the fact determines the quality of the artistic fiction, if not exclusively. Greenberg does not exhaustively examine artistic effect, preferring to define it in narrow aesthetic terms, as if those alone make sense of it as art. Yet why should the definition of art be limited to an aspect of aesthetic effect? Why should aesthetic effect be limited to an aspect of art, viz., art's dialectical articulation of its material medium? Modernism is totally inadequate to the complexity of artistic effect, let alone artistic creation. It sets limits prematurely; it avoids confusion, but its clarity blinds us. And above all, it does not let us understand its own motives—its own need for limiting artistic effect and the meaning of art itself. Modernism, which rationalizes itself as a scientifically empirical aesthetics, is in fact as ultimately absurd and irrational a conception of art, including abstract art, as it implies art is of life.

CHAPTER 7

Critique of the Critic's Critic

Kant wrote that the purpose of a critique "is not to extend knowledge, but only to correct it, and to supply the touchstone of the value or lack of value" of its general principles or "architectonic plan."[1] A critique deals with the principles or plan, not the knowledge. Specifically, a critique calls attention to the way the knowledge contradicts or falls short of the plan it implies. In this final chapter we are interested in the principles of art criticism suggested by Greenberg's knowledgeable practice of it—and the failure of that practice to live up to its own principles. Before demonstrating that failure, which arises from Greenberg's inability to resolve certain contradictions that emerge in the

course of his criticism, it seems necessary to recall that the critique can only be carried out if we accept at face value his assumption that art criticism is a species of knowledge rather than opinion, a matter of reasoning rather than feeling. It presents knowledge of artistic value rather than impressions that surmise but cannot demonstrate that value. If we do not accept this, we cannot assume that Greenberg's criticism necessarily has a plan. But also, if it did not have a plan it would not be a kind of knowledge.

In fact, Greenberg's art criticism is the first serious intellectual attempt by an American art critic to understand artistic value. It was he alone who first attempted to fuse immediate perception of art with intellectual responsibility for it. In general, Greenberg attempts to make art criticism a purposeful act of knowledge. Put on a sound basis, it would never again relapse to the partisanship which always threatens to undermine it from within. Criticism now comes to know art precisely rather than to accompany it poetically— to possess art, not simply to love it platonically. Greenberg has not only offered the most carefully thought out and operational plan of art criticism that exists, but the only contemporary art criticism with a plan to it. As such, his formalism has been a passion that has moved many art critics[2] as well as inspired much art. Eliot writes that in art "the mind digests and transmutes the passions which are its material."[3] In art criticism, the mind digests and transmutes the art which is its passion—transmutes its own passion for art. All future art criticism must digest and transmute Greenberg's formalism to transcend it, to know its plan before planning beyond it.

Like it or not, then, all contemporary art critics must work through his position before they come to their own. Unfortunately, few of them have come to a position as coherent, as consistent, and as responsible to the art as Greenberg's, so that we are still in a sense left with his ideas as a durable foundation for whatever else we wish to think about art and as a reminder that our own thinking must be logical, and logically connected to Greenberg's. What I will

do in this chapter is to point out the limitations of Greenberg's modernism, but not to dismiss it outright. It has many virtues, but it implies more than it delivers, and so it can be measured against its own implications. In the course of his practice of art criticism, as well as in his rationalization of it, Greenberg acknowledges many problems that he cannot handle, escaping them by arguing that they were not meant to be handled by art criticism since they have nothing to do with art's value as art. Yet, although they are supposedly outside of art criticism's purview, Greenberg keeps returning to these problems, suggesting that he is dissatisfied with his own stand on them, and perhaps aware that to dismiss them as nonsense creates even more problems for both practice and theory. The proper beginning is to turn our attention to the ideas about art that Greenberg claims lie outside of art criticism, and yet, as he acknowledges, impinge on it and will not go away.

As a prelude, however, let us locate Greenberg's position historically. It is a final, dense summing up of the cubist aesthetic of planarity as that aesthetic appears in the major works and writings of Braque, Mondrian, and Hans Hofmann, among others—a summing up amounting to a codification, crystallizing a working method into an ideology. This makes Greenberg something of a Francophile when it comes to stylistic matters. In fact, what he seems to advocate as the climax of modern high style—Abstract Expressionism, particularly Pollock's painting—is for him an amalgam of late Impressionism and early Cubism, perhaps with a touch of Surrealism as an intoxicating "stimulant." Thus, Greenberg condemns Kandinsky almost out of hand because of his "bad luck to have had to go through German modernism."[4] There is only one authentic modernism, French modernism, that of "the pictorial logic that guided the Cubist-Cézannian analysis of appearances—a logic that Matisse and every subsequent master of modernist painting has had to understand and come to terms with in order to realize himself." What Matisse understood and Kandinsky did not was Braque's conception of "limited means" as the

"charm and force" of painting. Braque stated that in contrast to "extension," which "leads . . . to decadence," limitation leads to fresh, "primitive" power—to abstraction.[5] In general, for Braque, "limitation of means determines style, engenders new forms, and gives impulse to creation," especially when limitation means absorption in the sheer "material" of art, "because there is as much sensibility in the technique as in the rest of the painting."[6] Cubism was the first art to make the principle of limitation of means explicit, which is why every "new generation" of modern artists has to "go through Cubism," acquire a "Cubist grounding," as the only way of securing the "unity and coherence" necessary for the "realization of . . . urgent vision" in contemporary times.[7] Van Gogh, Soutine, and everyone else Greenberg regards as expressionist— as having an excess of life content at the expense of the medium they are working in—are condemned by him for their lack of cubist grounding. This means they fail to understand the principle of limitation of means. Only the principle of limitation of means can produce form, the essence of art—life is already given, however hard it may be to determine its essence, while art can never be taken for granted as given. It must always be won from life, and the principle of limitation is the means of doing so. The principle guarantees art its own essence.

In a sense, the expressionists think they know the essence of life, viz., feeling. They regard art as no more than a means to mediate it, rather than as something in itself. The medium, whatever it is, must be made to express life-feeling, even if that means ignoring its formal possibilities. For Greenberg, the "urgent vision" of life that the expressionists mean to offer can never be adequately realized because of their indifference to, if not outright rejection of, the principle of limitation of means. They assume the principle of limitation of means to be irreconcilable with their ideal of excess—extension—of life. One might say that for the expressionists the principle by which art is advanced is in conflict with the principle by which life is advanced, with only a Pyrrhic victory possible. For the expressionists art

serves life; life is not subservient to art. Limitation seems an absurd way to abundance: life must have an abundance of means, use all kinds of artistry, to express its own. In fact, the expressionists seem to suggest that if there is no variety of "artistic" means to realize life, it will never flower.

Whereas for Greenberg the tension that develops from trying to express by limited means a feeling that originates from intense and abundant experience of life makes for great art, the expressionist assumes it leads to stifled life. Also, Greenberg insists on an ultimate unity of limited means in a unique style as the end of art. For the expressionist, such stylistic unity or integrity ultimately abolishes any traces of life, or at least leaves us with such attenuated traces that they seem nonsensical, and are easily misread. They certainly cannot be read as signs of abundant and strong feeling for life. Greenberg himself is aware that a completely unified style appears as an energyless equilibrium, the result of manipulation of conventionalized means. This is why he insists on a modicum of feeling, never completely digested by style—never assimilated into unity—to give style vitality or life-meaning. That is, Greenberg insists on a dialectical conception of style, however limited its means, to prevent it from becoming inert. "Dialectical" is his definition of expressionist: dialectic is controlled or tamed expressionism.

There is no doubt that Greenberg's advocacy of limitation of means was once salutary. For it came at a time when American art seemed mired in life, obsessed with life-meanings, and beginning to force them, i.e., becoming literary. (For Greenberg the literary stands to literature as the stylized stands to style. Both produce felicities which do not resist intention, whether the artist's or the spectator's. They especially do not resist the strong intention toward art of the critic, the ideal spectator or appreciator.) Modernism restored the rights of art, arguing in effect that life's right to expression interferes with art's right to exist. Modernism also gave criticism a new, "post-impressionistic" sense of purpose. Criticism was no longer literary, i.e., the transla-

tion of art into life. Such a translation destroyed the art it mediates, for the "life" in the art had to be forced from it, leaving behind only a ruin of anonymous formal means. Criticism was no longer the unwitting enemy of art values by reason of reading them as symbols of life, thereby transmuting art into literature, the seemingly universal medium—the medium of life. In Susan Sontag's words, modernism made criticism erotic or descriptive rather than hermeneutic or interpretative.[8] Whether systematic or impressionistic—conscious or unselfconscious—from the modernist point of view hermeneutics falsifies artistic experience, which depends upon attention to the literal effects of the work of art and their literal cause in the work.

Of course, hermeneutics, in its revitalized conception by Hans-Georg Gadamer, is more than "the art of clarifying and mediating by our own effort of interpretation what is said by persons we encounter in the tradition"[9] of thought about a subject—which is what I am doing with Greenberg. It also involves, as Gadamer says, the assumption that "being that can be understood is language," which is not a "metaphysical assertion" but "describes, from the medium of understanding, the unrestricted scope possessed by the hermeneutical perspective." The being of art, if it can be understood, whether by modernist or other methods, is a language, and as such a symbol, i.e., in a certain relationship to life. As Gadamer says, "in the last analysis, Goethe's statement 'Everything is a symbol' is the most comprehensive formulation of the hermeneutical idea. It means that everything points to another thing." It is hard to see how art can be said not to point to another thing, or how if this pointing is acknowledged it can be ignored in the determination of art value and the quality of individual works, or in any description of art. In any case, whatever its shortsightedness as a critical method, with its ideal of, in Susan Sontag's words, an "erotics of art," modernism became important to American artists as one, somewhat precious, means of access to abstraction, with its principles of limitation of means.

Greenberg's criticism is also important because of its philosophical, specifically dialectical, orientation. His idea of dialectical conversion is an application of dialectical principle, and, one might note, while rare in modern criticism, not unique to him. Ortega y Gasset has observed that "an artistic form, on reaching its maximum, is likely to topple over into its opposite."[10] There is no critic, however, who has made such wide application of the dialectical idea, and used it so concretely to analyze art and its situation. This use ranges from Greenberg's view of the general meaning of artistic reduction and self-limitation to his analysis of the way a particular piece of art works. For Greenberg, the general development of art and the quality of particular works are dialectically determined. Taste is exemplary of dialectic in its attempt to reconcile a historical understanding of art with an understanding of generic art values. Finally, Greenberg's positivism or materialism is unwittingly dialectical: his respect for fact repeatedly leads him into a discussion of feeling, which is at once a negation of fact and a reconciliation with it.

In making criticism philosophical—in showing that art works in a philosophical way and has philosophically important results—Greenberg means to make the critic more than a reporter of and publicist for art. He is determined that criticism transcend journalism. Criticism must not treat art as a "phenomenon" or as sensational news valued only because it is momentarily momentous. The reviewer, not the critic, is responsible for media hype and for the exaggeration—or exaggerated deflation—of artistic claims. The critic does not generate false expectations with hyperbole. Philosophical criticism is never cavalier in its judgments but is always ready to be called to account.

For Greenberg, the journalistic approach often goes hand in hand with the literary approach, which forces ideas or feelings on art and regards art itself as no more than a means of forcefully presenting them. Harold Rosenberg, for Greenberg, is *the* example of the literary journalist, and Rosenberg's existential conception of Abstract Expression-

ism is *the* case in point of literary journalism. Existentialism and Abstract Expressionism were news at the same time, and what Rosenberg did by forcing them together was to make bigger news, and to become news himself. In general, Greenberg believes that the literary journalist is indifferent to quality. Quality is not self-evident for the literary journalist, and even if it were it would not justify the work of art. Not even the most extended investigation of the quality of a work of art could prove its worth. For the literary journalist, its value is entirely a matter of the way it is grounded in life—entirely a matter of its intention toward life. For the literary journalist, artistic quality is comprehended and justified by the way it points to the quality of life. The situation is more complex for the philosophical critic. "Where the genuine artist," Greenberg writes, "starts from a personal, particular experience, the journalist-novelist starts from a general, public one, whose automatic cogency relieves him of the necessity of making it cogent by means of art."[11] The genuine critic—the philosophical critic—starts from a personal, particular experience of art. He makes it cogent by demonstrating how the art is actually made, not what it might possibly mean. Its life-meaning will emerge from this analysis as the final revelation that makes clear its general, public meaning. The work of art is never automatically cogent, either as a constructed object or as an intended meaning. The one must be demonstrated, and then, contingent on that demonstration, the other must be demonstrated, and at every point the analysis depends upon particulars personally observed and philosophically reconstructed. Only at the end of the entire process can it be said whether the art is newsworthy and important to life—but this initiates a third level of analysis.

The literary journalist assumes art's automatic cogency to life in general. Correlative with this, he assumes its automatic public significance. His criticism is an elaboration of this significance, which supposedly validates the art. But for Greenberg the literary journalist's activity can be understood as a form of "etiquette." That is, it deals with the

manners and morals of the art—its public presentability. The art is given some form of cognitive respectability. In some cases, this is the same as notoriety: the art seems to fill the horizon. Rosenberg made Abstract Expressionism, and especially de Kooning, notorious by analyzing them in terms of the most intellectually respectable—at least in the prevailing climate of public opinion—ideas of the day. This raised the abstract expressionists to a prominence they could not otherwise have expected if they had been dealt with simply as art, even if they were recognized as exceptional in the history of art. The strategy of the literary journalist is to raise the art to heroic status by not attending to the tradition out of which it emerges. Instead, the art is balanced on the shoulders of the leading intellectual novelty of the day. This both distorts its artistic importance and its life-meaning. Its reputation comes to seem out of all proportion to what these prove to be. In response, the philosophical critic dialectically qualifies the art in terms of other art and other ideas than those in which it is immediately understood. The work thereby loses some of its consensus—the easily convinced attention the literary journalist appeals to. At the same time, the art is put in a position to have its staying power tested. Its ability to carry both artistic meaning and life-meaning is subject to the test of time. This test, while it seems to make the immediate work recede, reveals its depths, and ultimately leads to its renewal. With every rebirth, it seems either more fresh—or stale—than ever. For the philosophical critic, there is no way its presence at the moment of its making can ever be separated from its future presence.

What the critic can do in the present is deal with what is empirically resolvable. All other problems are pseudo problems from this point of view. Criticism becomes modernist because only modernist terms—those dealing with the making of the art—deal with its empirical reality. Any other terms—they are automatically understood as interpretative—are fanciful and fallacious. They are condemned for the same reason the new criticism condemns investigations of the artist's intention, viz., the results can never be ver-

ified. Terms that interpret the work in poetic or spiritual or some inconceivably more generalized intention presuppose the existence of something that can never be made as manifest as the work itself. Even the artist's proclaimed personal intention can never be related altogether successfully to his material art. Poetic or spiritual interpretation presupposes a final life cause for art in general, while interpretation of intention presupposes an efficient life cause for the particular work. Literary journalism uses such methods habitually—methods which assume a ready understanding of the place of art in life. Greenberg has no such understanding, and so he is reduced to methods which understand art only in its own terms. He is interested only in the material cause of art, not in its immaterial significance. For Greenberg, to attempt to understand art in terms of life—or life in terms of art—is sheer folly born of the dominance of feeling over thinking. Feeling, frustrated by the facts of life as much as those of art, turns attention away from facts to meanings that seem independent of them. Facts are displaced by more manageable ultimate meanings. This makes a mystery—of both art and life—where there is none. Feeling creates obscurity altogether inimical to the critical, enlightened spirit. For Greenberg, the source of art's—and life's—profundity is in the emotional expectations of their observer, not in their mysterious nature.

Greenberg appears to use T. S. Eliot's criticism as a touchstone. It is at once a working method and a philosophical theory for him. Criticism requires, Greenberg writes, "a very sharp sense of [the] order of fact"—such as "is familiar to Eliot"—if it is to have "unfailing loyalty to the relevant."

> If the powers of criticism increase in proportion to its capacity to distinguish fact, then it is understandable why the high age of positivism should have produced the greatest literary critic. The pragmatic, empirical temper of the period 1900–25—common to its best thinking and affecting epistemologists and aesthetes alike—is precisely

what helped develop in Eliot that keen eye for fact by
which he has been able to discriminate the essential from
the non-essential in literary experience. Scientific method
is of no application in the forming of aesthetic judgment,
but it can guide us in the elimination of all that is ex-
traneous to it. Obeying the spirit, we can become very
faithful in differentiating between what actually happens
and what is fancied to happen.[12]

Guided by scientific method, Greenberg forces himself to
be pragmatic and empirical, and attempts to distinguish the
essential facts of art from nonessential speculation about it.
He differentiates what actually happens in art from what is
fancied to happen. Differentiating the essential from the
nonessential in contemporary art production by applying to
it the temper of 1900–1925 art, Greenberg in effect de-
clares himself the greatest art critic. The irony, of course, is
that he approaches the new American art with the temper
of the old European art—assuming that he has correctly
understood that temper, in all its complexity, and not re-
duced it, for the sake of a persuasive clarity, to one of its
factors. Presumably the new American art and the old
European art are both "modern," and the best in them is
modernist. But they still diverge, and not just because, in
another easy formulation, the one is pessimistic and the
other optimistic. This divergence means that Greenberg's
understanding of the value of the one in terms of the value
of the other is necessarily "off" and defective. His
positivism, after all, does not let him see why the new is
new, if not phenomenal, at least not in the journalistic
sense. Greenberg does not for a moment imagine that his
methods may be inadequate to the new American art and
may be unable to grasp its special contribution.

In any case, as if to assure us of his greatness, Greenberg,
like Eliot, "lays down the law": "The man of superior sensi-
bility and intelligence, having discovered new and valid
truth in such an atmosphere of obfuscation as was English
literary opinion between 1900 and 1930, has to lay down

the law."[13] Similarly, a man of superior sensibility and intelligence, like Greenberg, having discovered new and valid truth in such an atmosphere of obfuscation as was American art opinion in the first half of this century, has to lay down the law. He lays down the law in "How Art Writing Earns Its Bad Name," and especially in his dogmatic rewrite of the articles which became the canonical essays of *Art and Culture*. He laid down the law of abstraction at a time when literary illusionism was the preferred means and the rule of taste and when the approved criticism was impressionistically interpretative.

It is absurd to argue about Greenberg's "greatness." There is no doubt that he is important—that he marks a major change in critical expectations. He puts American art criticism on a new footing simply by expecting it to be factual and analytic. One can argue, however, about his value for American art. The picture he gives of it is distorted by his antiromanticism and his reluctance to recognize romantic influences in what he regards as classic abstraction. His dialectic is hesitant when it comes to reconciliation of the two great opposites, just as it is hesitant when confronted by a critical temper other than its own. One doubts that an empirical, pragmatic temper suffices to make a critic, let alone a great one. It seems impossible to forego a romantic admixture, if only because the effect of art is never exclusively literal. Also, one needs some sense of art as a spiritual or poetic phenomenon—a sense of its numinous presence —if only as a corrective to the empirical, pragmatic temper. For that temper also has its excesses: it fosters its own kind of obfuscation, or blindness to quality. Like the poetic, speculative temper it means to replace, the empirical, pragmatic temper makes a fetish of art. Only where the romantic temper fetishizes its effect into spirit, the classic temper fetishizes its facticity into literalness. Where the one exploits art's aura, the other denies it. Moreover, the empirical, pragmatic temper overgeneralizes as much as the speculative, poetic temper. Greenberg's assumption of a

constant modernist premise in the best art—as though that alone made it best—from Manet to the present is a case in point. His exclusively positivist explanation seems to betray the richness of effect in the art, and to vulgarize its existence. Indeed, the positivism is so shopworn it seems to demote rather than promote the art, obscure rather than reveal its significance. Greenberg is as guilty of vulgar positivism as he is of vulgar Marxism.

But the whole question of the source of greatness in art, and in criticism, changes its character when art and criticism are viewed in the context of the modern world. Greatness becomes an ambiguous, almost meaningless idea. Arp has written: "I don't want to be *great*—there are too many forces throughout the world today that are *great*." Commenting on this, George L. K. Morris writes: "This was not spoken in modesty; it merely represents a new relation between the artist and his work; we do not need that competition for omnipotence which the critics are so intent upon grading, only an impulse that can achieve distinction and sensibility in a fragment.¹⁴ Greenberg is probably the critic Morris has in mind, but the key point is that Morris' conception of the modern work of art as a fragment with some distinction and sensibility shows the pathos of its situation, and of the criticism that must deal with it. Neither the art nor the criticism can be complete, because both lack that largeness of outlook, which carries with it the power to transform the world, that we find elsewhere in the modern world. One of the great forces Arp might have mentioned is science, whose relationship to the world makes clear how limited and alienated that of art—and art criticism—is. Art can only be a fragment, for its power over content—over the world—seems meek and inconclusive in comparison to that of science. Both art and art criticism are rather romantic in the context of science, which is perhaps why they take it on as a protective coloring—why they declare themselves to be exclusively empirical and materialist. In fact, their very presence, fragmentary as it necessarily is, is a rebellion

against empiricism and materialism, a striving for unex-
pected effect in experience, effect that cannot be altogether
reduced to a material origin, but is generated in and part
of the complexity of the situation of response to art. For all
of Greenberg's efforts to show the essentially pragmatic
character of that response, the intensity of his own attrac-
tion to art—an attraction which, on his own terms, has to be
gratuitous—belies that pragmatism. One at times feels that
Greenberg is forcing himself to study the literal effect of
art to the exclusion of any other kind, to deliberately put
on blinders to its wider, more complex effect (one might
speak of this as an empirical forcing of fact, on a par with
the literary forcing of feeling) in order to avoid dealing
with his own larger spontaneity of purpose. How he can so
surely separate literal from psychological effect, tease the
one away from the other, is beyond me, except when I un-
derstand it as a desire to repress his spontaneous love of
art, for fear that it will lead to art adoration.

"Bad criticism," Eliot writes, "is nothing but an expression
of emotion."[15] Bad art, Greenberg argues, cultivates
psychological effect. The positivist campaign against emo-
tion that Eliot and Greenberg carry out seems to be an ex-
tension of Comte's campaign against the religious and the
metaphysical. For Comte they are immature conceptions of
reality, adding to it an "excess"—divinity and absolute prin-
ciples of being—that we do not need to comprehend reality.
Both give reality a finality of purpose—or "fictional final-
ity," in Alfred Adler's words—that falsifies its functioning,
and amounts to a protective layer of emotion around its
facticity. This layer permits the knower to feel comfortable
with the reality he knows. His feeling for reality, expressed
in religious and metaphysical terms, amounts to a kind of
sympathetic magic: reality is assumed to feel for him as
much as he feels for it. There is an exact parallel in Eliot
and Greenberg. The spiritual and poetic conceptions of art
falsify it and are rooted in emotion. They express the crit-
ic's love for art, and his feeling of harmony of purpose with
it. But they are an excess which interferes with our com-

prehension of its facts. They are immature in that they
do not understand that the reality of art can stand on its
own; it does not need human emotion to make sense of it.

Art itself, Greenberg seems to suggest, like science, went
through a religious phase and a metaphysical one and has
now arrived at a positivist phase. It has at last become ma-
ture: an assertion of fact, and an acknowledgment that
fact is physical. Art is now explicit—abstraction is the form
this openness takes—about what has always been implicit
in it. Art has become good because it is open, self-
conscious about its nature, and thus freshly articulate.
Criticism has also become good, for it has also become
positivist. It rejects the emotional, "decorative" approach to
art, which attempts to make its physical reality less vulgar,
and in general hopes to enter into a gracious relationship
with it. From the positivist point of view, religious or
metaphysical—spiritual or poetic—ornamentation of mate-
rial reality is more vulgar than the facts could ever be.
While Greenberg denies that "because he [Greenberg] has
seen 'purity' and 'reduction' as part of the immanent logic
of modernist art, he . . . believes in and advocates 'purity'
and 'reduction,' "[16] the fact is that without the positivist
spirit that they symbolize, both art and criticism would re-
gress and become expressions of emotion. Art would once
again attempt to make "magic," and would reinforce re-
ligious and metaphysical conceptions of reality. And criti-
cism would once again think of itself as a magical act of
worship, the final sanctification of art, crowning it with the
glory of self-consciousness. Reduction to purity demythol-
ogizes—de-emotionalizes—art and criticism, for it is in es-
sence reduction to fact. Reduction to purity is an aesthetic
fundamentalism—an asceticism scouring art and criticism
clean of emotional purpose and the encrusting conceptions
such purpose gives rise to. Poetic and spiritual conceptions
of art ultimately do in the art they mean to illuminate and
the critical purpose in which they originated. They render
both art and criticism inert. Only fact breathes, and makes
consciousness breathe.

But the separation of emotion from fact, psychological effect from literal effect, poetic and spiritual conceptions of art from the material analysis of it, not only reaffirms the modern disassociation of sensibility, but makes it law. What Whitehead calls the bifurcation of nature is established as a fact of nature—here the nature of art. One aspect of art and mode of analysis of it are labeled irrelevant—indeed, their relevance is openly suppressed. Greenberg has convinced us that poetic and spiritual conceptions of art do not do justice to its psychological effect, let alone help us understand its emotional source. But it is absurd to deny the importance of the psychological effect and emotional source of art because theory is inadequate to them. Moreover, Greenberg himself suggests a way beyond traditional crude comprehension or misreading of them. When first defining art he spoke of it as the triumph of intention over resistant matter. Clearly, intention is a more apt description of the source of art than emotion—intention subsumes emotion—and it is intention that makes itself felt in psychological effect. The psychological effect, or more generally, the expressive aura, of art is the residue of intention, a sign of the way it has worked.

Psychological or expressive effect is really intentional effect. Perhaps the only modern theory that has adequately dealt with it is the phenomenological theory of intentionality. Intentionality is as crucial to the virtuality of art as its facticity: art is constituted by both intention and resistant matter—intention which overcomes the resistance of matter. Greenberg's theory of art is unbalanced. While acknowledging intention and the expressive aura which is its sign he attends only to resistant matter and stylized matter, i.e., raw matter and artistically formed matter—matter before and after artistic intention has triumphed over it. It may be that intention is like the unconscious in that it can be read only through its signs rather than directly, and it may be that a greater sensitivity is needed to read these signs—to detect the expressive aura of art—than to read art's manifest material reality. But the importance of intention should not

be underestimated because it is latent, and the importance of material should not be overestimated because it is manifest. Greenberg, however, ignores artistic intention not because he means to deny its existence, but because he does not have the general ideas to deal with it. And yet to ignore artistic intention is inevitably to misconceive art and to be misled in the determination of artistic quality. The effects that constitute quality are reduced to the facts that constitute art, with no corresponding effort to "reduce" the artistic facts—which after all are not given the way facts of nature are—to their determination. Greenberg's truncated conception of artistic intention does no good either for an understanding of style or for an understanding of art's relationship to the life-world from which it emerges.

Greenberg might have used Kant more than he did. For Kant, art implies "purposiveness without purpose" or pure purpose[17]—that is, a general sense or unconditioned sense of intention, or intention with no empirical end. The sense of purpose that art suggests is part of its quality, and registers as expressive effect. Greenberg ignores Kant's notion of artistic aura because he views art only in terms of what Kant calls the " 'pure' ... simple mode of sensation." So obsessed is Greenberg with the pure, simple mode of sensation that he becomes insensitive to artistic aura, or incapable of registering it except in the most minimal—simple— way. He refuses to transcend sensation, rejecting more complex modes of response and comprehension—modes which lead to the recognition that, as Kant says, the work of art is derived "from a will." This makes the work of art as impure as it is pure, as much a matter of intention as of the medium. The will is no doubt more difficult to read than the medium, but this does not make it any the less pertinent—aesthetically pertinent, for will, like matter, is aesthetically transposed in the work of art.

Unfortunately, will is automatically associated with what Kant calls "interest" for Greenberg, and interest "spoils" both art and taste. Interest, overgeneralized into emotion by Greenberg (and Eliot), makes art and taste barbaric—no

longer disinterested. As Kant says: "That taste is always barbaric which needs a mixture of *charms* and *emotions* in order that there may be satisfaction, and still more so if it makes these the measure of its assent."[18] For Kant, barbaric taste confuses "empirical satisfaction" with aesthetic satisfaction, i.e., "the matter of satisfaction ... for the form."[19] Greenberg accepts this, but ignores the fact that for Kant the form of aesthetic satisfaction is in part constituted by recognition of the "purposiveness without purpose"—the aura of intention—that the work of art suggests. The aura of pure intention is evoked by the form of the work of art; Kant implies that to be civilized, taste must be sensitive to the aura. Greenberg is sensitive to it, but he seems reluctant to acknowledge that it can vary in quality. He is reluctant to analyze the aura in even the most general terms. This is because he assumes that to delve into it in depth is to be drowned in its indefinite depths—to be tempted by depth of feeling, with its concomitant theories of the spirituality or poetry of art. That is, to do anything more than point to art's aura of pure intention is to be overcome by the emotion or "interest" it transmutes. Why should analysis of art's aura of pure intention make us emotionally regress to empirical interest when modernist analysis of art does not make us do so?

For Kant, emotion is "a sensation in which pleasantness is produced by means of a momentary checking and a consequent more powerful outflow of the vital force."[20] Greenberg does not seem to understand that the emotion aroused by the work of art is one with emotion in general, except for the fact that it is an artistic form rather than a life-content that momentarily checks the vital force of the individual. That vital force expresses itself in and through will, and the work of art is a deliberate attempt to work on will, rather than leave it subject to what might accidentally check it in life. Indeed, in life it can be checked to the point of extinction, in art only to give it a swifter current. Form is a controlled checking of the life force to vitalize its flow. Greenberg can hardly acknowledge the influence form is

meant to have because he is so absorbed in its presence. This influence is vaguely characterized as aesthetic exhilaration, which is officiously self-conscious but reduces to the local color added to consciousness of form. It is the making of form Greenberg is interested in, and its literal effect is a reading of this making, while aesthetic exhilaration is the exclamation point at the end of the reading—"proof" that simple and therefore seemingly literal description can be vital.

In a sense, Greenberg's position as a working critic—his concern to determine the cause of the work of art's effect—prevents him from taking full account of its effect. Giving effect only a cursory reading, he dismembers it into what can be conveniently and inconveniently handled—into literal effect and emotional effect. He ignores the latter while overgeneralizing or totalizing the former. A subtler attention to the work of art's emotional effect would have precluded conversion of its literal effect into a sign of its self-sameness or hermetic harmony. Modernism amounts to a magic belief in the work of art's perfection of being, which draws attention away from the inevitability of its life-effect. Life cannot be perfected, but it can be intensified, even renewed, by art. If Greenberg was more of a philosopher of art than he thinks he is, he would have transcended the unfortunate consequences of being a working critic more than he has. He might still have mythologized his aesthetic satisfaction into divine exhilaration, and used it to give authority to his analysis of form, but he would not have made that analysis so rigidly materialistic. He would have studied his exhilaration more thoroughly, observing as precisely as possible how it affected him. That too, critically reconstructed, would have been a guide to the quality of the art.

Whitehead writes that "matter-of-fact is an abstraction, arrived at by confining thought to purely formal relations which then masquerade as the final reality."[21] There is no better analysis of what Greenberg's formalism does. Modernism reduces the work of art to matter-of-fact by analyz-

ing it strictly in terms of its formal relations, and then re-
garding them as the final reality of the work. While Green-
berg acknowledges that the purpose of art can never be
stated with finality, he seems to think its reality can be
completely described. He does not realize that finality in
any context is, in Kant's words, a transcendental illusion.
To believe that one's investigation leads one to final reality
is as absurd—and emotionally satisfying—as to believe that
it leads one to final purpose. What is excluded from the
final reality achieved by reduction is as much a part of the
reality of the work of art as what is included as basic to it.
The idea that the work of art is material in the last analysis
is as patently absurd—and yet no doubt affords as much
emotional security—as the idea that in the last analysis the
work of art is spiritual or poetic.

Whitehead also writes that "an abstraction is nothing else
than the omission of part of the truth. The abstraction is
well-founded when the conclusions drawn from it are not vi-
tiated by the omitted truth."[22] Unfortunately, the conclusions
about the "essential" nature of the work of art drawn from the
doctrine of modernism and from Greenberg's experience of
abstract art are vitiated by the omitted truth about art, i.e.,
that it is intentional, and as such is charged beyond its literal
effect, "effective" beyond its material and formal reality. In
fact, its material and form are the "instruments" of its inten-
tion. Modernism cannot be regarded as well founded, and
Greenberg's experience of abstract art can be understood to
falsify it. Greenberg creates a false consciousness in which we
are easily reconciled with abstract art, while it is not easily rec-
onciled with life. The disruptive effect of Abstract Expres-
sionism on emotion is altogether ignored: better Rosenberg's
awkward articulation of the emotional conflict and ambiguity
that "action painting" signifies than Greenberg's complete in-
difference to that ambiguity and simple-minded reading of
conflict as "energy." Indeed, Greenberg seems to prefer
post-painterly abstraction, with its relatively facile harmony
and quickly soothing effect, an easy unity of feeling to match
an easy unity of means.

In sum, the truth that art originates in intention—perhaps even in a tradition of intention, codified as spiritual or poetic—is acknowledged as a general truth by Greenberg, but is openly omitted by him from his investigations of particular kinds of art. The failure to bring a theory of general intention together with an empirical analysis of particular intentions is a major shortcoming of Greenberg's criticism. The failure to reconcile general and particular—to concretize the one and clarify the other—is a sign of both theoretical and empirical inadequacy. In Greenberg's case, it is all the more a failure because he explicitly states that he means to be a philosopher of art as well as a working critic—to be theoretically as well as empirically adequate. He shows once again that a failure in theory means a failure in practice. Greenberg means to generalize the ideas that arise in the course of his criticism of any given art in such a way that they can be returned to the criticism to clarify the art. He does not do this with the idea of intention. He does not seem to be aware that he thereby violates his own philosophical purpose. One whole part of the map of his criticism is incomplete, although marked as terra incognita.

In conclusion, I would like to take one final fling at Greenberg, focusing upon the point where he thinks he is impregnable but is in fact vulnerable: in his perception or "intuition" of particular works of art and artists. Here his practice as a working critic is most open to inspection. And here his taste reveals itself as secretly prejudiced or, as Kant might have put it, unwittingly barbaric. That is, interested rather than disinterested, emotional rather than objective, impure rather than pure. The facts of the art are obscured if not completely ignored, by being reported in terms of an emotionally charged rhetoric of cuisine. This rhetoric seems to confirm preconceptions rather than to convey freshness or vitality of perception. If what I say is correct, modernism was a kind of scholasticism from the start. The energy it

gives to perception by clearing away archaic conceptions of art and the responsibility it gives to statements about art by making them verifiable by direct observation are undermined by the inflexibility with which it is believed. This allows only for certain kinds of perceptions and certain kinds of statements. The rhetoric of cuisine is designed to disguise this narrowing of the field, to sweeten the absoluteness of viewpoint. At the same time, it leads to a kind of excess of emotion—one might even say an excess of realism about the nature of the art world, which expects partisan judgments. Greenberg's partisanship is conveyed indirectly, almost poetically, through the inconsistent use of an erratically rhetorical, value-laden language, which nonetheless has a pattern to it. In a sense, Greenberg's lapses into partisanship, into efforts to force his case rather than argue it on principle, temporary as they are, implicitly acknowledge the limits of his modernist principles. It is as if he becomes metaphorically overwrought—at times allows metaphoric excess in his language—whenever he is faced with the psychological effect his theory does not account for, and does not want to attend to. Metaphor becomes a way of exploring intention without giving it undue importance. Greenberg's rhetoric of cuisine reduces expressivity to a quirk of art.

For Greenberg, taste in operation is a matter of savoring artistic "cuisine." From his point of view, this is all the more easy to do with modern art than with traditional art, for modern art is explicitly positivist or physical while traditional art is literary, or at least has the model of literature. As Greenberg says, the "essence" of modern art lies "in the immediate sensation," in an ultimately luxurious experience of "luscious color, rich surfaces, decoratively inflected design."[23] Thus, modern art seems made to be literally tasted, offering as it presumably does the choicest sensations of the physical. That is, the flourishing of the physical in modern art seems a direct appeal to a taste that thinks of itself in all but literal terms. The modern critic has a taste for the physical in art on the order of a gourmet's taste for rare food.

He has a taste for the facts of art arranged in the most "sensational" stylistic manner possible, given these facts as the necessary ingredients of a certain kind of artistic meal.

For Greenberg, the best dishes have been served by French art. Like many gourmets, he thinks French cuisine offers the best taste sensations.

> To paint "French" is to use color and paint-surface as positive structural elements of the picture rather than as mere reinforcements of its design . . . the full and harmonious exploitation of the physical or sensuous properties of pigment—the properties of the medium, that is, as distinct from the resources of the tradition. The picture is to be a delectable object as well as a statement, with color as a major factor, color as a principle of design and not merely its accentuation. . . . French painting, with its cuisine, is related to Venetian.[24]

Of course there are other cuisines—the Florentine, for example, as Greenberg notes. But to be "definitely a first-rate painter" one must be "a master of the mechanics and cuisine" of French painting.[25] This does not guarantee that one will be "a first-rate artist," meaning one who has urgent and original vision, who makes an important statement. Rather, it means that one will have mastered one's craft. Indeed, good cuisine is a sign of superior craft: full control of one's medium, without any romantic or emotional expectations from it. Bad cuisine—generally expressionistic for Greenberg—indicates that one has not understood the basic craft of one's art.

But the issue is more complicated, for a master of good cuisine can be trapped by his craft, can be reduced to nothing but serving up tasty morsels to a public already predisposed to his art, or with a fixed taste for it. "But much as Bonnard's audience delighted in the purely culinary pleasures of painting, it did not want him to provide more than was asked for." This is not the worst fate for an artist, and certainly not for his connoisseur: "Still, there is enough to feed one's eyes on."[26] But catering to a taste for "fine" art is not all that matters in art, for the history of taste is

not the same as the history of art. Nonetheless, an artist can make art history by persisting at his craft in pursuit of cuisine. Thus, says Greenberg,

> by 1915 . . . his [Bonnard's] painting blossomed into big, boldly cut-out pictures that resemble screens or panels more than easel-paintings but are too hot in color to stay in place as mere decoration.
>
> It is to this last phase that Bonnard owes his present renown among those who profess to know and like painting for painting's sheer sake—for the poetry of the immediate vision, of cuisine, paint texture, manual sensitivity. And it is precisely this concentration on his stuff, on juice and matter, that seems to have led Bonnard to paint more and more abstractly: the greater the attention to pigment and brushstroke the less becomes the concern with the original data of the subject in nature.[27]

Greenberg believes that the artist who is "contemptuous of *cuisine* and eager for quick effects," and who mistakes the two,[28] does so at the peril of his place in history. He may win an immediate but not permanent consensus. He may seem "smart," but he will not last. To endure, he must learn cuisine, learn the sensations his medium can give. He must learn cuisine even if it means going against the grain of his natural talent, stepping out of his natural emotional element. "In the twenties Chagall set himself to assimilating French cuisine and suavity with the obsessiveness of a clumsy and sentimental man learning to dance."[29]

Let us examine some specimens of Greenberg's rhetoric of cuisine. "The green marsh mist and incandescent gases that dapple his canvases are distilled quite knowingly from the best materials, and designed to satisfy the most discriminatingly modern appetites. In my opinion this is the very last word in kitsch."[30] Tamer than this colorful attack on Darrel Austin's work is Greenberg's recognition of the "brown sauce" of both academic and primitive nineteenth-century American painting.[31] But when it comes to cuisine Greenberg is more given to praise or blame—partisan recognition—than neutral recognition. Thus, he notes that

Tchelitchew's "latest oils with their shrill saccharine color and gelatinous symbolism set a new high in vulgarity."[32] In the same vein, he wittily describes color in early Chirico (1911–17) as "stale Florentine sugar,"[33] and writes of Masson's "fermented-sweet decoration"[34] and Eugene Berman's way of "freshening up everything with Böcklin syrup," finally deriding Berman as a "simple specialist in *frissons* for the cocktail hour."[35] Clearly Greenberg has no sweet tooth, although sweetness in art is redeemable:

> The interest in his [William Dean Fausett's] case lies in the fact that his landscapes, remaining as they do within conventions stale by now—the sweet, smooth surface, the seductive tones, the equally sweet glazes—give valid pleasure nevertheless. . . . This very particular emotion about a particular thing is enough by itself to transform the conventionality of his style and to make some of his landscapes works of art.[36]

Greenberg also finds hot, spicy art distasteful. He obviously does not like the extremes of taste. He has a classically temperate taste which prefers art which suggests or is subtly flavored by the extremes, but does not move toward either one. "Rattner should not let himself be over-tempted by the succulence of paint; he should relinquish some of the richness and ripeness, the hot vitreous color, and the attempt to synthesize Rouault, stained glass and its leading, cubism and Picasso."[37] Similarly, Masson's painting is "turgid, over-heated, and discordant," its "energy . . . dissipated in all directions."[38] Greenberg does, however, trust smoke signals, for where there's smoke there's fire: "The only optimism in his [Pollock's] smoky, turbulent painting comes from his own manifest faith in the efficacy, for him personally, of art."[39] This, incidentally, written in response to Pollock's second one-man show at Art of This Century (1945), shows Greenberg's taste for a personal energy over and beyond that necessary to master craft and cuisine. For it is the artist's personal energy which stamps his work with its peculiar individual taste. Despite his admiration for Pollock's fiery

art, however, the cuisine Greenberg most prefers is cool, offering a taste neither sweet nor hot but rather like a *mot juste*. Thus, he likes "the bright, silky color by which Gauguin most particularly proves himself a genius,"[40] and "Boudin's 'gray' style . . . [in which occur] audaciously juxtaposed touches of gray ranging from soot to pearl."[41] He has a taste for a subtle look which, at its best becomes "musical": "Two landscapes . . . one a river scene with boats by Salomon van Ruysdael, the other a view of Arnhem by Jan van Goyen . . . achieve the perfection of this type of design—framed on gradations of dark and light against which delicate, restrained color beats an obbligato as subtle as any in music itself."[42]

Irreconcilably antithetical to this crisp, subtly clear look —a look which results from mastery of passionate or "colorful" materials—is the muddy look. This look must not be mistaken for that of "pâté": "The dexterity of Kalf's brush and the richness and juice of his *pâté* overcome the eye's resentment at the absence of decorative design."[43] For Greenberg, the accusation of muddiness is particularly bad blame. Muddiness is the ultimate ineptitude, an indication that the artist has muffed his chance at sublime physical harmony. Muddiness is chaos disguised; it has the makings of unity, but only a crude version of one. Muddiness is "the result of the crowding of tones or their insensitive juxtaposition just at the points where the design is most concentrated, [and] ruins otherwise well-fashioned canvases."[44] Kuniyoski fails where Bonnard succeeds: Bonnard risks muddiness, by his use of numerous complex colors, but avoids it, in one of the great triumphs of cuisine, by harmonizing them. "Warm colors, crimsons, oranges, pinks, yellows, mauves, acid viridians, and emeralds in off shades, all these are crowded close to one another—sometimes at dangerously close intervals that threaten to turn the effect into mud. And yet it is one of the tensions and dramatic virtues of Bonnard's art that such bright, hot colors should come close to mud."[45] In general, "bakers of mud pies"[46] are the worst artists for Greenberg, whether they are paint-

ers with no sense of cuisine or artists who impatiently and prematurely jump to vision.

American artists are most susceptible to muddiness: "But the fact that the hues of the American scene are not held to be as soft and harmonious as those of the European is no excuse for coarse brushwork and muddy color."[47] Muddiness is a result of American provinciality:

> Aside from the ineptness and natural lacks of most of the exhibitors [in the Pyramid group of artists], what is most distressing is a general backwardness, an expressionist constriction that no amount of self-assertive violence can break through. The effect is one of dun monotony.
>
> I wish to complain specifically about the color—the muddy, the gray, the blear, the garish, the pallid. Why do these painters, even though they use fresh pigment, insist on harmonies that convert it into mud? Why are they unable to achieve positive tones? Is it because they are timid, provincial, uncultured? They are all that, and more.[48]

But it is better to be muddy than to be empty. It is important to have substance, in whatever clumsy form: "Where their American equivalents tend to mud or garishness, French painters tend, apparently, to confetti and neon lights. If the Americans seem stodgy and dull, the liveliness and knowingness of the French are empty."[49] (This was written in 1947, in an examination of postwar French painting, in which Greenberg acknowledges that American painting has become more authentically or vitally Mediterranean than French painting.) One might note that sogginesss is next to muddiness in sin: "The distorted but expressive drawing of 'The Potato-Eaters' and its soggy color are the result in part, I feel sure, of the pathological pressure of feeling as well as of the resistance of a medium in which the artist was not yet at home."[50] That is, Van Gogh had not yet, in 1885, mastered the cuisine of painting; for Greenberg, he never did, even when he became consciously impressionist and frankly colorful.

In general, muddiness and sogginess are signs, presumably not always pathological—although almost always, even in Pollock—that an artist has not mastered his medium. He is

not at home with its cuisine: he has not understood the de-
lectable dishes he might serve up. In any case, neither mud-
diness nor sogginess, nor for that matter sweetness and
warmth, are qualities Greenberg values, for they imply emo-
tional excess—uncontrollable emotion. Greenberg's use of
the qualitative terms of cuisine is itself inherently emotional;
they are not unequivocally descriptive terms. It is impossible
to say that they are accurate, only that they are evocative.
They show an impressionistic side to Greenberg which
suggests a certain negligence, or relaxation of principle. Of
course, one can argue that the rhetoric of cuisine is a kind of
perceptual shorthand, but it is hard to say what intuitions it
abbreviates. Moreover, the kind of quality Greenberg's lan-
guage denotes he himself regards as ineffable and barely
able to be connoted. The one thing that his rhetoric does
clearly connote is judgment of value—and the rhetoric itself
is often the only justification for the judgment. The circular-
ity of this is admirably poetic, but contradicts Greenberg's
own concept of criticism. In the end, the language conveys a
personal sense of quality, almost possessive of its object, as
when Greenberg speaks of "the mustard yellow that was dur-
ing this time [the last ten years of his career] Eilshemius's
version of sunlight,"[51] or the "vividness . . . gained from the
introduction of a blood red" in Marin's watercolors.[52] Green-
berg shows great sensitivity to color, and beyond that an un-
expectedly poetic sensitivity to his own sensitivity.

Greenberg's rhetoric of cuisine implies that a good deal of
his analysis of art hides an unmistakable attitude to it. The
rhetoric not only makes the attitude self-evident, but im-
presses it upon us. It is as if Greenberg's language simulta-
neously registers and discharges a visceral reaction. Green-
berg cannot and does not want to keep it to himself. To
develop it would make it explicitly emotional; so the reaction
is shed, almost compulsively, by being poetically catapulted at
us. The rhetoric of cuisine means to get under our skin and
preempt our own visceral reaction to the art. This is a
species of forcing of feeling, and like all such forcing it un-
does, as Greenberg says, the art—in his case, the art of criti-

cism. For in and of itself the rhetoric of cuisine gives a distorted—emotional, arbitrary, unprincipled—view of art, and so can do no good, either for the critic who uses the rhetoric or the art appreciator it means to "impress" and guide. The terms Greenberg applies to Picasso's "distortions" describe exactly the distortions inherent in the rhetoric of cuisine: "They are arbitrary in an ultimate sense, not compelled by a style that is the emotion itself but superimposed or inserted with the label 'emotion,' " resulting in "vulgarity and theatre."[53] Greenberg's rhetoric of cuisine is vulgar and theatrical within the context of his modernism, which otherwise can in fact be said to articulate a positive intellectual style which is the pragmatic emotion of the modern world.

Greenberg's rhetoric of cuisine is an unwitting parody of modernist sensibility. It shows the poverty of the language of taste. It reminds us that like all rhetoricians Greenberg is willing to convince us of the truth of his ideas by invalid means—by any kind of exemplification which is persuasive, if only because it catches us off guard. For we have come to expect Greenberg to reason, not to poeticize—so that we just might be susceptible to his poetry, taking it as a cunning kind of reasoning. Greenberg's ventures into poetic writing puts an irrational pressure on us and makes us experience an art as more convincing—or unconvincing—than it is (if we can ever know that apart from criticism). In his use of rhetoric to put art on a pedestal—or knock it off one— Greenberg is not unlike other critics. He, too, in attempting to be true to the facts of art, can mythologize it, a fate to which it has always been susceptible.

Notes
Selected Bibliography
Index

Notes

CHAPTER 1: Issues and Attitudes

1 Clement Greenberg, *Art and Culture* (Boston, 1961).
2 Hilton Kramer, "A Critic on the Side of History: Notes on Clement Greenberg," *Arts Magazine* 37 (Oct. 1962): 61.
3 Barbara M. Reise, "Greenberg and the Group: A Retrospective View," *Studio International* 175 (May 1968): 254.
4 Edward Lucie-Smith, "An Interview with Clement Greenberg," *Studio International* 175 (Jan. 1968): 4.
5 Max Kozloff, "A Letter to the Editor," *Art International* 7 (June 1963): 88–92.
6 Patrick Heron, "A Kind of Cultural Imperialism?" *Studio International* 175 (Feb. 1968): 63.
7 Fairfield Porter, "Letter to the Editor," *Partisan Review* 8 (Jan.-Feb. 1941): 77.
8 Lawrence Alloway, "The Uses and Limits of Art Criticism," in *Topics in American Art since 1945* (New York, 1975), p. 267.
9 See Greenberg, "Can Taste Be Objective?" *Art News* 72 (Feb. 1973): 22–23.
10 Greenberg, "Greenberg on Berenson," *Perspectives USA*, No. 11 (1955): 150–54.

11 Greenberg, "Modernist Painting," in *The New Art,* ed. Gregory Battcock (New York, 1966), p. 101.
12 Nicolas Calas, "The Enterprise of Criticism," in *Art in the Age of Risk* (New York, 1968), pp. 139–42.
13 Greenberg, "T. S. Eliot: A Book Review," *Art and Culture* (Boston, 1961; paperback ed., Boston, 1965), p. 239.
14 Greenberg, "The Early Flemish Masters," *Arts Magazine* 35 (Dec. 1960): 28.

CHAPTER 2: Dialectical Conversion

1 Clement Greenberg, "The Role of Nature in Modern Painting," *Partisan Review* 16 (Jan. 1949): 78–81. In *Art and Culture* (Boston, 1961; paperback ed., Boston, 1965), pp. 171–74.
2 Hilton Kramer, "A Critic on the Side of History: Notes on Clement Greenberg," *Arts Magazine* 37 (Oct. 1962): 61.
3 Greenberg, "The Late Thirties in New York," in *Art and Culture,* p. 230.
4 Kramer, p. 63.
5 Barbara M. Reise, "Greenberg and the Group: A Retrospective View," *Studio International* 175 (May 1968): 255.
6 Greenberg, "Art" (Gustave Courbet), *Nation* 168 (Jan. 8, 1949): 51.
7 Greenberg, "After Abstract Expressionism," *Art International* 6 (Oct. 1962): 26.
8 Greenberg, "Old India: Her Monuments," *Art International* 16 (Nov. 1972): 19.
9 Greenberg, "Counter-Avant-Garde," *Art International* 15 (May 1971): 16.
10 Greenberg, "The Impressionists and Proust," *Nation* 163 (Aug. 31, 1946): 247 (review of *Proust and Painting* by Maurice Chernowitz).
11 Greenberg, "David Smith's New Sculpture," *Art International* 8 (May 1964): 37.
12 Greenberg, "Milton Avery," *Arts Magazine* 32 (Dec. 1957): 45.
13 Greenberg, "Byzantine Parallels," *Art and Culture,* p. 168.
14 Greenberg, "Later Monet," *Art News Annual* 26 (1977): 132–48. In *Art and Culture,* pp. 37–47.
15 Greenberg, "Matisse in 1966," *Boston Museum Bulletin* 64 (1966): 67–76.
16 Greenberg, "Reply" (to George L. K. Morris), *Partisan Review* 15 (June 1948): 685.

17 Greenberg, "The Necessity of the Old Masters," *Partisan Review* 15 (July 1948): 812–15.
18 Greenberg, "The Plight of Culture," in *Art and Culture*, p. 28.
19 Greenberg, "Master Léger," *Partisan Review* 21 (Jan.-Feb. 1954): 92.

CHAPTER 3: Unity

1 Clement Greenberg, "Jacques Lipchitz," in *Art and Culture* (Boston, 1961; paperback ed., Boston, 1965), p. 105.
2 Greenberg, "Van Gogh and Maurer," *Partisan Review* 17 (Feb. 1950): 171.
3 Greenberg, "Soutine," in *Art and Culture*, p. 117.
4 Greenberg, "Abstract, Representational, and So Forth," *Art and Culture*, pp. 137, 134.
5 James Faure Walker, "Clement Greenberg Interviewed," *Art Scribe*, No. 10 (Jan. 1978), p. 20.
6 Greenberg, "The Role of Nature in Modern Painting," *Partisan Review* 16 (Jan. 1949): 78.
7 Greenberg, "Kandinsky," in *Art and Culture*, p. 111.
8 Greenberg, "Jacques Lipchitz," in *Art and Culture*, p. 106.
9 Greenberg, "Art" (Paul Klee), *Nation* 164 (May 17, 1947): 578.
10 Greenberg, "Art" (Piet Mondrian), *Nation* 158 (March 4, 1944): 288.
11 Greenberg, " 'American-Type' Painting," in *Art and Culture*, p. 221.
12 Greenberg, "Georges Rouault," in *Art and Culture*, p. 85.
13 Greenberg, "Chaim Soutine," *Partisan Review* 18 (Jan.-Feb. 1951): 85.
14 Greenberg, "Van Gogh and Maurer," p. 171.
15 Ibid., p. 173.
16 Greenberg, "Art" (Jean Dubuffet, Jackson Pollock), *Nation* 164 (Feb. 1, 1947): 137.
17 Greenberg, "Art" (Piet Mondrian), p. 288.
18 Greenberg, "Art" (Isamu Noguchi), *Nation* 168 (March 19, 1948): 341.
19 Greenberg, review of *The Seventh Cross* by Anna Seghers, *Nation* 155 (Oct. 17, 1942): 390.
20 Greenberg, "Contribution to a Symposium," in *Art and Culture*, p. 125.
21 Greenberg, "A Victorian Novel," in *Art and Culture*, p. 251 (review of *The American Senator* by Anthony Trollope).

22 Greenberg, " 'Primitive' Painting," in *Art and Culture,* p. 132.
23 Greenberg, "Soutine," in *Art and Culture,* p. 118.
24 Greenberg, "The Camera's Glass Eye" (Edward Weston's Photography), *Nation* 162 (March 9, 1946): 295.
25 Greenberg, "Art" (Piet Mondrian's *New York Boogie Woogie*), *Nation* 157 (Oct. 9, 1943): 416.
26 Greenberg, "T. S. Eliot: A Book Review," in *Art and Culture,* p. 240.
27 Greenberg, "Art" (Camille Corot, Paul Cézanne, Louis Eilshemius, Wilfredo Lam), *Nation* 155 (Dec. 12, 1942): 659.
28 Greenberg, "Art" (Whitney Annual), *Nation* 164 (April 5, 1947): 405–6.
29 Greenberg, "The Art of Delacroix," *Nation* 159 (Nov. 18, 1944): 617.
30 Greenberg, "Art" (Hans Hofmann), *Nation* 160 (April 21, 1945): 469.
31 Greenberg, "The Art of Delacroix," p. 617.
32 Greenberg, "Kafka's Jewishness," in *Art and Culture,* p. 273.
33 Greenberg, quoting Mondrian, in "Art" (Piet Mondrian), p. 288.
34 Greenberg, "Art" (André Derain), *Nation* 158 (Jan. 22, 1944): 109.
35 Greenberg, "Art" (Georges Rouault), *Nation* 160 (May 19, 1945): 581; "Soutine," in *Art and Culture,* p. 117.
36 Greenberg, "Soutine," in *Art and Culture,* p. 115.
37 Greenberg, "Art" (André Derain), p. 109.
38 Greenberg, "Art" (Piet Mondrian), p. 288.
39 Greenberg, "The Early Flemish Masters," *Arts Magazine* 35 (Dec. 1960): 28.
40 Greenberg, "Cézanne and the Unity of Modern Art," *Partisan Review* 18 (May-June 1951): 328–29.
41 Leo Steinberg, "Other Criteria," in *Other Criteria* (New York, 1972), p. 74.
42 Greenberg, "The New Sculpture," *Partisan Review* 16 (June 1949): 638.
43 Greenberg, "Art" (Willem de Kooning), *Nation* 166 (April 24, 1948): 448.
44 Greenberg, "Sculpture in Our Time," *Arts Magazine* 32 (June 1958): 22.
45 Nicolas Calas, "The Enterprise of Criticism," in *Art in the Age of Risk* (New York, 1968), p. 141.
46 Greenberg, "Cézanne," in *Art and Culture,* p. 53.
47 Greenberg, "Cézanne and the Unity of Modern Art," p. 326.

48 Greenberg, "Avant-Garde Attitudes: New Art in the Sixties," *Studio International* 179 (April 1970): 144.
49 Edward Lucie-Smith, "An Interview with Clement Greenberg," *Studio International* 175 (Jan. 1968): 4.
50 Greenberg, "Picasso at Seventy-Five," in *Art and Culture,* p. 63.
51 Greenberg, "Collage," in *Art and Culture,* p. 82.
52 Greenberg, "The Role of Nature in Modern Painting," p. 80.
53 Greenberg, "Master Léger," *Partisan Review* 21 (Jan.-Feb. 1954): 92.
54 Greenberg, "Anthony Caro," *Studio International* 174 (Sept. 1967): 116.
55 Greenberg, "Milton Avery," *Arts Magazine* 32 (Dec. 1957: 43.
56 Greenberg, "The Art of Cézanne," *Nation* 161 (Dec. 29, 1945): 743 (review of *The Art of Cézanne* by Earle Loran).
57 Greenberg, "Cézanne and the Unity of Modern Art," p. 326.
58 Greenberg, "Art" (Painting and French Existentialism), *Nation* 163 (July 13, 1946): 54.
59 Greenberg, "The Situation at the Moment," *Partisan Review* 15 (Jan. 1948): 82.
60 Greenberg, "Master Léger," p. 91.
61 Greenberg, "Thomas Eakins," in *Art and Culture,* p. 177.
62 Greenberg, "Art" (Winslow Homer), *Nation* 159 (Oct. 28, 1944): 541.
63 Greenberg, "Cézanne, Gateway to Contemporary Painting," *American Mercury* 74 (June 1952): 71–72.
64 Greenberg, "Art" (Jean Dubuffet, Jackson Pollock), p. 137.
65 Greenberg, "Cézanne, Gateway to Contemporary Painting," pp. 69, 71.
66 Greenberg, "Art" (Giorgio de Chirico), *Nation* 164 (March 22, 1947): 340.
67 Greenberg, "Art" (Henri Rousseau), *Nation* 163 (July 27, 1946): 109.
68 Greenberg, "Art" (Painting in France), *Nation* 164 (Feb. 22, 1947): 228.
69 Greenberg, "Art" (Romantic Painting in America, Whitney Annual), *Nation* 158 (Jan. 1, 1944): 24.
70 Lucie-Smith, "Interview with Clement Greenberg," p. 4.
71 Quoted by Greenberg, "Cézanne," in *Art and Culture,* p. 56.
72 Greenberg, "The Decline of Cubism," *Partisan Review* 15 (March 1948): 366.
73 Greenberg, "Art" (Romantic Painting in America, Whitney Annual), p. 24.

74 Greenberg, "Art" (Whitney Annual), p. 768.
75 Greenberg, "David Smith," *Art in America* 51 (July-Aug. 1963): 112 (originally appeared in *Art in America* 44 [Winter 1956]: 30–33). For additional comments on Smith's "baroque exuberance," see also "Art" (David Smith), *Nation* 164 (April 19, 1947): 459–60.
76 Greenberg, "Art" (Vincent Van Gogh), *Nation* 157 (Nov. 6, 1943): 536.
77 Greenberg, "Art" (Camille Corot, Paul Cézanne, Louis Eilshemius, Wilfredo Lam), *Nation* 155 (Dec. 12, 1942): 660.
78 Greenberg, "Art" (Art of This Century, William Baziotes, Robert Motherwell), *Nation* 159 (Nov. 11, 1944): 598.
79 Greenberg, "Master Léger," in *Art and Culture*, p. 101.

CHAPTER 4: The Decorative

1 Clement Greenberg, "The Crisis of the Easel Picture," *Partisan Review* 15 (April 1948): 482.
2 Greenberg, "Art" (Arnold Friedman), *Nation* 158 (April 15, 1944): 456. See also "Art" (Arnold Friedman), *Nation* 160 (March 17, 1945): 314; and "Art" (Pierre Bonnard), *Nation* 164 (Jan. 11, 1947): 53–54.
3 Greenberg, "Art" (Wassily Kandinsky), *Nation* 160 (Jan. 13, 1945): 52–53.
4 Greenberg, "Is the French Avant-Garde Overrated?" *Art Digest* 27 (Sept. 1953): 12.
5 Greenberg, "The Crisis of the Easel Picture," p. 482.
6 Greenberg, "Milton Avery," *Arts Magazine* 32 (Dec. 1957): 41.
7 Greenberg, "Influences of Matisse," *Art International* 17 (Nov. 1973): 28.
8 Greenberg, "Feeling Is All," *Partisan Review* 19 (Jan.-Feb. 1952): 98.
9 Greenberg, "Picasso at Seventy-Five," *Arts Magazine* 32 (Oct. 1957): 45.
10 Greenberg, "Milton Avery," p. 45.
11 Greenberg, "Greenberg on Berenson," *Perspectives USA*, No. 11 (1955): 152; quoted from Berenson by Greenberg.
12 Greenberg, "The New Sculpture," *Partisan Review* 16 (June 1949): 638–39.
13 Greenberg, "David Smith," *Art in America* 51 (July-Aug. 1963): 112.

14 Greenberg, "Art" (Piet Mondrian's *New York Boogie Woogie*), *Nation* 157 (Oct. 9, 1943): 416.

15 Greenberg, "Art" (Romantic Painting in America, Whitney Annual), *Nation* 158 (Jan. 1, 1944): 24.

16 Greenberg, "Art" (Camille Corot, Paul Cézanne, Louis Eilshemius, Wilfredo Lam), *Nation* 155 (Dec. 12, 1942): 660.

17 Greenberg, "Art" (Abstract and Surrealist Artists under Forty), *Nation* 158 (May 27, 1944): 634.

18 Greenberg, "Art" (Louis Eilshemius, Nicholas Mocharniuk), *Nation* 157 (Dec. 18, 1943): 741.

19 Greenberg, "Art" (Henri Matisse), *Nation* 168 (March 5, 1949): 285.

20 Greenberg, "Art" (Isamu Noguchi), *Nation* 168 (March 19, 1949): 341.

21 Greenberg, "Art" (Naum Gabo, Antoine Pevsner), *Nation* 166 (April 17, 1948): 423.

22 Greenberg, "Art" (Josef Albers, Adolph Gottlieb, Jackson Pollock), *Nation* 168 (Feb. 19, 1949): 222.

23 Greenberg, "Art" (Vincent Van Gogh), *Nation* 157 (Nov. 6, 1943): 536.

24 Greenberg, "Art" (John Tunnard), *Nation* 159 (Nov. 18, 1944): 626.

25 Greenberg, "Art" (Alexander Calder, Giorgio de Chirico), *Nation* 157 (Oct. 23, 1943): 480.

26 Greenberg, "Art" (Abstract and Surrealist Artists under Forty), p. 634.

27 Greenberg, "Art" (Art of This Century, William Baziotes, Robert Motherwell), *Nation* 159 (Nov. 11, 1944): 599.

28 Greenberg, "Art" (Romantic Painting in America, Whitney Annual), p. 24.

29 Greenberg, "Art" (Arnold Friedman), *Nation* 160 (March 17, 1945): 314.

30 Greenberg, "The Camera's Glass Eye" (Edward Weston's Photography), *Nation* 162 (March 9, 1946): 294.

31 Greenberg, "Art" (Pepsi-Cola's "Paintings of the Year," Ben Shahn), *Nation* 165 (Nov. 1, 1947): 481.

32 Greenberg, "The Camera's Glass Eye" (Edward Weston's Photography), p. 295.

33 Greenberg, "Art" (Giorgio de Chirico), *Nation* 164 (March 22, 1947): 342.

34 Greenberg, "Art" (Collages at the Museum of Modern Art), *Nation* 167 (Nov. 27, 1948): 613.

35 Greenberg, "Art" (Worden Day, Jackson Pollock, Carl Holty), *Nation* 166 (Jan. 24, 1948): 107

36 Greenberg, "Art" (Henri Matisse), *Nation* 166 (Feb. 21, 1948): 223.

37 Greenberg, "Art" (Ben Nicholson, Larry Rivers), *Nation* 168 (April 16, 1949): 453.

38 Greenberg, "Art" (Alfred Maurer), *Nation* 165 (Dec. 20, 1947): 687–88.

39 Greenberg, "Art" (William Congdon, Adaline Kent), *Nation* 168 (May 28, 1949): 621.

40 Greenberg, "The State of American Writing" (symposium), *Partisan Review* 15 (Aug. 1948): 876.

41 Greenberg, "Art" (Painting in France, 1939–46), *Nation* 164 (Feb. 22, 1947): 228.

42 Greenberg, "Braque Spread Large," *Partisan Review* 16 (May 1949): 531.

43 Greenberg, "Art" (Whitney Annual), *Nation* 167 (Dec. 11, 1948): 676.

44 Greenberg, "Art" (Isamu Noguchi), p. 341.

45 Baldesar Castiglione, *Book of the Courtier* (Garden City, N.Y., 1949), p. 43.

46 Greenberg, "Art" (Isamu Noguchi), p. 341

47 Greenberg, "Art" (Marsden Hartley), *Nation* 159 (Dec. 30, 1944): 810.

48 Greenberg, "Art" (Stuart Davis, Roger de la Fresnaye), *Nation* 161 (Nov. 17, 1945): 533.

49 Ibid.

50 Greenberg, "The Camera's Glass Eye" (Edward Weston's Photography), p. 294.

51 Greenberg, "Art" (Hans Hofmann), *Nation* 160 (April 21, 1945): 469.

52 Greenberg, "Art" (Paul Gauguin, Arshile Gorky), *Nation* 162 (May 4, 1946): 552.

53 Greenberg, "Art" (Pierre Bonnard), *Nation* 166 (June 12, 1948): 667.

54 Greenberg, "Cézanne and the Unity of Modern Art," *Partisan Review* 18 (May-June 1951): 328.

55 Greenberg, "Independence of Folk Art," *Art News* 52 (Sept. 1953): 27.

56 Greenberg, "Pasted-Paper Revolution," *Art News* 57 (Sept. 1958): 49.

57 Greenberg, "Art" (Max Beckmann, Robert de Niro), *Nation* 162 (May 18, 1946): 610

58 Greenberg, "Paul Klee," *Partisan Review* 8 (May-June 1941): 226.

59 Greenberg, "Chaim Soutine," *Partisan Review* 18 (Jan.-Feb. 1951): 82.

60 Greenberg, "The Camera's Glass Eye" (Edward Weston's Photography), p. 295. See also "Toward a Newer Laocoon," *Partisan Review* 7 (Fall 1940): 296–310, where the distinction between literature and purity is spelled out in detail.

61 Greenberg, "Independence of Folk Art," p. 27.

62 Greenberg, "Primitive Painting," *Nation* 155 (Oct. 10, 1942): 351 (review of *American Primitive Painting* by Jean Lipton).

63 Greenberg, "The Situation at the Moment," *Partisan Review* 15 (Jan. 1948): 84.

64 Greenberg, "Milton Avery," p. 41.

65 Greenberg, "Paul Klee," p. 226.

66 Greenberg, "Avant-garde and Kitsch," in *Art and Culture* (Boston, 1961; paperback ed., Boston, 1965), p. 15.

CHAPTER 5: American Abstract Art

1 Clement Greenberg, "Art" (Abstract Art), *Nation* 154 (May 2, 1942): 526.

2 Greenberg, "Art" (Adolph Gottlieb), *Nation* 165 (Dec. 6, 1947): 629. In "Art" (Worden Day, Jackson Pollock, Carl Holty), *Nation* 166 (Jan. 24, 1948): 107, Greenberg describes 1947 as one of the best years in American abstract art.

3 See Greenberg, "How Art Writing Earns Its Bad Name," *Encounter* 17 (Dec. 1962): 67–71. See also " 'American-Type' Painting," in *Art and Culture* (Boston, 1961; paperback ed., Boston, 1965), p. 209 n. 1.

4 Greenberg's responsibility for the sculpture after Smith's death —Greenberg was one of the executors of Smith's estate—is examined in Rosalind Krauss, "Changing the Work of David Smith," *Art in America* 62 (Sept.-Oct. 1974): 30–34. See also the letters in *Art in America* 66 (March-April 1978): 5; and 66 (May-June 1978): 5.

5 Greenberg, "Post-painterly Abstraction," *Art International* 8 (Summer 1964): 63–64.

6 Greenberg, "The School of Paris," in *Art and Culture*, p. 120.

7 Greenberg, "Some Advantages of Provincialism," *Art Digest* 28 (Jan. 1954): 6–8.

8 See Greenberg, "Art" (Contemporary British Artists), *Nation* 165 (Oct. 11, 1947): 390.

9 Greenberg, "Art" (Abstract Art), p. 526. For a different interpretation of provincialism see Donald B. Kuspit, "Regionalism Reconsidered," *Art in America* 64 (July-Aug. 1976): 64–69.

10 See Lucy Lippard, "Eccentric Abstraction," in *Changing: Essays in Art Criticism* (New York, 1971), pp. 98–111.

11 See Greenberg, "Art" (Charles Burchfield, Milton Avery, Eugene Berman), *Nation* 157 (Nov. 13, 1943): 565–66; "Art" (Arshile Gorky), *Nation* 160 (March 24, 1945): 342–43; "Art" (Paul Gauguin, Arshile Gorky), *Nation* 162 (May 4, 1946): 552–53; "Art" (Arshile Gorky, Karl Knaths, Whitney Annual), *Nation* 166 (Jan. 10, 1948): 51–52. Greenberg later changed his mind and recognized the originality of Gorky and Avery—i.e., their transcendence of provincialism. See "Art" (Arshile Gorky), *Nation* 166 (March 20, 1948): 331–32; and "Milton Avery," *Arts Magazine* 32 (Dec. 1957): 40–45.

12 Greenberg, "The School of Paris: 1946," in *Art and Culture*, p. 120.

13 James K. Feibleman, *In Praise of Comedy* (New York, 1970), p. 51.

14 Greenberg, "Art" (Adolph Gottlieb), p. 629.

15 Greenberg, "Contribution to a Symposium," in *Art and Culture*, pp. 124–26.

16 Ibid., p. 125

17 See Meyer Schapiro's understanding of these artists in *Vincent Van Gogh* (New York, 1950) and *Paul Cézanne*, 3rd ed. (New York, 1965). Greenberg and Schapiro are in essential agreement about the character of these artists, although they value them differently.

18 Greenberg, "Problems of Criticism: Complaints of an Art Critic," *Artforum* 6 (Oct. 1967): 38.

19 See Greenberg, "Surrealist Painting," *Nation* 159 (Aug. 12, 1944): 192–94; 159 (Aug. 19, 1944): 219–20.

20 Greenberg, "Picasso at Seventy-Five," in *Art and Culture*, p. 62.

21 Greenberg, "Art" (American Abstract Artists), *Nation* 160 (April 7, 1945): 397.

22 Greenberg, "Art" (Jane Street Group), *Nation* 164 (March 8, 1947): 284.

23 Greenberg, "Art" (Hyman Bloom, Robert Motherwell, David Smith), *Nation* 162 (Jan. 26, 1946): 109.

24 Greenberg, "State of American Art," *Magazine of Art* 42 (March 1949): 92.

25 Greenberg, "Art" (David Smith), *Nation* 164 (April 19, 1947): 460.

26 Greenberg, "Art" (Hyman Bloom, Robert Motherwell, David Smith), p. 109.

27 Greenberg, "The Jewishness of Franz Kafka," *Commentary* 20 (Aug. 1955): 178.

28 Immanuel Kant, *Critique of Judgment* (New York, 1952), pp. 58–59. See also p. 61 on the "charm of colors."

29 Greenberg, "Art" (Paul Gauguin, Arshile Gorky), p. 552. See also "Art" (Arshile Gorky), pp. 342–43; and "Art" (Arshile Gorky, Karl Knaths, Whitney Annual), p. 52. In addition, see "Art" (Georgia O'Keeffe), *Nation* 162 (June 15, 1946): 727, on the "charm" of O'Keeffe's art.

30 Greenberg, "Feeling Is All," *Partisan Review* 19 (Jan.-Feb. 1952): 97.

31 Greenberg, "Art" (A Problem for Critics), *Nation* 160 (June 9, 1945): 657.

32 Greenberg, "Art" (American Abstract Artists), p. 396.

33 Greenberg, "Religion and the Intellectuals" (symposium), *Partisan Review* 17 (May-June 1950): 466.

34 Greenberg, "Art" (Abstract Art), p. 526.

35 Greenberg, "Art" (Georgia O'Keeffe), p. 727; and "Art" (Gaston Lachaise, Henry Moore), *Nation* 164 (Feb. 8, 1947): 164–65. For Greenberg, O'Keeffe is in effect the Thomas Hart Benton of American abstraction.

36 Greenberg, "Feeling Is All," p. 99.

37 Greenberg, "Problems of Criticism: Complaints of an Art Critic," p. 38.

38 Greenberg, "Art" (Arshile Gorky, Karl Knaths, Whitney Annual), p. 51.

39 Greenberg, "Art" (Worden Day, Jackson Pollock, Carl Holty), p. 108. See also "Art" (American Abstract Artists), p. 444, and "The Decline of Cubism," *Partisan Review* 15 (March 1948): 366–69, where Greenberg argues that despite its decline Cubism remains a creatively viable idiom.

40 Greenberg, "Art" (Marc Chagall), *Nation* 162 (June 1, 1946): 672.

41 Greenberg, "Art" (Jean Dubuffet, Jackson Pollock), *Nation* 164 (Feb. 1, 1947): 137.

42 Greenberg, "Recentness of Sculpture," *Art International* 11 (April 1967): 19.

43 Greenberg, "Counter-Avant-Garde," *Art International* 15 (May 1971): 18.
44 Greenberg, "Art" (Painting in France, 1939–46), *Nation* 164 (Feb. 22, 1947): 228.
45 Greenberg, review of *The Lonely Ones* by William Steig, *Nation* 156 (Jan. 16, 1943): 102.
46 Greenberg, "Art" (A Problem for Critics), p. 659.
47 Greenberg, "De Profundis," *Nation* 158 (June 3, 1944): 657 (review of *The Bottomless Pit* [*Der Brunnen des Abgrunds*] by Gustav Regler).
48 Greenberg, "Counter-Avant-Garde," p. 18.
49 Greenberg, "Art" (Willem de Kooning), *Nation* 166 (April 24, 1948): 448.
50 Greenberg, " 'American-Type' Painting," in *Art and Culture*, p. 209.
51 Greenberg, "Recentness of Sculpture," p. 19.

CHAPTER 6: Taste and the Concept of Criticism

1 Clement Greenberg, "Three Current Art Books," *Partisan Review* 9 (March-April 1942): 129.
2 Greenberg, "How Art Writing Earns Its Bad Name," *Encounter* 17 (Dec. 1962): 67–71.
3 Greenberg, "Pictures and Prattle," *Nation* 161 (Oct. 13, 1945): 378 (review of *Abstract and Surrealist Art in America* by Sidney Janis).
4 Greenberg, "The Seeing Eye," *Nation* 170 (April 22, 1950): 381 (review of *Landscape Painting* by Kenneth Clark and *Landscape, Portrait, Still Life: Their Origin and Development* by Max J. Friedländer).
5 Greenberg, "Art" (Arshile Gorky), *Nation* 166 (March 20, 1948): 331.
6 Greenberg, "The Seeing Eye," p. 382.
7 Greenberg, "Problems of Criticism: Complaints of an Art Critic," *Artforum* 6 (Oct. 1967): 39.
8 Greenberg, "T. S. Eliot: A Book Review," in *Art and Culture* (Boston, 1961; paperback ed., Boston, 1965), p. 239.
9 Greenberg, "The Seeing Eye," p. 382.
10 Greenberg, "The New Sculpture," *Partisan Review* 16 (June 1949): 637.
11 Greenberg, "Art" (Arshile Gorky), p. 331.

12 Greenberg, "The New Sculpture," p. 637.
13 Greenberg, "Two Reconsiderations," *Partisan Review* 17 (May-June 1950): 510–11.
14 Greenberg, "The Seeing Eye," p. 382.
15 Greenberg, "Problems of Criticism: Complaints of an Art Critic," p.38.
16 Greenberg, "Picasso at Seventy-Five," *Arts Magazine* 32 (Oct. 1957): 40.
17 Greenberg, "Frontiers of Criticism," *Partisan Review* 13 (Spring 1946): 251 (review of *Les Sandales d'Empédocle* by Claude-Edmonde Magny).
18 Greenberg, "The Question of the Pound Award," *Partisan Review* 16 (May 1949): 515–16. (Greenberg was one of a number of intellectuals asked to comment on this controversial award.) Greenberg himself can never be regarded as a moral idiot—as lacking in social conscience—as his sociopolitical articles make clear. See "Goose-Step in Tishomingo," *Nation* 156 (May 29, 1943): 768–70, an article about an American prisoner-of-war camp, and "Ten Propositions on the War," *Partisan Review* 8 (July-Aug. 1941): 271–78, written with Dwight Macdonald.
19 Greenberg, "Irrelevance versus Irresponsibility," *Partisan Review* 15 (May 1948): 577.
20 Ibid., p. 574; Greenberg, quoting Valéry.
21 Ibid., p. 577.
22 Meyer Schapiro, "The Liberating Quality of Avant-Garde Art," *Art News* 56 (1957): 36–42.
23 Greenberg, "Frontiers of Criticism," p. 255.
24 Greenberg, "Religion and the Intellectuals" (symposium), *Partisan Review* 17 (May-June 1950): 467.
25 Ibid., p. 466.
26 Ibid., pp. 466–67.
27 Ibid., p. 467.
28 Ibid., p. 468.
29 Greenberg, "Frontiers of Criticism," p. 255.
30 T. S. Eliot, "The Perfect Critic," in *The Sacred Wood* (London, 1920), p. 96. For a study of Eliot's concept of criticism see Austin Warren, "Continuity and Coherence in the Criticism of T. S. Eliot," in *Connections* (Ann Arbor, 1970), pp. 152–83.
31 Greenberg, "Modernist Painting," in *The New Art: A Critical Anthology,* ed. Gregory Battcock (New York, 1966), p. 101.
32 Greenberg, "Counter-Avant-Garde," *Art International* 15 (May 1971): 18.

33 Greenberg, "Art" (Gaston Lachaise, Henry Moore), *Nation* 164 (Feb. 8, 1947): 164.

34 Greenberg, "Art" (Whitney Annual), *Nation* 162 (Feb. 23, 1946): 242.

35 Greenberg, "Art" (David Smith), *Nation* 164 (April 19,1947): 460.

36 Greenberg, "Art" (Pierre Bonnard), *Nation* 166 (June 12, 1948): 667.

37 Greenberg, "Feeling Is All," *Partisan Review* 19 (Jan.-Feb. 1952): 101.

38 Greenberg, "Art" (Ben Nicholson, Larry Rivers), *Nation* 168 (April 16, 1949): 453.

39 Greenberg, "Master Léger," *Partisan Review* 21 (Jan.-Feb. 1954): 95.

40 Greenberg, "Art" (Contemporary British Artists), *Nation* 165 (Oct. 11, 1947): 390.

41 Edward Lucie-Smith, "An Interview with Clement Greenberg," *Studio International* 175 (Jan. 1968): 4.

42 Greenberg, "Post-painterly Abstraction," *Art International,* 8 (Summer 1964): 64.

43 Greenberg, "Counter-Avant-Garde," p. 19.

44 Ibid., p. 18.

45 Greenberg, "How Art Writing Earns Its Bad Name," p. 70.

46 Greenberg, "Three Current Art Books," *Partisan Review* 9 (March-April 1942): 129.

47 Greenberg, "How Art Writing Earns Its Bad Name," p. 70.

48 Greenberg, "The Venetian Line," *Partisan Review* 17 (April 1950): 364.

49 Greenberg, "Art" (Contemporary British Artists), p. 390.

50 Greenberg, "The Necessity of the Old Masters," *Partisan Review* 15 (July 1948): 815.

51 William Rubin has shown how it does so in "Jackson Pollock and the Modern Tradition," *Artforum* 5 (Feb. 1967): 14–22; (March 1967): 28–37; (April 1967): 18–31; (May 1967): 28–35.

52 George L. K. Morris and Clement Greenberg, "An Exchange," *Partisan Review* 15 (June 1948): 681–90.

53 Greenberg, "David Smith," *Art in America* 51 (July-Aug. 1963): 116.

54 Greenberg, "How Art Writing Earns Its Bad Name," p. 70.

55 Greenberg, "Can Taste Be Objective?" *Art News* 72 (Feb. 1973): 22.

56 Ibid., p. 23.

57 Karl Marx, *Capital* (Chicago, 1933), 1:83.
58 T. S. Eliot, "Tradition and Individual Talent," in *The Sacred Wood,* pp. 58–59.
59 Ibid., p. 56.
60 Ibid., p. 54.
61 Greenberg, "Problems of Criticism: Complaints of an Art Critic," p. 38.
62 Greenberg, "Seminar One," *Arts Magazine* 48 (Nov. 1973): 45.
63 Greenberg, "Avant-Garde Attitudes: New Art in the Sixties," *Studio International* 179 (April 1970): 142. In this context see Hannah Arendt's discussion of taste as a "political faculty" in "The Crisis of Culture," *Between Past and Future* (New York, 1968), pp. 215–24.
64 Greenberg, "Letter to the Editor" (reply to F. R. Leavis), *Commentary* 19 (June 1955): 596.
65 Greenberg, "Two Reconsiderations," p. 513.
66 See Greenberg, "Art Note," *Nation* 157 (Oct. 16, 1943): 455, where Greenberg acknowledges the error of his description of the colors of Mondrian's *New York Boogie Woogie* ("Art," Oct. 9, 1943, p. 416). The error is so glaring as to suggest that Greenberg did not know what a Mondrian typically looked like and did not even understand the principle behind Mondrian's choice of colors.
67 Greenberg, "Art" (Georgia O'Keeffe), *Nation* 162 (June 15, 1946): 727.
68 Adolph Gottlieb and Mark Rothko, "Statement" (1943), in *Theories of Modern Art,* ed. Herschel B. Chipp (Berkeley, 1969), p. 545.
69 Eliot, "Tradition and Individual Talent," p. 54.
70 Greenberg, "Problems of Criticism: Complaints of an Art Critic," p. 39.

CHAPTER 7: Critique of the Critic's Critic

1 Immanuel Kant, *Critique of Pure Reason,* B26–27.
2 For a discussion of some of the critics influenced by Greenberg, see Barbara M. Reise, "Greenberg and the Group: A Retrospective View," part 2, *Studio International* 175 (June 1968): 314–16; and Carter Ratcliff, "Art Criticism: Other Minds, Other Eyes," part 6 (1961–73), *Art International* 19 (Jan. 1975): 50–60. In both cases Michael Fried is the major figure discussed.

3 T. S. Eliot, "Tradition and Individual Talent," in *The Sacred Wood* (London, 1920), p. 54.

4 Clement Greenberg, "Kandinsky," *Art and Culture* (Boston, 1961; paperback ed., Boston, 1965), p. 111.

5 Georges Braque, "Thoughts and Reflections on Art" (1917), in *Theories of Modern Art,* ed. Herschel B. Chipp (Berkeley, 1969), p. 260.

6 Ibid., p. 262.

7 Greenberg, "Kandinsky," in *Art and Culture,* pp. 111–12.

8 Susan Sontag, "Against Interpretation," in *Against Interpretation* (New York, 1964), p. 14.

9 Hans-Georg Gadamer, "Aesthetics and Hermeneutics," in *Philosophical Hermeneutics* (Berkeley, 1976), p. 103.

10 José Ortega y Gasset, *The Dehumanization of Art* (Garden City, N.Y., 1956), p. 27.

11 Greenberg, "Koestler's New Novel," *Partisan Review* 13 (Nov.-Dec. 1946): 580 (review of *Thieves in the Night* by Arthur Koestler).

12 Greenberg, "T. S. Eliot: The Criticism, The Poetry," *Nation* 171 (Dec. 9, 1950): 531.

13 Ibid.

14 George L. K. Morris and Clement Greenberg, "An Exchange," *Partisan Review* 15 (June 1948): 648–85.

15 T. S. Eliot, "The Perfect Critic," in *The Sacred Wood,* p. 15.

16 Greenberg, "Problems of Criticism: Complaints of an Art Critic," *Artforum* 6 (Oct. 1967): 39.

17 Immanuel Kant, *Critique of Judgment* (New York, 1952), p. 55.

18 Ibid., p. 58.

19 Ibid., p. 59.

20 Ibid., p. 62.

21 Alfred N. Whitehead, *Modes of Thought* (Cambridge, 1956), p. 25.

22 Ibid., p. 189.

23 Greenberg, "Art" (School of Paris), *Nation* 162 (June 29, 1946): 792.

24 Greenberg, "Art" (Pablo Picasso), *Nation* 168 (April 21, 1949): 397.

25 Greenberg, "Art" (Arshile Gorky), *Nation* 160 (March 24, 1945): 343.

26 Greenberg, "Art" (Pierre Bonnard), *Nation* 166 (June 12, 1948): 668.

27 Greenberg, "Art" (Pierre Bonnard), *Nation* 164 (Jan. 11, 1947): 53.

28 Greenberg, "The Art of Delacroix," *Nation* 159 (Nov. 18, 1944): 617.

29 Greenberg, "Art" (Marc Chagall), *Nation* 162 (June 1, 1946): 672.

30 Greenberg, "Art Note" (Darrel Austin), *Nation* 154 (March 14, 1942): 321.

31 Greenberg, "Art Note" (American Primitives), *Nation* 154 (April 11, 1942): 441.

32 Greenberg, "Art" (Pavel Tchelitchew, John B. Flannagan, Peggy Bacon), *Nation* 155 (Nov. 14, 1942): 522.

33 Greenberg, "Art" (Alexander Calder, Giorgio de Chirico), *Nation* 157 (Oct. 23, 1943): 480.

34 Greenberg, "Art" (André Masson, Joan Miró), *Nation* 158 (May 20, 1944): 605.

35 Greenberg, "Art" (Charles Burchfield, Milton Avery, Eugene Berman), *Nation* 157 (Nov. 13, 1943): 565.

36 Greenberg, "Art" (William Dean Fausett, Stuart Davis), *Nation* 156 (Feb. 20, 1943): 284.

37 Greenberg, "Art" (Abraham Rattner), *Nation* 159 (Oct. 14, 1944): 445.

38 Greenberg, "Art" (André Masson, Joan Miró), p. 605.

39 Greenberg, "Art" (American Abstract Artists), *Nation* 160 (April 7, 1945): 397.

40 Greenberg, "Art" (Paul Gauguin, Arshile Gorky), *Nation* 162 (May 4, 1946): 552.

41 Greenberg, "Art" (Henri Matisse, Robert Motherwell, Eugène Boudin, John Piper, Misha Reznikoff), *Nation* 166 (Feb. 21, 1948): 221.

42 Greenberg, "Art" (Dutch Painting), *Nation* 160 (Feb. 24, 1945): 231.

43 Ibid.

44 Greenberg, "Art" (Arnold Friedman), *Nation* 166 (May 15, 1948): 556.

45 Greenberg, "Art" (Pierre Bonnard), *Nation* 164 (Jan. 11, 1947): 53.

46 Greenberg, "Art" (American Abstract Artists), p. 396.

47 Greenberg, "Art" (Portrait of America), *Nation* 161 (Dec. 1, 1945): 605.

48 Greenberg, "Art" (Alfred Maurer), *Nation* 165 (Dec. 20, 1947): 687.

49 Greenberg, "Art" (Painting in France, 1939–46), *Nation* 164 (Feb. 22, 1947): 228.

50 Greenberg, "Van Gogh and Maurer," *Partisan Review* 17 (Feb. 1950): 170. In a letter to Emile Bernard, written at the beginning of December 1889, Van Gogh recognizes the necessity of "cuisine," speaking of it as "technique, tricks if you like, cuisine, but it is a sign all the same that you are studying your handicraft more deeply, and that is a good thing" (*Theories of Modern Art,* ed. Chipp, p. 45).

51 Greenberg, "Art" (Camille Corot, Paul Cézanne, Louis Eilshemius, Wilfredo Lam), *Nation* 155 (Dec. 12, 1942): 660.

52 Greenberg, "Art" (John Marin), *Nation* 157 (Dec. 25, 1943): 770.

53 Greenberg, "Art" (Painting in France, 1939–46), p. 228.

Selected Bibliography

Greenberg's exhibition reviews for *The Nation* and his articles on art for *Partisan Review* are listed separately and in chronological order. The *Nation* reviews are entitled "Art," sometimes "Art Notes." I have dispensed with these titles and indicated the subject of the review. Greenberg's other writings are arranged in alphabetical order by the name of the magazine in which they appeared, and chronologically within that alphabetical order. A selected bibliography of secondary sources follows the list of Greenberg's writings.

The selection is not exhaustive. It means to call attention to the most important sources of Greenberg's criticism and theory and to the treatment of him by other writers.

WRITINGS BY GREENBERG

Books

Joan Miró. New York: Quadrangle Press, 1949.
Hofmann. English edition. Paris: Georges Fall, 1961.
Art and Culture. Boston: Beacon Press, 1961. Beacon paperback
 edition, 1965.

The Nation (Exhibition Reviews)

André Masson, 154 (March 7, 1942): 293.

Darrel Austin, 154 (March 14 1942): 321.

American Primitives, 154 (April 11 1942): 441.

Abstract Art, 154 (May 2, 1942): 525–26.

Pavel Tchelitchew, John B. Flannagan, Peggy Bacon, 155 (Nov. 14, 1942): 522.

Morris Graves, 155 (Nov. 21, 1942): 554.

Camille Corot, Paul Cézanne, Louis Eilshemius, Wilfredo Lam, 155 (Dec. 12, 1942): 659–60.

Joseph Cornell, Larry Vail, 155 (Dec. 26, 1942): 727–28.

Contemporary American Art, 156 (Jan. 2, 1943): 32–33.

Hannaniah Harari, 156 (Jan. 9, 1943): 68–69.

Contemporary American Sculpture, 156 (Jan. 23, 1943): 140–41.

Cubist, Abstract, and Surrealist Art, 156 (Jan. 30, 1943): 177.

French Landscape Painting, 156 (Feb. 13, 1943): 248.

William Dean Fausett, Stuart Davis, 156 (Feb. 20, 1943): 284.

Piet Mondrian, 157 (Oct. 9, 1943): 416.

Piet Mondrian, 157 (Oct. 16, 1943): 455.

Alexander Calder, Giorgio de Chirico, 157 (Oct. 23, 1943): 480–81.

Vincent Van Gogh, 157 (Nov. 6, 1943): 536–37.

Charles Burchfield, Milton Avery, Eugene Berman, 157 (Nov. 13, 1943): 565–66.

Marc Chagall, Lyonel Feininger, Jackson Pollock, 157 (Nov. 27, 1943): 621.

Louis Eilshemius, Nicholas Mocharniuk, 157 (Dec. 18, 1943): 741–42.

John Marin, 157 (Dec. 25, 1943): 769–70.

Romantic Painting in America, Whitney Annual, 158 (Jan. 1, 1944): 24–25.

André Derain, 158 (Jan. 22, 1944): 109–10.

Modern Painters and Sculptors versus the Museum of Modern Art, 158 (Feb. 12, 1944): 195–96.

Piet Mondrian, 158 (March 4, 1944): 288.

Arnold Friedman, 158 (April 15, 1944): 456.

Mark Tobey, Juan Gris, 158 (April 22, 1944): 495.

André Masson, Joan Miró, 158 (May 20, 1944): 604–5.

Abstract and Surrealist Artists under Forty, 158 (May 27, 1944): 634.

Contemporary Art, 158 (June 10, 1944): 688–89.

Thomas Eakins, 159 (July 1, 1944): 24–25.

José Posada, 159 (Sept. 30, 1944): 389–90.

Abraham Rattner, 159 (Oct. 14, 1944): 445.

Winslow Homer, 159 (Oct. 28, 1944): 539–41.

William Baziotes, Robert Motherwell, 159 (Nov. 11, 1944): 598–99.

Eugene Delacroix, 159 (Nov. 18, 1944): 617–18.

John Tunnard, 159 (Nov. 18, 1944): 626.

Marsden Hartley, 159 (Dec. 30, 1944): 810–11.

Wassily Kandinsky, 160 (Jan. 13, 1945): 52–53.

Edgar Degas, Richard Pousette-Dart, 160 (Jan. 20, 1945): 82.

Morris Graves, 160 (Feb. 17, 1945): 193.

Dutch Painting, 160 (Feb. 24, 1945): 230–31.

Arnold Friedman, 160 (March 17, 1945): 314.

Arshile Gorky, 160 (March 24, 1945): 342–43.

Wassily Kandinsky, Piet Mondrian, Jackson Pollock, 160 (April 7, 1945): 396–98.

Hans Hofmann, 160 (April 21, 1945): 469.

Claude Monet, 160 (May 5, 1945): 526–27.

Georges Rouault, 160 (May 19, 1945): 581–82.

A Problem for Critics, 160 (June 9, 1945): 657–59.

Stuart Davis, Roger de la Fresnaye, 161 (Nov. 17, 1945): 533–34.

Portrait of America, 161 (Dec. 1, 1945): 605–6.

Käthe Kollwitz, 161 (Dec. 15, 1945): 669.

Hyman Bloom, Robert Motherwell, David Smith, 162 (Jan. 26, 1946): 109–10.

David Hare, 162 (Feb. 9, 1946): 176–77.

Whitney Annual, 162 (Feb. 23, 1946): 241–42.

Edward Weston's Photography, 162 (March 9, 1946): 294–96.

American Abstract Artists, Jacques Lipchitz, Jackson Pollock, 162 (April 13, 1946): 444–45.

Paul Gauguin, Arshile Gorky, 162 (May 4, 1946): 552–53.

Max Beckmann, 162 (May 18, 1946): 610–11.

Marc Chagall, 162 (June 1, 1946): 671–72.

Georgia O'Keeffe, 162 (June 15, 1946): 727–28.

School of Paris, 162 (June 29, 1946): 792–93.

Painting and French Existentialism, 163 (July 13, 1946): 53–54.

Henri Rousseau, 163 (July 27, 1946): 109.

Fourteen Americans, 163 (Nov. 23, 1946): 593–94.

Whitney Annual, 163 (Dec. 28, 1946): 767–68.

Pierre Bonnard, 164 (Jan. 11, 1947): 53–54.

Jean Dubuffet, Jackson Pollock, 164 (Feb. 1, 1947): 136–39.

Gaston Lachaise, Henry Moore, 164 (Feb. 8, 1947): 164–65.

Painting in France, 1939–46, 164 (Feb. 22, 1947): 228–29.

Jane Street Group, Rufino Tamayo, 164 (March 8, 1947): 284.

Giorgio de Chirico, 164 (March 22, 1947): 340–42.
Art of This Century, Pablo Picasso, Henri Cartier-Bresson, 164 (April 5, 1947): 405–6.
David Smith, 164 (April 19, 1947): 459–60.
Paul Klee, 164 (May 17, 1947): 578–79.
Robert Motherwell, Theo van Doesburg, 164 (May 31, 1947): 664–65.
Joan Miró, 164 (June 7, 1947): 692–94.
Contemporary British Artists, 165 (Oct. 11, 1947): 389–90.
Ben Shahn, 165 (Nov. 1, 1947): 481–82.
Albert Pinkham Ryder, 165 (Nov. 15, 1947): 538–39.
Adolph Gottlieb, 165 (Dec. 6, 1947): 629–30.
Alfred Maurer, 165 (Dec. 20, 1947): 687–88.
Arshile Gorky, Karl Knaths, 166 (Jan. 10, 1948): 51–52.
Worden Day, Jackson Pollock, Carl Holty, 166 (Jan. 24, 1948): 107–8.
Alberto Giacometti, Kurt Schwitters, 166 (Feb. 7, 1948): 163–65.
Henri Matisse, Eugène Boudin, Robert Motherwell, 166 (Feb. 21, 1948): 221–23.
Mordecai Ardon-Bronstein, 166 (March 6, 1948): 284–85.
Arshile Gorky, 166 (March 20, 1948): 331–32.
Naum Gabo, Antoine Pevsner, 166 (April 17, 1948): 423–24.
Willem de Kooning, 166 (April 24, 1948): 448.
Arnold Friedman, Yasuo Kuniyoshi, 166 (May 15, 1948): 556–57.
Le Corbusier, 166 (May 29, 1948): 612–13.
Pierre Bonnard, 166 (June 12, 1948): 667–68.
Colleges at the Museum of Modern Art, 167 (Nov. 27, 1948): 612–14.
Whitney Annual, 167 (Dec. 11, 1948): 675–76.
John Marin, 167 (Dec. 25, 1948): 732–34.
Gustave Courbet, 168 (Jan. 8, 1949): 51–53.
Thomas Cole, Robert Delaunay, 168 (Jan 22, 1949): 108–10.
Jean Arp, 168 (Feb. 5, 1949): 165–66.
Josef Albers, Adolph Gottlieb, Jackson Pollock, 168 (Feb. 19, 1949): 221–22.
Henri Matisse, 168 (March 5, 1949): 284–85.
Isamu Noguchi, 168 (March 19, 1948): 341–42.
Pablo Picasso, 168 (April 2, 1949): 397–98.
Ben Nicholson, Larry Rivers, 168 (April 16, 1949): 453–54.
Edgar Degas, 168 (April 30, 1949): 509–10.
George Bellows, 168 (May 14, 1949): 565–66.
William Congdon, Adaline Kent, 168 (May 28, 1949): 621–22.

Partisan Review (Articles)

"Avant-Garde and Kitsch," 6 (Fall, 1939): 34–49.
"Toward a Newer Laocoon," 7 (Fall 1940): 296–310.
"On Paul Klee," 8 (May-June 1941): 224–29.
"The Situation at the Moment," 15 (Jan. 1948): 81–84.
"The Decline of Cubism," 15 (March 1948): 366–69.
"The Crisis of the Easel Picture," 15 (April 1948): 481–84.
"Irrelevance versus Irresponsibility," 15 (May 1948): 573–79.
"Reply to George L. K. Morris," 15 (June 1948): 685–90.
"The Necessity of the Old Masters" 15 (July 1948): 812–15.
"The Role of Nature in Modern Painting," 16 (Jan. 1949): 78–81.
"Jean Dubuffet and 'Art Brut,' " 16 (March 1949): 295–97.
"Braque Spread Large," 16 (May 1949): 528–31.
"The New Sculpture," 16 (June 1949): 637–42.
"Van Gogh and Maurer," 17 (Feb. 1950): 170–73.
"The Venetian Line," 17 (April 1950): 360–64.
"Two Reconsiderations," 17 (May-June 1950): 510–13.
"Chaim Soutine," 18 (Jan.-Feb. 1951): 82–87.
"Cézanne and the Unity of Modern Art." 18 (May-June 1951): 323–30.
"Feeling Is All," 19 (Jan.-Feb. 1952): 97–102.
"Master Léger," 21 (Jan.-Feb. 1954): 90–97.

Other Periodicals

"Cézanne, Gateway to Contemporary Painting," *American Mercury* 74 (June 1952): 69–73.
"Is the French Avant-Garde Overrated?" *Art Digest* 27 (Sept. 1953): 12–14.
"Some Advantages of Provincialism," *Art Digest* 28 (Jan. 1954): 6–8.
"Critic Picks Some Promising Painters; Exhibition at Kootz Gallery," *Art Digest* 28 (Jan. 1954): 10–11.
"David Smith," *Art in America* 44 (Winter 1956): 30–33. Reprinted in 51 (July-Aug. 1963): 112, 116.
"America Takes the Lead, 1945–1965," *Art in America* 53 (July-Aug. 1965): 108–9.
"David Smith: Comments on His Latest Works," *Art in America* 54 (Jan.-Feb. 1966): 27–32.
"Louis and Noland," *Art International* 4 (May 1960): 27–28.
"After Abstract Expressionism," *Art International* 6 (Oct. 1962): 24–32.

"David Smith's New Sculpture," *Art International* 8 (May 1964): 34–37.

"Post-painterly Abstraction," *Art International* 8 (Summer 1964): 63–64.

"Modernist painting," *Art and Literature*, no. 4 (Spring 1965): 193–201. Reprinted in *The New Art*, ed. Gregory Battcock (New York, 1966), pp. 100–110.

"Recentness of Sculpture," *Art International* 11 (April 1967): 19–21.

"Counter-Avant-Garde," *Art International* 15 (May 1971): 16–19.

"ROSC '71," *Art International* 16 (Feb. 1972): 12–17.

"Necessity of 'Formalism,' " *Art International* 16 (Oct. 1972): 105–6.

"Influences of Matisse," *Art International* 17 (Nov. 1973): 28–31.

"Seminar Four," *Art International* 19 (Jan. 1975): 16–17.

"Cross-Breeding of Modern Sculpture," *Art News* 51 (June 1952): 74–77.

"Independence of Folk Art," *Art News* 52 (Sept. 1953): 26–27.

"Impress of Impressionism," *Art News* 55 (May 1956): 40–42.

"New York Painting Only Yesterday," *Art News* 56 (Summer 1957): 58–59.

"Pasted-Paper Revolution," *Art News* 57 (Sept. 1958): 46–49.

"Hans Hofmann: Good Old Rebel," *Art News* 57 (Jan. 1959): 26–29.

"Can Taste Be Objective?" *Art News* 72 (Feb. 1973): 22–23.

"Later Monet," *Art News Annual* 26 (1957): 132–48.

"Interview by James Faure Walker," *Art Scribe*, no. 10 (Jan. 1978): 15–21.

"Picasso at Seventy-five," *Arts Magazine* 32 (Oct. 1957): 40–47.

"Milton Avery," *Arts Magazine* 32 (Dec. 1957): 40–45.

"Sculpture in Our Time," *Arts Magazine* 32 (June 1958): 22–25.

"Seminar One," *Arts Magazine* 48 (Nov. 1973): 44–46.

"Seminar Six," *Arts Magazine* 50 (June 1976): 90–93.

"Detached Observations," *Arts Magazine* 51 (Dec. 1976): 86–89.

"Looking for the Avant-Garde," *Arts Magazine* 52 (Nov. 1977): 86–87.

"Seminar Seven," *Arts Magazine* 52 (June 1978): 97–98.

"Matisse in 1966," *Boston Museum Bulletin* 64 (1966): 66–76.

"Three New American Painters," *Canada Art* 20 (May–June 1963): 172–75.

"Plight of Our Culture," *Commentary* 15 (June 1953): 558–66; 16 (July 1953): 54–62.

"The Sculpture of Jacques Lipchitz," *Commentary* 18 (Sept. 1954): 257–59.

"The Jewishness of Franz Kafka," *Commentary* 19 (April 1955): 320–24; 19 (June 1955): 595–96; 20 (Aug. 1955): 177–78.

"Chagall," *Commentary* 23 (March 1957): 290–92.

"How Art Writing Earns Its Bad Name," *Encounter* 17 (Dec. 1962): 67–71.

"State of American Art," *Magazine of Art* 42 (March 1949): 92.

"Surrealist Painting," *Nation* 159 (Aug. 12, 1944): 192–94; 159 (Aug. 19, 1944): 219–20.

"Bertolt Brecht's Poetry," *Partisan Review* 8 (March-April 1941): 114–27.

"Ten Propositions on the War," *Partisan Review* 8 (July-Aug. 1941): 271–78 (with Dwight Macdonald).

"Greenberg on Berenson," *Perspectives USA,* No. 11 (1955): 150–54.

"Anthony Caro," *Studio International* 174 (Sept. 1967): 116–17.

"An Interview with Clement Greenberg" (by Edward Lucie-Smith), *Studio International* 175 (Jan. 1968): 4–5.

"Avant-Garde Attitudes: New Art in the Sixties," *Studio International* 179 (April 1970): 142–45.

"Seminar Five," *Studio International* 189 (May 1975): 191–92.

SECONDARY SOURCES

Calas, Nicolas. "The Enterprise of Criticism." *Arts Magazine* 42 (Sept. 1967): 9–12. Rpt. in Calas, *Art in the Age of Risk* (New York, 1968): pp. 139–42.

Cavaliere, Barbara, and Robert C. Hobbs. "Against a Newer Laocoon." *Arts Magazine* 51 (April 1977): 114–17.

Foster, S. C. "Clement Greenberg: Formalism in the '40s and '50s." *Art Journal* 35 (Fall 1975): 20–24.

Heron, Patrick. "The Ascendancy of London in the Sixties." *Studio International* 172 (Dec. 1966): 280–81.

———. "A Kind of Cultural Imperialism?" *Studio International* 175 (Feb. 1968): 62–64.

Higgens, Andrew. "Clement Greenberg and the Idea of the Avant-Garde." *Studio International* 182 (Oct. 1971): 144–47.

Kozloff, Max. "Critical Reception of Abstract Expressionism." *Arts Magazine* 40 (Dec. 1965): 27–33.

———. "A Letter to the Editor." *Art International* 7 (June 1963): 88–92.

Kramer, Hilton. "A Critic on the Side of History: Notes on Clement Greenberg." *Arts Magazine* 37 (Oct. 1962): 60–63.

Ratcliff, Carter. "Art Criticism: Other Minds, Other Eyes: Clement Greenberg." *Art International* 18 (Dec. 1974): 53–57.

Reise, Barbara M. "Greenberg and the Group: A Retrospective View." *Studio International* 175 (May 1968): 254–57; 175 (June 1968): 314–16.

Index

DESIGNED BY IRVING PERKINS
COMPOSED BY CREATIVE COMPOSITION CO.
ALBUQUERQUE, NEW MEXICO
MANUFACTURED BY McNAUGHTON & GUNN
ANN ARBOR, MICHIGAN
TEXT AND DISPLAY LINES ARE SET IN BASKERVILLE

Library of Congress Cataloging in Publication Data
Kuspit, Donald Burton.
Clement Greenberg, art critic.
Bibliography: p.
l. Greenberg, Clement, 1909- I. Title.
N7483.G73K87 709'.2'4 79-3967
ISBN 0-299-07900-7

7/9/87

5.95 paid 19877